PENCIL DRAWING
Step by Step

for Tracy

Jennie

from

Pia

BYE DARLING!

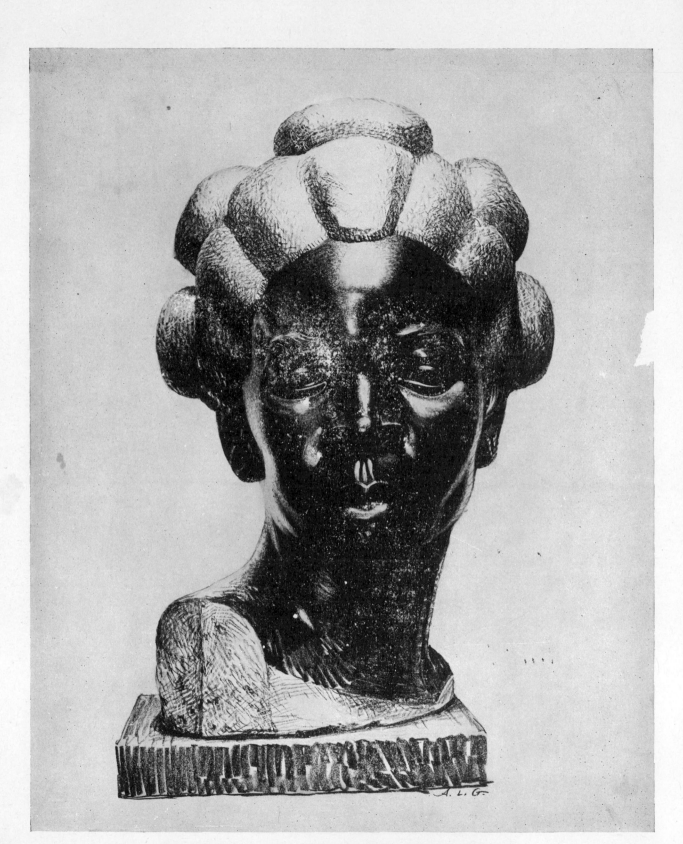

FRONTISPIECE · STUDY FROM HEAD BY MALVINA HOFFMAN

Occasionally it will help you to try such a photographic handling.

PENCIL DRAWING

Step by Step

A Revised and Reorganized Edition

Arthur L. Guptill, A.I.A.

VNR VAN NOSTRAND REINHOLD COMPANY
NEW YORK CINCINNATI TORONTO LONDON MELBOURNE

Library of Congress Catalog Card Number 59-13643

ISBN 0-442-26225-6

Printed in the United States of America

Published by Van Nostrand Reinhold Company
135 West 50th Street, New York, NY 10020, U.S.A.

Van Nostrand Reinhold Limited
1410 Birchmount Road
Scarborough, Ontario M1P 2E7, Canada

Van Nostrand Reinhold Australia Pty. Ltd.
17 Queen Street
Mitcham, Victoria 3132, Australia

Van Nostrand Reinhold Company Limited
Molly Millars Lane
Wokingham, Berkshire, England

16 15 14 13 12 11 10 9 8 7

Editor's Note

Arthur L. Guptill was known to his host of friends, students, and just plain fans, as "Guppy." He wrote a good many books during his lifetime, and nursed and edited a good many others. His first book was one on pencil drawing; the precursor of *Pencil Drawing Step by Step*, it was called *Sketching and Rendering in Pencil*. The demand was so great and the book so useful that it remained in print from 1922 to 1947. It had first run serially in the magazine, *Pencil Points* (now *Progressive Architecture*), during 1920 and 1921 when that magazine was just getting under way and when Guppy, too, was a youngster.

Because of his driving interest in art, and particularly in pencil drawing, Guptill somehow made time to produce a brand new book. It took hundreds of hours to do this because not a single drawing or page of text was carried over from the earlier book. The new volume, *Pencil Drawing Step by Step*, was published in 1949. It sold out and was reprinted in 1953. In 1957, one year after Guptill's untimely death, it was again sold out. By this time manufacturing costs had risen enough that the book as then constituted, could not be reprinted without raising its price.

However, the reputation of *Pencil Drawing Step by Step* had spread and orders for the book continued to come in. As a result, we attempted to find some practicable means of restoring the book to its public at a reasonable price. All of Guptill's original teaching was to be retained, as well as the delightful flavor of the whole.

The problem was finally solved by reducing the physical size of the book to 8¼" by 10¼" (still a good sized book), and by taking out the only section that contained no instruction — the examples of other artists' work. As for editing, this classic book teaches fundamental truths of technique so honestly, simply, and thoroughly that the only editing we could do was to delete the recommended supplementary reading matter, since most of these books are now out of print.

Contents

PART II SOME SPECIAL MATERIALS AND TECHNIQUES

Author's Note

Years ago, when I was asked to write my first book — the volume *Sketching and Rendering in Pencil* which this present book replaces — my teaching experience had been limited to the classroom, where I could discover each student's individual problems at first hand and then help him to find their solution. I therefore felt misgivings as to my ability to offer on the printed page much of value to the aspiring pencil artist. I believed, and still do, that the average student can make faster and finer progress under capable personal tuition than through books, especially if it is his privilege to work daily among congenial companions in a class where competition is keen. Not only is this spirit of good-natured rivalry an incentive to supreme effort, but if one is the least bit gifted — or even sincerely interested — he can't help absorbing something of value each day through the mere proximity of his classmates and their work. Their exchange of comments — sometimes brutally frank —plus any individual or class criticism by the teacher, should be of the greatest help, especially in pointing out any incipient faults.

Despite the above-mentioned misgivings, I of course did my best with that early book, and the fact that it was well received on publication gave me increased confidence in the value of such written instruction as I had to offer. As the book continued to enjoy a gratifying sale over the years, and as my later books on other media and methods met a similar reception, I gradually came to realize that, just as an art classroom has its virtues, so — though in a somewhat less personal and dramatic way — has the printed page. Even in the classroom, a sound book can prove a desirable supplement to one's other instruction for, in the last analysis, it's not so much a matter of where one acquires his inspiration and information as of what he does with it when he gets it.

A book possesses at least one vital advantage over a classroom; it can find its way to that youngster — or oldster, for that matter — on the farm or in the obscure village and bring him at least some small measure of the thing he craves, and of which he might otherwise be deprived. I was a small town boy myself so, in my writing, it gives me particular satisfaction to keep uppermost in my mind today's boys and girls who are similarly situated. A hundred times as I do each chapter I ask myself whether I am telling these youthful readers the things which really count at their state of progress, and telling them plainly. If, in this endeavor, I now and then over-stress the obvious or needlessly repeat certain elementary essentials long familiar to all but the novice, I hope that older or more advanced readers will bear with me. As I see it, this is less of a fault than to fall short in the opposite direction.

At best, there is of course a limit to what can be taught about any art, whether through a book or personal instruction. No teacher can hope to do more than give the student the right start, a word of encouragement when needed, and a modest degree of guidance as he progresses. The rest is up to the student.

The one thing which can be covered with reasonable thoroughness in such a book as this is the *craft* of pencil drawing — the technique of that particular medium. The *art* of the medium is another matter. Only as one experiences and understands life — as he reads and talks and thinks and grows — is he likely to get far with any art (unless he is born with a particular insight which is all too rare). So in this book we shall confine ourselves largely to the craft of the pencil, the logical technical

steps as they apply to what is commonly called naturalistic or realistic representation. We shall first introduce the reader to his pencils and papers, and suggest exercises in their use. Next, we shall help him to learn how to lay out proportions correctly, and to manage, tellingly, his tones of light and dark, with adequate attention to the interpretation of colors and textures. He should also soon acquire the power to direct attention wherever he wishes in a drawing, emphasizing the essentials while omitting or subordinating the non-essentials. He will find ways of suggesting depth, distance, and detachment, and of representing a host of subjects as they appear near-by and in the background, above the eye and below, in sunlight and in shadow. And these are but a few of the many things which he can accomplish.

In short, I can honestly say — for I have seen it happen again and again — that practically any intelligent person, willing to make the effort, can, through following such instructions as we shall offer on the following pages, learn to produce representational pencil drawings of which he can well be proud. But to break through into the ranks of the real masters — the true creative artists — is another thing. In order to do this, one needs more than real interest and perseverance; he must have something special within him — call it genius, soul, rare insight, poetic feeling, creative skill, or what you will — which but relatively few in any one generation possess. So, to restate a previous thought, one mustn't expect too much from any single book or, for that matter, from any class or teacher. The main contribution must be his own, according to his capacity. No one can make his drawings for him.

Acknowledgment

To all of those who have had a part in the making of this book, the author and publisher are glad to offer this word of appreciation. Galleries, publishing houses, institutions, and individuals in various fields have been most helpful.

Part I
FUNDAMENTALS
OF LEAD PENCIL DRAWING

The Pencil; Its Virtues and Faults

Plus a General Word of Advice

Before plunging into our technical discussions, let's take a minute to consider some of the possibilities and limitations of the pencil as a medium of esthetic expression. Especially should these preliminary words be read by the beginning student, who is all too often inclined to undertake the mastery of the pencil rather casually, perhaps, with the attitude, "Oh, it's only a cheap lead pencil! What can one expect from it?" Of course, such a novice can't expect much unless he can be made to realize that, far from being trivial, the pencil is one of the most useful tools at the artist's command — a thing of amazing potentialities.

True, the pencil has its faults and limitations — what medium hasn't? — yet its possibilities far outweigh them, as even the quickest thumbing through of the following pictorial pages will demonstrate. As you view each example, say to yourself, "This was done with the common, everyday pencil," and you may find your respect for this instrument increasing.

Let's enumerate a few of the pencil's outstanding virtues:

1. It is cheap to buy, as are the papers and other materials to use with it. Even the most prolific pencil artist could scarcely consume more than a hundred dollar's worth of such materials yearly; the beginner can make dozens of drawings for a dollar or two.

2. Equipment is everywhere accessible. Also, this equipment (as well as the finished pencil drawings) can be packed away in small space, or easily carried about. It requires no lengthy or difficult preparation, being ready for instant use. It is not messy. It seldom deteriorates with age. Finished pencil drawings need no special care; if on fine quality paper, they will remain fresh and attractive indefinitely. If exposed to light, they may eventually yellow slightly, but they will not fade.

3. The common employment of the pencil for writing and figuring has given us all some familiarity with it, so the beginning artist finds the pencil natural to hold and to manipulate properly when drawing — a highly important matter, as it leaves him free to concentrate on other problems.

4. The pencil responds readily to almost any demand. Sharply pointed, it gives a line as fine and clean-cut as that of the pen; bluntly pointed, it can be used much like the brush. It will make strokes sufficiently light and delicate, or bold and vigorous, to suit the most exacting technician, or tones so smooth that in them no trace of line can be found. It is responsive to the slightest variation of pressure or direction, allowing the artist to produce almost any type of individual stroke or, in the case of tone, to create uniform areas or to grade at will from light to dark or vice versa. Pencil tones may range all the way from the white of the paper to intense black — as full a gamut as any medium can promise.

5. Not the least of the virtues of the pencil is that it permits unusual freedom in correcting or erasing at any time during the progress of the work. (As we shall later see, the eraser is used occasionally as a supplementary tool for the production of unique and pleasing effects.)

6. If speed is desired, as when the artist is trying to record some ephemeral aspect of nature, the pencil permits amazingly rapid manipulation, yet, when time is not pressing, the very same pencil proves suitable for the most painstaking study.

7. The pencil is excellent for either finished results — drawings which are ends in themselves — or preparatory sketches or studies for final interpretation in pencil or other media. Even important paintings, lithographs, etchings, and drawings in pen or brush often get their start through the aid of the pencil.

8. The pencil combines perfectly with many

media, frequently playing an important part in conjunction with pen-and-ink, brush-and-ink, wash, watercolor, etc. There is also a unique method in which a solvent such as kerosene or turpentine is brushed over pencil work; this partially dissolves the graphite and spreads it in a wash-like manner to bring about agreeable results.

9. When it comes to color, the pencil admittedly is not at its best, yet there are many satisfactory colored pencils to be had, including the so-called watercolor pencils. In using these, the pencilling, once in place, is brushed over with water, the action creating something of a watercolor effect.

10. Practice with the pencil is ideal training for work in other media: Drawing in fine line prepares one for pen-and-ink and etching; broad line shading, together with shading in mass — "pencil painting," as it is sometimes called — helps one greatly with crayon, charcoal, and other chalky media, providing at the same time an excellent approach to lithography, along with at least a limited background for painting in wash, watercolor, and oil.

The above, then, are some of the advantages offered by the pencil. As to its limitations, the most obvious is that this simple instrument quite naturally cannot approach oil paint, watercolor, or pastel in an abiliiy to provide richness and depth of hue; neither can it yield their types of tone or texture. Nor is the pencil a logical tool for covering large surfaces; it is far better adapted to relatively small drawings. In fact, there is sometimes danger that, because of the fineness of the pencil's point, the student will fall into finicky ways, losing all breadth of effect in this struggle to cover large surfaces or to interpret a maze of detail.

When we check such faults against the virtues, it becomes evident — if proof be needed — that within certain natural limits the pencil can be the artist's real friend.

But if the pencil is valuable to the artist, it is practically indispensable to such a person as the architect, the architectural designer, and the draftsman; nothing can take the place of the graphite point for the major portion of his work. What other medium would answer for the laying out of his accurate plans, elevations, sections, details, and perspectives? And aside from this instrumental work (which is hardly within our scope), numerous drawings of a freehand nature are required, such as designs for carved wood and stone, ornamental iron, and other types of decorative detail. Lettering, too, must be done. The pencil is also of particular worth for the rendering of presentation drawings to show the client how proposed structures will appear when built. And, in designing such structures, the pencil is almost constantly in the architect's hand. Even "on the job," the pencil is essential; by means of a few quick strokes the architect can often make an obscure point clear to his client, the contractor, or some workman. This all adds up to the fact that the draftsman or other assistant who is looking for advancement is smart if he does everything in his power to improve his pencil facility.

The landscape architect, interior decorator, furniture designer, industrial designer, and costume designer are among many others who, with their assistants, find skill with the pencil a real asset. Also, in numerous branches of illustration and advertising art, the pencil is used more than any other tool. Practically every page of our millions of books, magazines, catalogs, and like types of printed matter is originally laid out in pencil — partly with instruments, partly freehand; to thousands in this field the pencil is therefore an absolute "must." And, to all of these individuals who use the pencil vocationally, we can add a host who draw with the pencil merely for fun.

Granting, then, that the pencil is a mighty useful medium, very well worth studying whether for pleasure or profit, the question arises as to the best way to master it. Probably no two authorities would give an identical answer, though fortunately the days of the dogmatic "Do it my way; there is no other right way!" seem to have vanished. In this book we shall stick to teaching the time-tested fundamentals, endeavoring to lead the reader along a logical and, we hope, enjoyable path, all the while stressing his need to develop his own judgment as to what suits his particular requirements.

We are assuming that he already possesses a passable knowledge of the principles of freehand drawing for, until he can portray things correctly in proportion — including perspective — and has some knowledge of light and shade, whatever of technical facility with the pencil he may gain will be of little use. For the occasional reader who is not so qualified, however, we offer in Chapter 4, Sections 1 through 5, a reasonably adequate course in the methods of constructing a freehand drawing, while in other pages we include basic suggestions on light and shade.

To the student somewhat versed in these prin-

ciples, the logical start with the pencil is to experiment thoughtfully for at least a few hours with all sorts of graphite points on different kinds of paper, performing exercises such as we shall soon offer. Then, one at a time, he should explore contrasting types of subject matter — still life, flowers, landscape, animals and birds, figures, faces. He should simultaneously learn to vary his handling. This he can best accomplish by concentrating, in a natural order, on the several techniques typical of the pencil — fine line, broad line, mass shading, etc. — acquiring reasonable facility in each before going on to the next. Also, he will be wise to try quick sketching, perhaps alternating it with more painstaking study. Memory sketching will provide salutary practice, too. We shall refer to all of this again and again as we go along, leaving the reader to select those of our suggestions which he thinks will prove beneficial if he is eventually to gain the all-around versatility rightly expected of the true pencil master. There's one encouraging thing: every step which the student takes will prepare him for the next and more difficult step; every bit of skill which he acquires will apply forevermore.

Novices sometimes ask, "How much natural ability should one possess in order to become a pencil artist?" This is not east to answer. Students who at the start seem exceptionally gifted often make disappointing progress, usually because of their unwillingness to work hard, while others who seem less talented frequently develop a high degree of skill, even though great effort may be required. This would seem to indicate that deep interest is about as important as innate ability. It is trite but true to say that there is no easy road to success; regardless of one's potential skill, his progress will demand lots of time and conscientious effort — enthusiastic effort. If he loves his work, he won't begrudge the long hours; he will enjoy each one. Even if he never quite attains his goal — for one's standards rise with each fresh accomplishment — he is almost certain to become creditably adept; his satisfaction even in this will normally more than compensate for the effort expended.

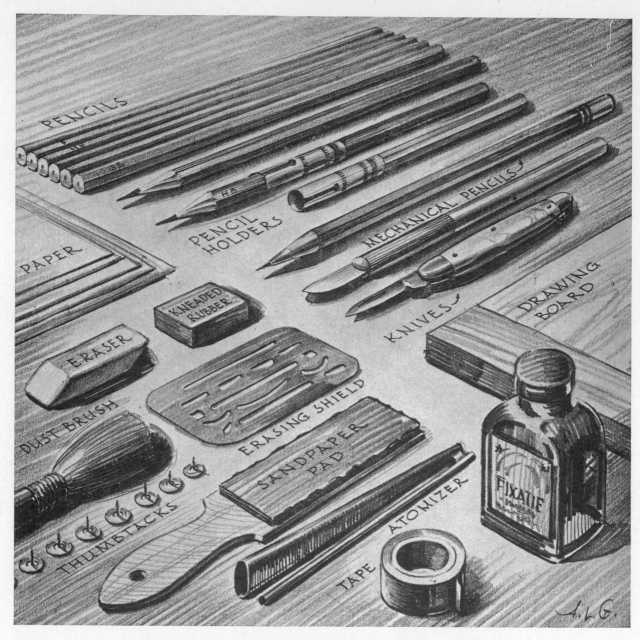

FIGURE 1 · THE BEGINNER'S EQUIPMENT IS EASILY OBTAINED

A CHECK LIST OF ESSENTIALS

The following selections are recommended at the start — see text of Chapter 1 for description: (1) A dozen or so assorted graphite drawing pencils; (2) A few pencil holders; (3) Block of pencil drawing paper, or several sheets of different kinds; (4) Drawing board, perhaps 16" x 20"; (5) A kneaded eraser, and a medium red or green eraser; (6) Thumbtacks; (7) Draftsman's erasing shield; (8) Sharp knife or razor blade; (9) Sandpaper pad; (10) Bottle of fixatif and atomizer. . . . Any dealer should be able to supply these. . . . Gradually, as we go along, additional items will be described.

The Beginner's Equipment

But Few Things Are Needed

The pencil artist doesn't require many materials. Figure 1 shows all that he might need at the start; if necessary, he can do with less. As we go on, we shall present other materials suitable for more advanced work — see especially Part II.

Graphite Pencils — A majority of pencil drawings are done with graphite (lead) pencils, so these should be mastered before turning to other types, of which there are several — see Chapters 8 and 9.

While it is sometimes possible to do a good drawing with a cheap pencil — the kind used in schools and offices — the standard drawing pencils which are made especially for the artist and draftsman cost but little extra and are vastly superior. Their lead is more highly refined, being comparatively free from gritty particles which, in cheaper pencils, often cause defective strokes or even scratches or tears in the paper. Also, the wood of drawing pencils is customarily of uniform grain (making them easier to sharpen) and better seasoned (which means that they are less likely to warp and so break the leads within). Still more important, these higher-priced pencils come in many accurately graded degrees of lead, so that by referring to the letters or figures prominently displayed at the end of each pencil, the experienced artist can tell exactly how soft or hard the lead is; thus he can judge instantly whether or not it is suited to his immediate purpose.

Grading — Most manufacturers offer their pencils in 17 degrees, graduated from 6B, the softest and blackest, to 9H, the hardest and least black, in this order: 6B, 5B, 4B, 3B, 2B B, HB, F, H, 2H, 3H, 4H, 5H, 6H, 7H, 8H, 9H. Of these, artists prefer the softer points, the 3B and 2B being general favorites. The 6B and 5B are also well-liked but, due to their extreme softness, they wear down quickly, requiring almost constant resharpening. They are also in-clined to break, and drawings made with them smudge badly if rubbed.

For many purposes, one may prefer such medium pencils as the HB, F, and H, and occasionally even as hard a lead as a 3H or 4H. On the whole, however, pencils harder than H are used almost entirely for instrumental drafting or for ultra-precise types of freehand work.

By performing such exercises as follow, one will soon learn exactly what kinds of line and tone he can make with each grade; doubtless he will then narrow his choice to six or eight pencils and, of these, most of his work will be accomplished with two or three. Sometimes a drawing (particularly a quick sketch) will be done entirely with a single pencil; again, it may prove desirable to use several. In the latter case, most of the work would probably be carried out with a soft or medium point, the harder ones being reserved for light, transparent tones and fine detail. The artist's preference will vary, though, according to conditions, his choice often depending somewhat on the nature of his paper (as we shall later demonstrate), or even on the weather (to create a dark tone on damp paper requires a softer pencil than is needed when the paper is dry). The type of subject matter — and especially its textures — may also influence one's choice, as may the technical treatment he has in mind. More about all of this in due time.

Makes of Pencils — As the products of different manufacturers vary somewhat, notably as to composition of the lead and as to standards of grading (neither of which is exactly uniform throughout the trade), it is perhaps just as well for the student to become fully familiar with one good make and then stick to it. (Some artists prefer one make and some another, though artists as a general rule have less definite predilections than do draftsmen.)

Among the best-known quality pencils are the

following — the name of the manufacturer of each is given in parenthesis:

Ben Franklin (Blaisdell)
Castell (A. W. Faber)
Eldorado (Dixon)
Kimberly (General)
Kohi-noor (Koh-i-noor)
Mars (Staedler)
Turquoise (Eagle)
Van Dyke (Eberhard Faber)
Venus (American)

Mechanical or Refill Pencils — One of the great annoyances of the wood-cased lead pencil is that it demands constant whittling away of the wood. Many pencil users therefore prefer mechanical pencils; these should be of the kind made especially for the artist or draftsman. (One needs a separate pencil for each degree of lead.) Try them if you wish; you will discover that they have both advantages and disadvantages.

Pencil Holders (Lengtheners) — It's hard to work with stubby pencils and rather expensive to throw them away, so most artists (unless they choose mechanical pencils) like to keep on hand a half dozen or so holders (see illustration), one for each frequently used grade. Then, as a pencil gets shorter than half length, it can be inserted in a holder and utilized to the last inch.

Special Pencils — Pencils of wax, carbon, etc. — as well as colored pencils — will be dealt with in Part II.

Paper — There are numerous papers on the market and, as artists seldom agree as to which kinds are best, it is impossible to give specific recommendations here. Your dealer can probably advise you as to the relative merits of the types he carries. He doubtless has paper both in loose sheets and in pads (blocks); also in sketchbook form. The common types of paper measure, in inches, approximately 8½ x 11 (standard notebook size), 9 x 12, and 11 x 14, or 11 x 15. You can also buy paper in larger sheets and by the roll. Some like to purchase drawing paper of the Imperial size (22 x 30) and then halve or quarter it when smaller proportions are desired — a good plan.

The typical surface of drawing paper is somewhat rough, having a "tooth" to "bite" the pencil; otherwise the pencil would not give off its graphite freely, nor would the paper retain it. For this reason, glazed paper is seldom desirable; such paper is also badly marred if any but the softest of erasers is used, or if it becomes dampened as by perspiration from the hands. Yet occasionally one finds glazed papers which are the exception, as they lend themselves very graciously to the making of crisp, snappy sketches. To achieve such results an extremely soft pencil (or a lithographic pencil — see page 120) is almost invariably required.

The slightly rough cardboard known as "kid-finished bristol" has much to recommend it — it is the author's preference for many purposes — while some of the better grades of the still heavier "illustration" boards also have their virtues, particularly for large work.

In recent years, tracing paper — long a favorite among architects — has become very popular with pencil artists. Its outstanding characteristic is its transparency; this makes it possible to rough out a subject on one sheet and then to render it on a second sheet laid over the first. Then, also, tracing paper often has an ideal surface for pencil drawing, possessing just the right amount of tooth. Such paper comes in pads, sheets, and by the roll. A pad measuring about 9 x 12 can prove useful in innumerable ways; frequently a still larger one is convenient.

Certain papers made for other purposes — bond typewriting paper, to name one — serve very well for drawing. In Chapter 51 we shall say something about tinted papers; they can prove highly effective.

Drawing Board — Unless one draws in a sketchbook, on a pad, or on stiff cardboard, he will need a support for his paper. A wooden drawing board is excellent — one about 16 x 20 is large enough to accommodate most drawing paper and still leave room to support the hand. The smoother the board the better; even tiny irregularities like thumbtack holes or the grain of the wood may transfer through to injure the appearance of a drawing — for a preventative, see below.

Thumbtacks; Masking Tape — One will require a few thumbtacks for fastening his paper to the drawing board. If he prefers not to mutilate his paper with thumbtack holes, the tacks may be placed just outside the edges, their heads overlapping the paper to hold it in position. Some artists substitute for tacks the draftsman's type of masking tape, taping the drawing sparingly at the corners.

Unless one's drawing paper is unusually thick, several extra sheets (or a sheet of smooth cardboard) should be placed beneath it, before it is secured to the board, so that any such defects as were just mentioned under "Drawing Board" will not transfer to the drawing as it develops.

Erasers — Do as little erasing as possible, not only because erasers tend to abrade the paper surface, making it difficult to draw over it again, but also for the reason that it is hard to erase a given area without smudging the surrounding tone. When erasing is necessary, kneaded rubber has a unique virtue; it is possible to press a clean piece of it against the offending pencilling and "lift" many of the graphite particles without disturbing adjoining areas. If the tone is so firmly embedded that this pressure, several times repeated, doesn't do the trick, use the kneaded rubber like any other eraser. Even when so employed, it is less likely than most erasers to create a messy effect. Kneaded rubber is also ideal for lightening the construction lines before the final pencilling is done, as it picks up its own erasings, leaving the paper relatively clean.

Occasionally it becomes necessary to remove lines or tones which will not yield to even brisk applications of the kneaded eraser; under this condition, the typical red or green eraser will usually do a satisfactory job. On glazed paper, or other delicate surfaces, the abrasive action of kneaded rubber and most other erasers may prove too strong, marring the effect. For these, artgum or some other extremely soft eraser should be substituted.

Erasing Shield — A draftsman's erasing shield (see illustration) is an exceptionally valuable gadget as it enables the artist to erase a limited area of almost any shape without injuring the near-by pencilling.

Dust Brush — An extremely soft brush is of great help in keeping the drawing free of erasings, dust, etc. The paper should always be dusted (or blown free of dirt) after any erasing, but with maximum care lest the drawing be smooched. This dusting is a wise precaution, as even tiny specks which look harmless can cause unsightly spots or streaks to develop as the pencil passes over them.

Knife — The proper pointing of wood-cased pencils is an art. The first requisite is a sharp knife or razor blade for cutting away the wood (the X-acto knife is good). Few pencil sharpeners will do this without simultaneously removing too much lead. The knife will also be useful for trimming paper, lifting thumbtacks, and cutting masking tape.

Sandpaper Pad — A block of sandpaper such as draftsmen use — preferably the type with a handle — is convenient for pointing the lead after the wood has been cut away. (For the use of this block, see page 22.) If such a block is not obtainable, a sheet of fine sandpaper or emery cloth (or even a rough sheet of drawing paper) may be substituted.

Fixatif — Work done in pencil — especially soft pencil — is so easily ruined if accidentally rubbed that it is generally sprayed on completion with a varnish-like liquid known as fixatif (fixative). Thus a thin protective coating is created. Fixatif can be purchased for a modest sum at any artist's materials store. (For the use of fixatif, see page 82.)

drawing board
masking tape
kneaded rubber
dust brush
fixatif

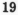

3

Planning an Indoor Working Space

A Private Sanctum Is Ideal

Pencil drawing can be done successfully practically anywhere and under almost any conditions. To work to the greatest advantage, however, the beginner needs a well-lighted spot where he will be free to draw with a minimum of interruption. A private room — a sanctum over which he has absolute control — is ideal.

Lighting — Studio lighting calls for careful planning. Not only should one have adequate light on his paper, both day and night, but it should so fall that his hand and pencil will not cast disturbing shadows on his work. Nor should the light create unpleasant reflections to tire the eyes. For the right-handed person, light from the left is recommended, and vice versa.

One's subject matter — especially the human face or figure — must likewise be lighted advantageously; a single source of light, perhaps located above and to one side, will bring out most forms with particular effectiveness. Reflectors — merely white cloth or cardboard placed vertically at suitable points — sometimes prove desirable. Artificial light should, so far as possible, be planned to take the place of daylight. An adjustable lighting fixture is desirable. If color is to be a part of one's problem, a daylight type of lamp should be chosen.

Posture — One's working position must be thoughtfully considered. If he is to draw well, he must always be relaxed; therefore, he should sit naturally in a comfortable chair, with his paper at such a height and slant that he can view it directly — i.e., it must not be viewed at such a foreshortened angle that distortions of

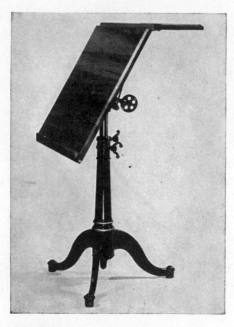

*Photographs,
courtesy, F. Weber Company*

FIGURE 2 · TABLE UPRIGHT

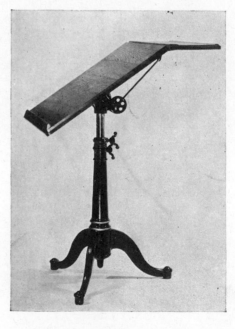

FIGURE 3 · TABLE SLOPING

proportion may develop while he is working.

Table — While thousands of artists — even professionals — manage very well by leaning their board or pad against the edge of an ordinary table (or placed on the table top, its far edge propped on a few books or like support), others think it a good investment to purchase, sooner or later, some such drawing stand as we picture in Figures 2 and 3. This one is adjustable to many positions. It can be used like an easel, with the paper upright — the artist may either sit or stand — or the top can be slanted to an angle (perhaps 15° or 20° from the horizontal) which will permit comfortable working when seated. Such stands provide ample leg room, and are very steady; when not in use, they occupy but small space.

Working Habits — Form the habit of keeping your pencils and other items of equipment always in the same relative position, so that you will automatically reach for the right pencil or eraser and then return it to its proper place. To aid in this, an artist's taboret or similar stand will prove an asset.

Supplementary Stand — When still-life objects are to be posed as subjects (or inspiration), a second stand, well within the range of easy vision, will be useful.

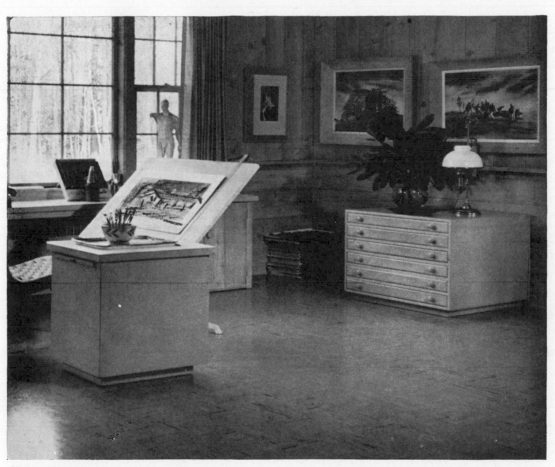

*Photograph,
courtesy, Russell O. Kuhner*

FIGURE 4 · A PRACTICAL WORKING STUDIO

21

4

Sharpening the Pencil

It's Quite a Knack

Before undertaking exercises in the use of your pencils, concentrate for a few minutes on different ways of pointing them. For it is quite a knack to do a workmanlike job especially with the softer grades; their leads are forever breaking, particularly if the pencils have previously been dropped or otherwise abused.

First a word as to tools. We have already hinted that there seems to be little to recommend most pencil sharpeners, whether of mechanical or hand type. Though occasionally they may serve (when leads are fairly hard, and sharp points wanted), a keen-edged knife or a single-edged razor blade will usually be your choice — see Figure 5.

With your knife ready, remember that each pencil has a right and a wrong end to sharpen! If you whittle off the identifying letters or numbers, it won't be easy later for you to judge the pencil's degree. Start by cutting away sufficient wood, using extreme care neither to break the precious lead nor to reduce its size

greatly. With the harder grades, you can safely expose half an inch or so. When sharpening soft pencils — 6B, 5B, 4B — you can't cut away much wood without risking immediate breakage.

Next, shape the exposed lead into the desired point on your sandpaper pad or a sheet of rough paper (see Figure 6). Sometimes both are employed, the paper providing the means for a final slicking up after the lead has been shaped. Each time you finish with the sandpaper pad, rap it repeatedly on the rim of your wastebasket (or other suitable receptacle) to free any loose graphite; also, wipe your pencil point with a rag or paper tissue. For if graphite particles find their way to your drawing paper they can easily cause smooches.

There are several rather definite types of points, one's choice usually depending on his immediate purpose:

1. The first, and simplest to make (and very satisfactory for all-around work), is that shown at 1 in Figure 7. This, with its taper quite uni-

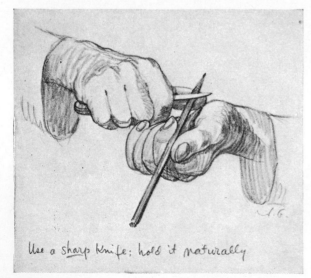

Use a sharp knife; hold it naturally

FIGURE 5 · REMOVING THE WOOD

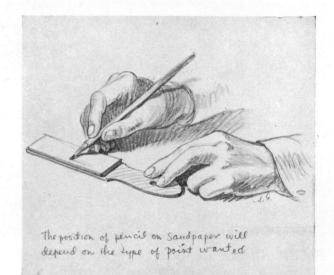

The position of pencil on sandpaper will depend on the type of point wanted

FIGURE 6 · POINTING THE LEAD

form, is not unlike the point made with a pencil sharpener excepting that less lead is cut away and the tip is not quite so sharp. No sandpapering is done.

2. A second type is the blunt or broad point shown at 2. In making this, the wood only is first cut away (A), a fairly long lead of full circumference being exposed (excepting in the brittle softest degrees). With the pencil then held in normal drawing position (B), the point is rubbed on the sandpaper until quite blunt, after which the end of the lead is smoothed by means of a few strokes on paper. This point will make either a broad or a fine stroke depending on whether the pencil is held in its normal drawing position as at B, or inverted as at C. Occasionally the sides of the lead are also sandpapered to create a flat point (D) which is ideal for broad, crisp individual strokes (E) such as may be needed for indicating square or rectangular details, for example — bricks, shingles, or panes of glass.

3. Some artists like what is known as a chisel point — one sandpapered on two sides to produce a thin edge (F). This will draw either a fine or a broad line, according to how it is held, or it may be manipulated to form a stroke varying in character throughout its length. It breaks rather easily.

Artists do most of their work with the medium or blunt point (1, above) to which the pencil naturally wears, preparing a special point only for some particular purpose. The main thing is to use always the type of point — as well as the degree of lead — which you think will best serve your need at the moment. As you carry out the exercises which follow in early chapters, try all sorts of points and you will gradually learn the possibilities of each. (In Chapter 36, page 114, are some suggestions for special pencils of graphite, having exceptionally big leads or leads of unusual shape.)

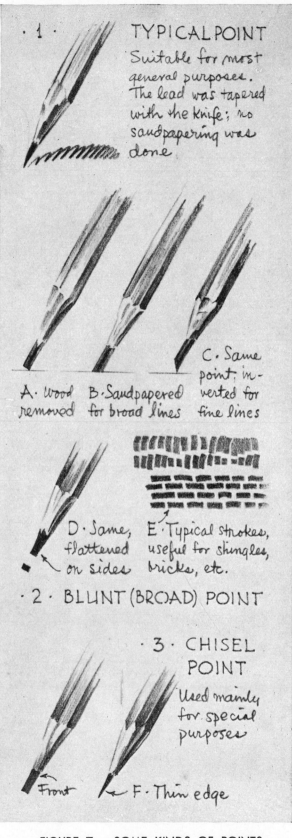

· 1 · TYPICAL POINT
Suitable for most general purposes. The lead was tapered with the knife; no sandpapering was done.

A. Wood removed B. Sandpapered for broad lines C. Same point, inverted for fine lines

D. Same, flattened on sides E. Typical strokes, useful for shingles, bricks, etc.

· 2 · BLUNT (BROAD) POINT

· 3 · CHISEL POINT
Used mainly for special purposes

Front F. Thin edge

FIGURE 7 · SOME KINDS OF POINTS

5

Holding the Pencil

Be Natural!

Your hand position will depend largely on the placing of your paper — whether it is vertical, steeply sloping, or nearly flat — and on the technical requirements of your drawing — whether it calls for sweeping strokes, carefully executed lines, or what. For typical work, most artists hold the pencil much as for writing, with the hand resting lightly on the table (see 1, Figure 8), though they use the pencil with far greater freedom. For short strokes, and strokes demanding considerable pressure, little arm movement is needed; the hand may swing at the wrist, or the fingers alone may perform the necessary motions. For longer strokes — notably quick, dashing strokes — the pencil is more likely to be held well back from the point, and often the entire forearm and hand are swung freely from the elbow, with a minimum of wrist

and finger movement (see 2, Figure 8). For particularly unrestrained effort, such as that required by the quick blocking in of the construction lines of a subject (especially if one is engaged at an easel or on drawings of large size), the pencil (which should preferably be of full length) may be held with the unsharpened end in the palm (see 3), the hand and wrist being very boldly swung. The hand may even be inverted (see 4); this position permits amazingly rapid progress.

For most shaded work, the quality of line and tone desired will determine the hand position, which will therefore change frequently. Occasionally, the pencil will be kept almost vertical (see 5, Figure 8); this position sometimes proves useful when building up tone very carefully with a sharp point.

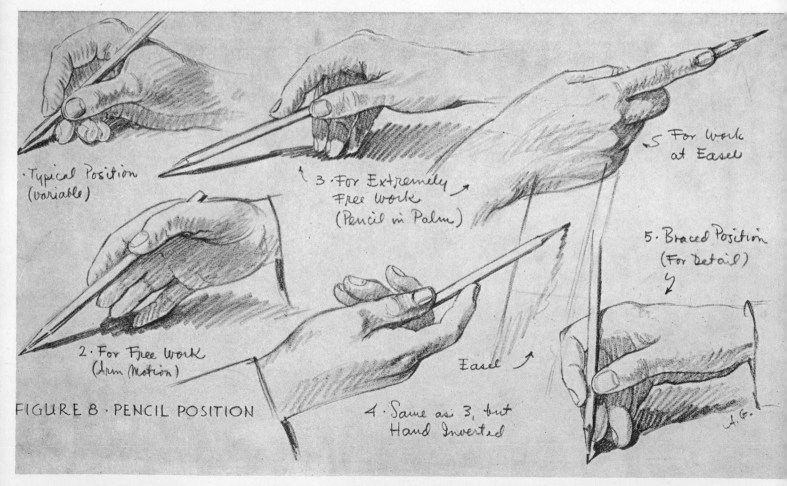

FIGURE 8 · PENCIL POSITION

Line Practice

Now Comes Your Real Start

The pencil being primarily a linear tool, a good starting point for the student is to experiment in the drawing of lines — hundreds of lines of all kinds: long and short; fine, medium, and broad; straight, crooked, curved; unbroken, broken; dots and dashes. Every grade of pencil should be employed, and on different papers. Pressure should be varied, too, as well as hand position and speed.

Suggestions for your practice are given in Figures 9, 10, and 11. Try some of these lines and invent others of your own, for your purpose is to discover every type of line of which your pencil is capable.

As the sharp point best expresses the linear character of your medium, you might begin with that, next trying broader and broader points and, finally, the full-sized lead, as in the illustration below.

Although Figures 9, 10, and 11 are reproduced at the exact size of the originals, do at least a part of your work at larger scale and with greater boldness. Try lines an inch long, two inches, three, six. "Sweep in" strokes a foot in length; let some of these take the natural curve which the swing of the arm tends to impart — draw others as straight as you can.

Turn through our pages and copy a few lines here and there, remembering that many of our reproductions have been reduced considerably from the original. If you have access to any original drawings in pencil, see how closely you can imitate their individual strokes.

Thus you will gradually come to a fuller appreciation of the pencil's possibilities, while developing your own technical repertoire. Eventually you will make, almost subconsciously, the type of stroke which every purpose demands.

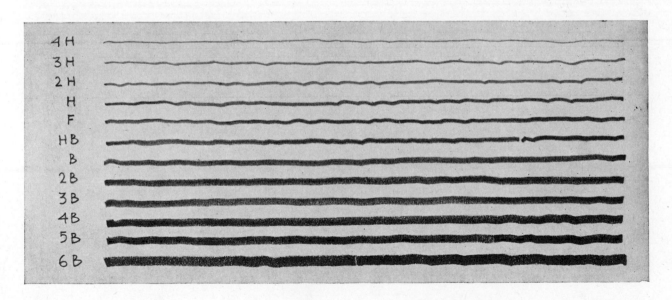

FIGURE 9 · DIFFERENT PENCILS PRODUCE DIFFERENT RESULTS

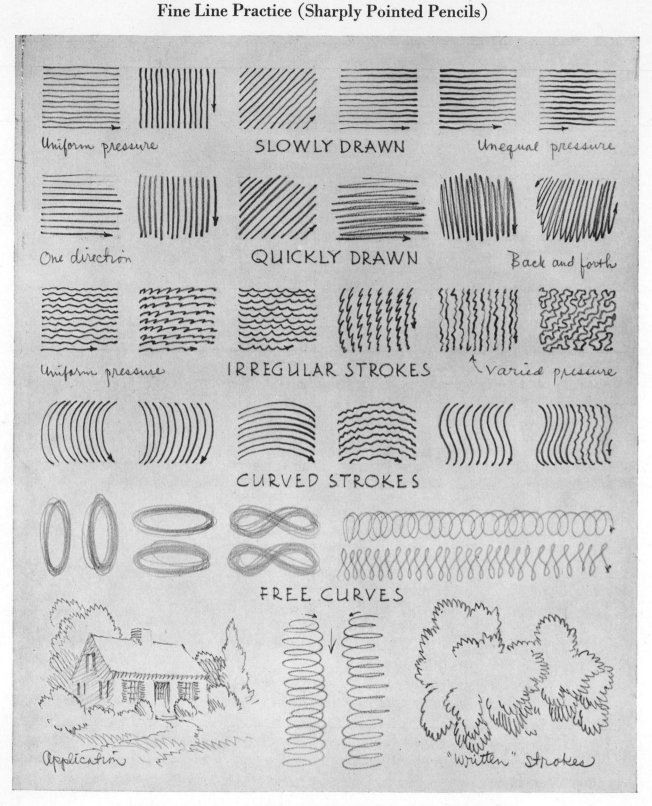

FIGURE 10 · AN AMAZING VARIETY OF FINE LINES IS POSSIBLE

Make pages and pages of strokes, using all of your pencils.

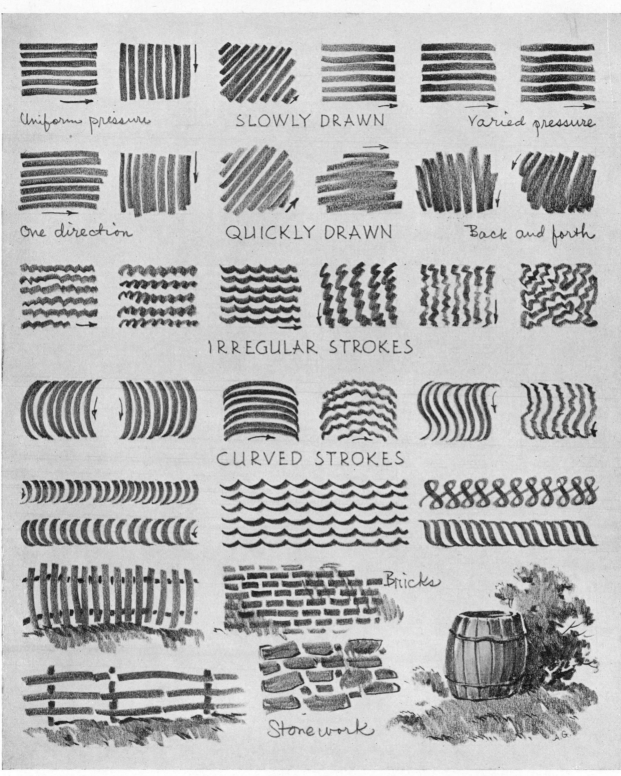

FIGURE 11 · THE MOST NATURAL STROKES ARE USUALLY THE BEST

Copy these strokes — though not slavishly — and invent many others.

7

Tone Building Methods

Of These There Are Many

Once you have thoroughly tested all of your pencils as linear instruments, experiment to see how many varieties of gray and black tones you can produce with them.

Two Types of Tones — Fundamentally, there are but two types: those in which the component pencil lines (or dots) are so merged that their individual identity is wholly or largely lost, and those in which at least some lines (or dots) are plainly visible. Tones of the former type might be called "true" tones; an example is shown at 1, Figure 12, where the area was repeatedly gone over in different directions with fine strokes until all traces of line disappeared.

At 2 we have a typical example of the second type of tone, consisting of lines so closely grouped that we are conscious — particularly if we view the area from a little distance — of a tonal, rather than a linear, impression. Such a tone might be called "false" in that it is only an illusion of tone, the eye gaining a tonal impression by automatically blending (to some extent) the dark lines and the white spaces between.

Similarly, example 3 is another illusory tone, for here closely spaced dots are merged through the process of vision. Short dashes, if close together, would also create a tonal effect of this basic type.

Try all Types — In pencil drawing, all such tones — we find them in infinite variety — are utilized according to need, often in combination. You should therefore experiment with every method of creating tone which occurs to you. The examples in Figure 13 typify both the solid and the linear (or dotted) kinds.

Flat and Graded Tones — For some purposes, tones which are uniform throughout — "flat" or "ungraded," as they are known — are preferable; other requirements may call for "graded" or "graduated" tones in which the amount of light or dark varies by degrees from part to part. More rarely, we find "hit-or-miss" tones which follow no set pattern. Note the decorative tones opposite.

Grade of Pencil — Obviously, your darkest tones can best be made with your softest pencils. By using less and less pressure, these same leads can produce medium or light tones, but such tones may be granular in effect — perhaps unpleasantly so. Medium pencils are therefore generally better for medium tones, and hard pencils for light tones (the latter pencils, in fact, can seldom be used for other than light tones).

Textures — Though textures are a matter for later consideration, we should at least point out here that in representative drawings of natural objects it is not enough to interpret the shapes correctly, along with the tones of light and dark; textures must simultaneously be indicated.

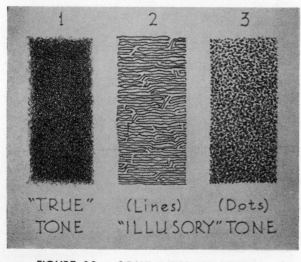

FIGURE 12 · SOME TYPES OF TONES

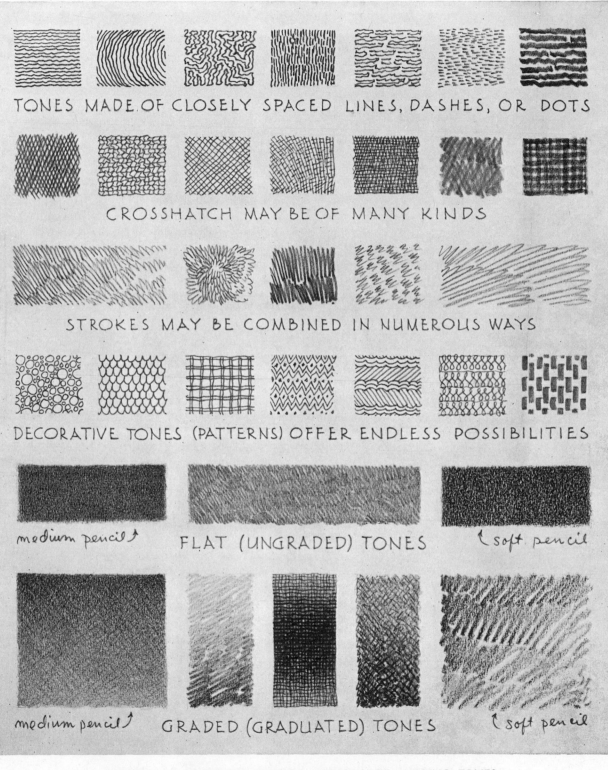

TONES MADE OF CLOSELY SPACED LINES, DASHES, OR DOTS

CROSSHATCH MAY BE OF MANY KINDS

STROKES MAY BE COMBINED IN NUMEROUS WAYS

DECORATIVE TONES (PATTERNS) OFFER ENDLESS POSSIBILITIES

medium pencil↗ FLAT (UNGRADED) TONES ↙soft pencil

medium pencil↗ GRADED (GRADUATED) TONES ↙soft pencil

FIGURE 13 · THERE ARE ENDLESS METHODS OF BUILDING TONES

The pencil is an amazingly versatile tone building medium.

8

Tone Building Influences

Two Are Especially Vital

Of the various matters recently covered, two deserve special emphasis: First, the grade of pencil controls to quite an extent the quality of the tone which the artist produces. Second, paper also has a vital bearing on tone quality.

In Figure 14, we demonstrate how essential it is always to select the right pencil according to the tone quality one desires. In the upper row of tones (1), an attempt was made to produce the same gray by using three different pencils on a single paper. Observe that the 6B makes a more granular tone than the HB. (Sometimes one type would be preferred; sometimes the other.) At 2 is proof that while the

6B can be used for light tones, it is seldom at its best for them. At 3 we are again reminded that hard pencils will produce only light tones.

As to the influence of paper, in Figure 15 we see in what way four typical grades of pencil respond to three different kinds of paper; rough, medium, and smooth. A soft pencil on rough paper gives an extremely broken, granular tone. A hard pencil requires the bite of a somewhat rough paper; it will scarcely mark on smooth. (These basic truths of course apply whether one works in line or tone.)

However, there are exceptions to the rule; for these see page 140.

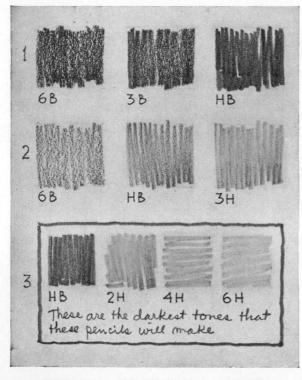

FIGURE 14 · PENCIL GRADE COUNTS

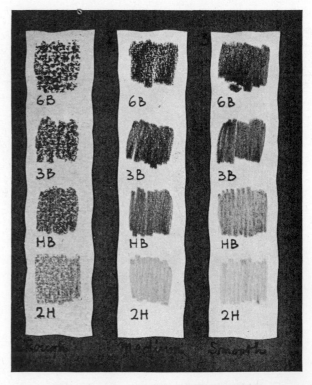

FIGURE 15 · PAPER IS IMPORTANT

Interpreting Nature's Tones

Values and How to Use Them

Now that we have learned to create many sorts of tones with our pencils, it is time to start thinking about the tones which we see about us in such natural objects — people, places, and things — as will soon become the subjects of our first efforts at delineation.

Local Tones — If we look analytically at these objects (let's forget colored ones for the moment), we will observe that each has its natural or innate surface tone. If, for instance, a box is made of white cardboard, white is its true or "local" tone. If a house is painted gray, gray is its local tone. Black is the local tone of a black automobile. Some objects have but one local tone, some many. In drawing, we occasionally represent an object by local tones alone.

Light, Shade and Shadow — Usually, however, we can gain a far more realistic effect in our drawing if we picture each object not as we know it to *be* (with its purely local tones of white, gray, and black), but rather as it appears to the eye, with its local tones modified by the light which illuminates the object, and by the accompanying shade and shadow.

We are all aware, of course, that we can't even see an object in the darkness of night, while in sunshine (or under a brilliant lamp) it stands out very clearly. Between these extremes, its appearances varies from moment to moment according to the kind and amount of illumination reaching it, and the direction from which this falls.

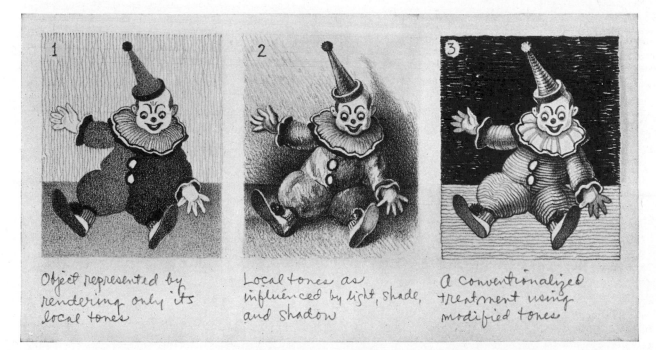

Object represented by rendering only its local tones

Local tones as influenced by light, shade, and shadow

A conventionalized treatment using modified tones

FIGURE 16 · LOCAL TONES ARE INFLUENCED BY LIGHT AND SHADE

In short, light not only reveals objects to us, but it so influences their appearance that *the artist normally represents each local tone much as he sees it modified by light, shade, and shadow* — see 2, Figure 16.

Conventionalized Treatments — It is not the artist's job, however, to imitate the camera by recording his subject matter exactly as it appears, down to the last detail. Instead, he is an interpreter. He selects from all the matter before him just those shapes and tones which seem essential to his purpose, and he gives each precisely the amount of emphasis or subordination it seems to call for. In other words, he filters nature's appearances through his mind before he portrays them on paper. As a rule he makes few adjustments of form — though there are plenty of exceptions — but often he takes liberties with his expression of tone (and color). Not infrequently, he conventionalizes his subject matter, particularly in his treatment of light, shade, and shadow. In doing this, he may use modified tones of white, gray, or black (see 3, Figure 16), or he may go still further and rely on outline alone.

The words "shade" and "shadow," by the way, are very loosely used in the field of art. Strictly speaking, they are not synonymous. When, in nature, light falls upon an object from some source of illumination, such surfaces of the object as receive the light rays directly are said to be in light. Those surfaces from which the light is more or less excluded (because they are turned from the light source and hence do not receive direct rays) are said to be in shade. Shadow is "cast" by the object upon the background (or upon other objects) through the interception by the object of some of the light rays. Thus shadow often represents, or preserves, something of the form of the object which intercepts the light. (See dictionary for further definitions.)

Shapes Influence Tones — While fundamentally the tonal appearance of an object depends upon (1) its local tones, and (2) the kind, intensity, and direction of light, there are several causative or modifying influences at work, of which shape is one of the most important. For instance, a flat-sided object such as a white cube, if exposed to light from one side, will usually display (because of its shape) a very simple arrangement of flat tones; each visible plane will quite possibly have a distinct tone of its own, limiting the effect of the entire cube to not over three well-defined tones, one for each visible plane. On the contrary, a white sphere, exposed to the very same light, may reveal an almost endless number of tones or, rather, a progressive grading of tone from that part of the sphere's surface which is turned most directly towards the source of light (and which therefore looks the lightest — pure white, if the light is bright enough) to that part which is the most turned away and so looks the darkest — perhaps almost black.

Incidentally, when the light is bright — as in the case of direct sunlight — shade and shadow areas will customarily appear clean-cut, with definite edges, while if the light is indirect or subdued, as it usually is indoors, the shade and shadow areas will blend together somewhat, and reveal soft, indefinite edges.

Light coming simultaneously from two or more sources, rather than one, will complicate matters, producing overlapping areas of tone, as well as multiple shadow edges. (Colored light still further confuses appearances, though it affects the pencil artist's work but little.) Reflected light, such as is frequently thrown onto an object from brilliantly illuminated surfaces in the immediate vicinity — surfaces which are most often located beneath or behind the object — is another factor which must be considered, as it modifies the effects caused by direct light.

Textures Influence Tones — Even the texture of an object — whether it is shiny or dull, smooth or rough — can greatly affect its tonal appearance. It is no news that the shiny surface of a black automobile seldom looks uniformly black. On the contrary, such a surface, though appearing intensely black in certain areas, may in others mirror the light of the sky and the tones of near-by buildings and trees, thus displaying a highly complex range of tones — some of them surprisingly light — not to mention colors. Similarly, a shiny dark vase indoors may reflect the image of a brilliant window and so exhibit an area of light which will appear extremely brilliant — far brighter than even the lightest parts of adjacent white objects which chance to be dull. Light objects (unless they are so shiny as to act as mirrors) usually appear somewhat lighter if smoother than if

rough because, if rough, each minor surface irregularity will have its own little areas of shade (and, perhaps, shadow) to play their part in darkening the whole. The artist often makes some endeavor to interpret these textures.

Tone Adjustments — Can the student ever come to understand such varied appearance as we have just described (there are many others!) and learn to interpret them in his work? The answer is of course "yes." The principles behind nature's appearances are simple, and by observation and experimentation — which one must do for himself; we can only offer suggestions — he will soon learn how objects, whether animate or inanimate, look under different circumstances. It will then be relatively easy, through practice, for him to learn how to represent them.

Let us repeat that the artist doesn't try to be a camera to record every visible variation and intricacy of nature's effects. On the contrary, it is his prerogative to exercise an amazing amount of freedom in his adjustment not only of forms but, more particularly, of tones, arranging them almost at will to suit his need or desire of the moment. The spectator who views the finished drawing is seldom disturbed by all this adjustment even if he is aware of it. He is so accustomed to nature's variety and changeableness of tone (and, so far as that goes, to the diversity of interpretation practiced by artists) that he will accept without question whatever the artist shows him, providing the effect looks convincing. That is his only criterion.

We can summarize this whole thing as follows: (1) If the artist can express his subject satisfactorily through the use of local tones only, that is his privilege. (2) He may render it in light and shade alone. (3) It's more than likely that he will combine these two procedures. (4) He may even forget tones and rely wholly on outline. (5) He may use other conventional treatments, such as a combination of outline with black or with flat tones of gray. (6) Seldom — though there may be exceptions — will he wholly neglect textures; if an object is rough or smooth, he will try to draw it accordingly.

The Interpretation of Colors — But what of color? What is the artist to do when he wishes to draw objects which, instead of appearing white, gray, or black, reveal color? How shall he interpret the red of the apple, the green of the grass, the blue of the sky?

Unless he chooses to utilize colored pencils (which is rarely the case) he must depend on artistic convention and, not unlike the sculptor working in marble, either ignore color or substitute for each important hue of nature a suitable tone of black, gray, or white. As there can be no rule about this, the artist must trust to his own judgment, which will of course improve with practice.

Values — In art circles, the term "value" is often used in place of "tone," whether reference is to the object itself or to a drawing. As by "value" we refer to the relative degree of light or dark in any given tone, a tone may be referred to as "light in value," "medium in value," or "dark in value." In a pencil drawing, a value may stand at any point between the white of the paper and the darkest tone of which a soft pencil is capable.

* * *

Scale of Values — As the student is certain to have the constant task of representing every degree of value which nature reveals, utilizing for this purpose all the tones of which his pencils are capable, some preliminary experimentation seems indicated at this point in order to prepare him for the work to follow.

A good start is to make a "scale of values" on the order of that at 1, Figure 17. The preparation of such a scale will, in itself, increase one's awareness of differences in tone, whether in the objects which he sees about him or in his drawing. Also, when ultimately he undertakes to work from nature, he can hold up this scale as a measure with which to compare every tone in his selected subject. In other words, by comparing a tone in nature with such a scale, one can better judge how light or dark to represent that tone in his drawing. On the following page are directions for preparing such a scale.

On a sheet of kid-finished bristol board, lay out nine squares (or other simple shapes) more or less like those at 1 in Figure 17. (We here select nine arbitrarily, merely because this number provides a convenient sequence of graduated

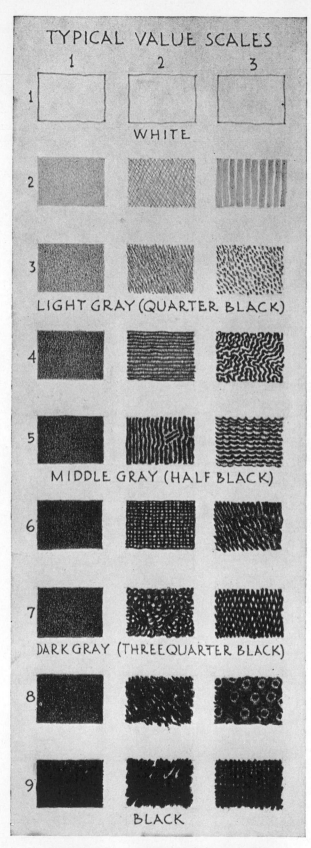

TYPICAL VALUE SCALES

1 2 3

1 — WHITE

2

3 — LIGHT GRAY (QUARTER BLACK)

4

5 — MIDDLE GRAY (HALF BLACK)

6

7 — DARK GRAY (THREEQUARTER BLACK)

8

9 — BLACK

FIGURE 17 · MASTER YOUR VALUES

steps.) Leave the first of these square (top) bare, as your white paper is the lightest value you can produce. Using a soft pencil, fill in the ninth (bottom) square with black tone — the darkest your pencil will make. Between the two, try to fill the fifth square with a gray tone exactly half-way in value between white and back; a medium pencil is best. This tone might be called "middle gray" or "half black," though its name matters little. Next, in your third square, attempt to create a value exactly half-way between white and middle. This might be called "light gray" or "quarter black." Similarly, in your seventh square would fall a value half-way between middle and black; this can be designated as "dark gray" or "three-quarter black." With these five stages completed, the same means should be extended to provide the four intermediates shown at 2, 4, 6, and 8, giving you at last a scale with uniformly graduated steps.

If artists always made their drawings with solid masses of tone, this one scale might prove sufficient, but we have seen that tones are often composed of lines or dots. It is therefore good practice to do several scales similar to those at 2 and 3, seeing how close you can come to matching the values at 1. (Don't merely copy 2 and 3, but invent scales of your own.) Use different pencils and papers and vary your manner of building the tone. This exercise should prove the best of preparation for subsequent work from nature, where you will constantly be faced with the task of interpreting nature's values through the employment of all sorts of lines and tones.

* * *

Some pencil drawings utilize many values, others but few. As we shall see later, a simple value scheme is usually to be preferred. Too many values, or complicated arrangements of values, can prove confusing.

Light, Shade, and Shadow

With a Word on Reflected Light

We have pointed out that, complex as nature's lighting effects are, they follow definite principles. These are not, however, the kind of principles which can easily be stated in words. Only through concentrated observation of objects in nature can one learn to grasp them fully. Perhaps they can best be comprehended by first-hand study of such simple geometric solids as we have already mentioned — cubes, spheres, and the like. Often dishes or other objects to be found around the house will serve just as well. Some of these objects should be dull, some shiny; some light and some dark.

The lessons learned from simple objects will apply later to the handling of every type of subject matter, regardless of its size or complexity — as is suggested by Figure 18, in which it will be seen that buildings can often be thought of as combinations of spheres, cylinders, cones, prisms, and pyramids. The dome of a building is basically hemispherical. Gas and water tanks are in many cases cylinders, with conical or domical tops. Room interiors and numerous items of furniture are geometrically proportioned, too, as are dozens of household utensils. Many a tree is more or less spherical or ovoidal in its leafy masses, while its trunk is cylindrical. Even people and animals — their larger basic forms, that is — can be fairly well interpreted geometrically.

Rounded Forms: The Sphere — At 1, Figure 19, we have drawn a white sphere having a relatively smooth surface. This sphere was placed on the object stand, indoors (A), and rendered in mass shading as fully and accurately as possible (some of the background tone was omitted, however). The light was coming downward from the left, the lightest spot on the sphere being at "a" where the rays hit most directly. From this point, the tone darkened very gradually in every direction as the surface curved away, thus forming graded

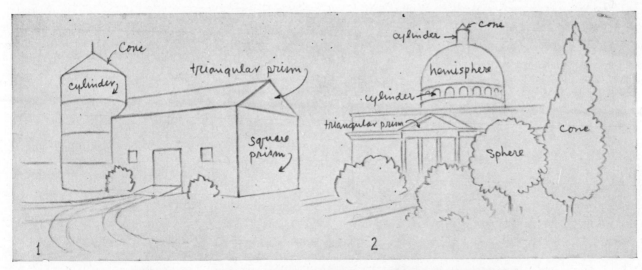

FIGURE 18 · REDUCE YOUR SUBJECTS TO THEIR LOWEST TERMS

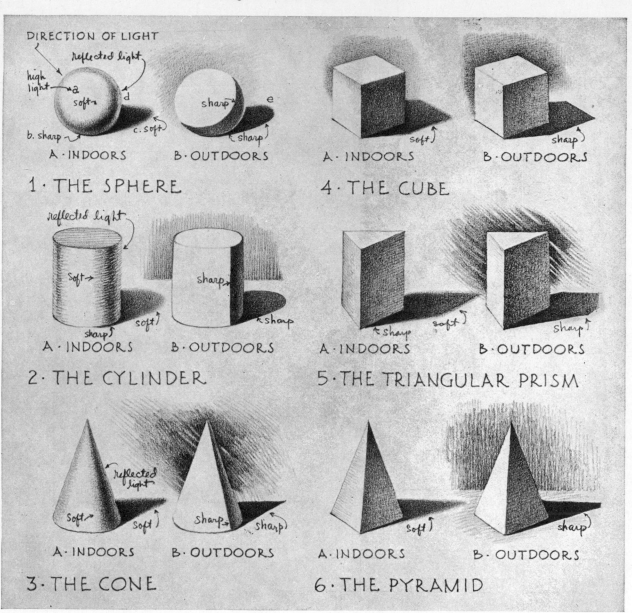

DIRECTION OF LIGHT
reflected light
high light
a
soft
d
b. sharp
c. soft
sharp
e
A · INDOORS B · OUTDOORS
1 · THE SPHERE

reflected light
Soft
soft
sharp
sharp
A · INDOORS B · OUTDOORS
2 · THE CYLINDER

reflected light
Soft
soft
sharp
sharp
A · INDOORS B · OUTDOORS
3 · THE CONE

soft
sharp
A · INDOORS B · OUTDOORS
4 · THE CUBE

sharp
soft
sharp
A · INDOORS B · OUTDOORS
5 · THE TRIANGULAR PRISM

soft
sharp
A · INDOORS B · OUTDOORS
6 · THE PYRAMID

FIGURE 19 · MASTER SIMPLE FORMS FIRST; OTHERS WILL BE EASY

shade tones on those areas turned somewhat from the light. Because the sphere intercepted light rays which otherwise would have reached the supporting table, the sphere cast a definite shadow upon the table.

At B we have a drawing of the same sphere placed in bright sunlight out-of-doors. The subtleties of surface shading are now lost. Note

the distinct division between light and shade areas.

Shadow Edges — It will likewise be noted that although in the drawing at A the shadow edges are sharp at "b," where they are near the object, and softer at "c," where the increased distance has allowed the light to become somewhat diffused, at B, with the object in strong

outdoor light, all shadow edges are relatively sharp (though diffraction has caused a slight softening at the most distant point, "e"). This comparison reinforces a previous statement that, whether the object is indoors or out, the effect will vary according to the amount, intensity, and direction of the light.

Reflected Light — In the drawing at A, It will be observed at "d" that light from the supporting surfaces is thrown back (reflected) onto the under side of the sphere, this reflection modifying the shade tone in a graded manner which increases the effect of surface curvature. We have already seen that such reflections of light from one surface to another are common in nature. Our apple at 1, Figure 36, page 53, has a similar reflection; in fact, the apple is quite like the sphere excepting for the addition of its local color. The bottle at 1, Figure 20, page 39, also exhibits reflected light, as do many of the other objects throughout the book.

To dramatize for yourself the influence of reflected light, take a large sheet of white paper or cardboard and, turning it toward a bright window, walk about your room, reflecting light into the dark corners from the paper. Or, if you wish, substitute a mirror; the effect may be even more dramatic. You can actually obliterate shadow tones if you reflect sufficient light into them; normally, you can only soften them.

Try, also, to prove to yourself that highly polished surfaces, such as those of shiny metal, act like mirrors to catch images — often distorted — of surrounding objects. When you render these polished surfaces, you will commonly picture (or indicate) at least the most prominent of their reflections. We shall say more about this in Chapter 11.

The Cylinder and Sphere — At 2, Figure 19, we have substituted a cylinder for the sphere, while at 3 a cone serves as model. Note in these the shadow edges, the gradation of surface tone, the reflected light.

Squared Forms — At 4, 5, and 6, we see the cube, triangular prism, and pyramid. These drawings strengthen an earlier point: that tone relationships are more simple in flat-sided objects than in curved. Many tones are uniform throughout, or nearly so, rather than graded.

Draw Such Objects — All the text matter in the world is of less value in this connection than a few hours of practice in drawing from actual objects with your own pencils. Why not try some simple geometric solids at this time? (Or perhaps you will prefer to wait until you have read the next few chapters and Chapter 12 with its suggestions on laying out the proportions of a subject.)

In your selection of objects, an egg or a white rubber ball can be your model for rounded forms; a cardboard box will serve as a squared form. Pyramids, cones, and prisms can easily be made from white cardboard. But don't limit yourself to models which are white. As we advised in opening the chapter, try things light and dark, dull and shiny.

Controlled Lighting — Inasmuch as light, shade, and shadow play so large a part in the appearance of objects, the artist, in posing his living model, or in "setting up" his still life, experiments with all sorts of lighting arrangements. Light, in other words, can be considered as an element of design — one uses it consciously for creating the finest possible arrangement of his tonal areas.

Therefore, even if your task is as simple as the rendering of a cube or a cylinder, once your object is in place on the model stand, you should experiment by lighting it from different angles, and with lights of diversified intensities. Try lighting it from two sides, or from two or more sources of illumination on the one side. Your task is much like that of the photographer who often takes great pains in order to create exactly the lighting effect that he desires.

When working outdoors, you of course can't arrange the lighting to your will, so, if your task is important, you must have the patience to wait until Mother Nature has lighted the subject to full advantage. Most outdoor subjects are more attractively illuminated in early morning or late afternoon than when the sun is directly overhead.

It is the contrast of light against dark or dark against light which gives subjects much of their appeal. No subject shows to best advantage in the full glare of light from several directions; the objects look flat, lifeless, and uninspiring.

11

Texture Representation

A Subject of Major Importance

We have repeatedly seen that the artist has to reckon with the textures of objects, for obviously if he wishes his work to be convincing, he must not only correctly picture forms and local values (the latter as influenced by light and shade), but he must make plain whether the objects are smooth or rough, dull or shiny. It will be a part of his job to learn to represent the textures of things as diversified as glass, wood, fur, stone, water, cloth, leather, foliage, feathers, clouds, and human flesh. When he draws a stone wall it must seem heavy and solid; foliage must appear yielding; water must give an impression of wetness, and, as a rule, of mobility; clouds must look soft and ethereal. A part of his success in all of this will depend on how well he handles his textures. He should therefore try to become texture-conscious even before he undertakes his first serious drawings.

Realistic Textures — There can be no definite rules for texture representation. As in so many other things, the student must learn almost wholly through his own observation and experimentation. We can, however, toss out a few hints. For instance, if everything in one's subject is rough, he may decide to work on rough paper; or he may use soft pencils, knowing their tendency to form granular tones. If, on the other hand, the surfaces to be represented are smooth and glassy, smoother paper or harder pencils may be in order. For mirror-like surfaces, quickly drawn strokes such as those used for the glass at 1 and in the water at 2, Figure 20, have merit. Hesitant, slowly drawn strokes, on the contrary, are better for portraying rough surfaces, as in the stonework at 3 and the old felt hat at 4.

Often several quite different surfaces in the same subject call for correspondingly diversified handlings. In Sketch 2, for example, see what a different treatment was used for rendering the rough stone from that selected for the calm, smooth water. Occasionally a special point on one's pencil proves of help: for the basket at 5, clean-cut strokes made with a squared point quite satisfactorily suggest the woven texture of the basketry. The tree at 6, on the other hand, exhibited such differences of effect in its fine twigs, larger branches, and the rough bark of its trunk, that it called for a variety of points.

Later, when we deal with representative drawing at greater length, we shall see additional ways of indicating textures, but before we reach that discussion, you can profit from studying all sorts of surfaces in nature, trying to imagine how to draw them with your pencil.

Decorative Textures — The use of textured tone is not limited to realistic representations. The artist sometimes imparts to a given area a certain amount of texture merely because it pleases him to do so — he wishes to make that area more decorative, or otherwise more interesting. Tones such as those used in our drawings of geometric solids (Figure 19), for instance, are far less exciting to view (or to do) than are many others which will be found scattered throughout the book. Turn the pages with this in mind; see in particular the extreme examples in Figure 117, page 43. These were produced by making "rubbings" with the paper placed on top of suitable fabrics or like backgrounds — a unique if somewhat artificial method.

Other interesting textures — some realistic and some decorative — can be created on such special papers as "laid" paper or Ross board; see later chapters, Part II.

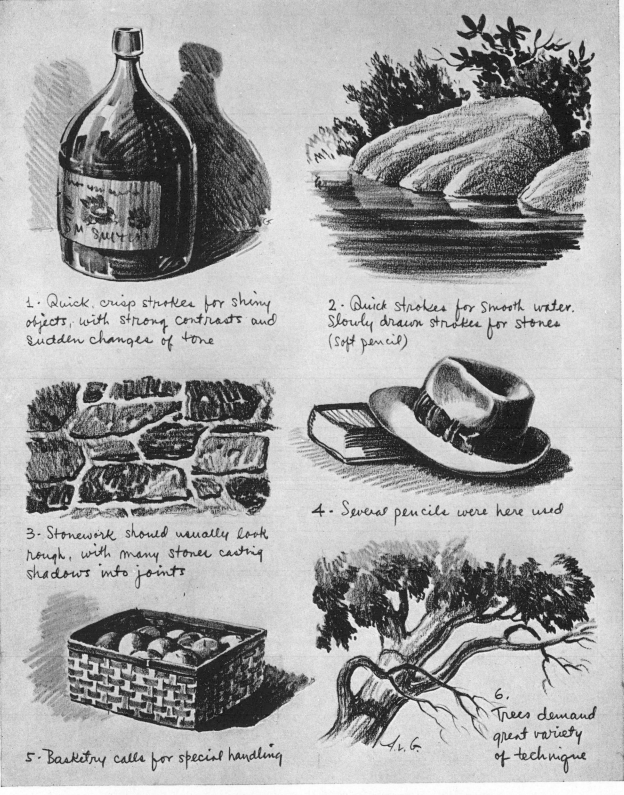

1. Quick, crisp strokes for shiny objects, with strong contrasts and sudden changes of tone

2. Quick strokes for smooth water. Slowly drawn strokes for stones (soft pencil)

3. Stonework should usually look rough, with many stones casting shadows into joints

4. Several pencils were here used

5. Basketry calls for special handling

6. Trees demand great variety of technique

FIGURE 20 · NATURE REVEALS THE KEY TO TEXTURE TREATMENT

12

Constructing the Subject

The Outline Method

Perhaps we have been getting ahead of our story, for until the novice has learned to lay out his subjects well, there is little point in discussions of light and shade, textures, etc. As we stated at the start, however, we must assume here that our reader is already familiar with the common methods of construction. Our only reason for turning to the matter somewhat briefly in this and the other sections of this chapter is to lend a helping hand to the occasional reader who may lack even the most elementary knowledge of construction. Even to him we can offer nothing on the somewhat involved subject of perspective but refer him to some of the good books on this subject alone.

Selecting the Subject — Before you can construct the proportions of a subject, you must naturally have a subject. For your first work, choose something simple, with definite form — possibly your sphere or cube discussed in Chapter 3, Section 1, or some more interesting common object, or even a group of two or three. (For the advantages of still-life drawing, see Chapter 29.)

Construction — The method of construction used by most artists is illustrated in Figure 21.

Step 1: The Main Proportions — Seat yourself comfortably, for every time you shift your position you will see proportions differently. Decide whether to place your drawing vertically or horizontally on your paper; this will usually depend on your subject. Locate your subject on the paper by means of light pencil touches to indicate its extremities. (Study first stage at 1.) Vertical center lines for symmetrical objects such as bottles may be of help. Sweep in the larger proportions rapidly, with the pencil freely held. Use a medium pencil, and *draw lightly* so that errors can easily be erased.

Testing — At this point, set the drawing back near the subject. Then assume precisely your former position and compare the two. Does the over-all height seem right in relation to the width? Do the shapes look correct? Are the slants of sloping lines satisfactory? (Further tests will be found in Chapter 17.)

Step 2: Adding Subdivisions — With your drawing returned to your stand, correct wrong proportions, erasing faulty lines. Then block in the main subdivisions, and perhaps some of the details. Your drawing is fast becoming a complete and accurate construction diagram on which to render — see second stage at 2, Figure 21.

Set your layout back by the objects again — you can't do this too often. Compare. Turn away for a few minutes to rest the eye, being sure on your return that you sit exactly as before. With a fresh eye, you will often discover unsuspected mistakes.

Step 3: Supplying the Detail — The number of stages through which your drawing will pass before you are ready to render will depend on your skill and the complexity of the subject. Never add the smaller details until the larger proportions look right. Just before rendering, refine all proportions, and erase incorrect or superfluous lines — see 3. Then soften the correct lines until they show only as faint guides. (In Chapter 19, we shall deal with the outline rendering of a very similar object.)

If in this preliminary work you have injured your paper, a transfer to a fresh sheet may be indicated — see Chapter 18.

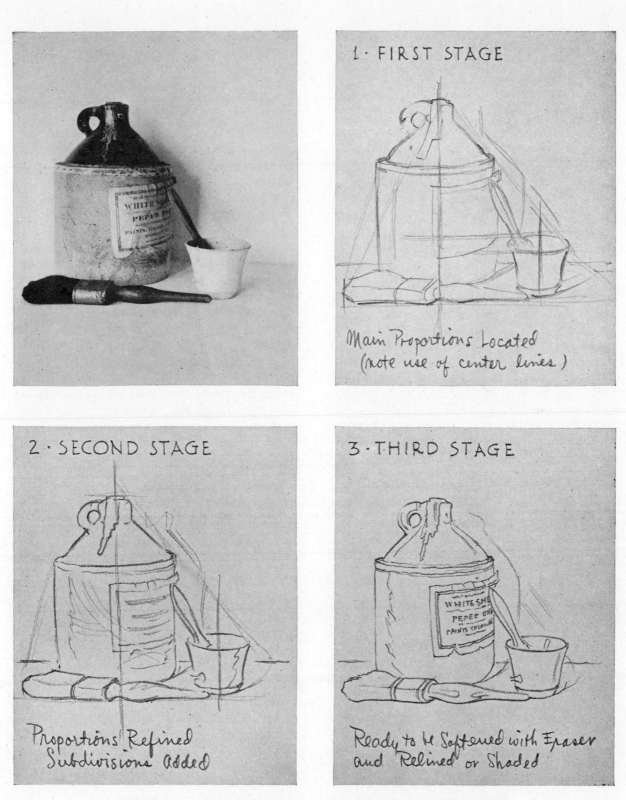

1 · FIRST STAGE

Main Proportions Located
(note use of center lines)

2 · SECOND STAGE

Proportions Refined
Subdivisions Added

3 · THIRD STAGE

Ready to be Softened with Eraser
and Relined or Shaded

FIGURE 21 · ALWAYS PROCEED METHODICALLY BY EASY STAGES

Think of the object's form or mass, rather than its outline.

13

Constructing the Subject

Tracing Paper Method

In recent years, more and more teachers of freehand drawing are turning to tracing paper as an aid in constructing proportions. For this purpose, such paper should be quite transparent; it is most convenient in pad form — 9x12 inches is a handy size. A surface should be selected which takes the pencil well. The procedure varies but little from that just presented.

Construction — As soon as the student is seated, he opens his pad near the center and snaps on a clothespin or rubber band (see Figure 22) to hold the paper in place. On the sheet thus exposed, he sketches the main construction lines. Inasmuch as moisture, such as perspiration from the hand, sometimes buckles tracing paper badly (because of its extreme thinness), it is wise always to keep extra paper under the hand.

Now comes the first difference between this and the previous method: When the student is ready to go to the second stage, instead of erasing as a preliminary to later drawing, he merely lowers a fresh sheet of tracing paper over the first — that, of course, is the reason for working near the center of the pad — and proceeds to trace the main lines, improving them as he traces.

When he has thus transferred to his second sheet all that is needed from the first, he tears

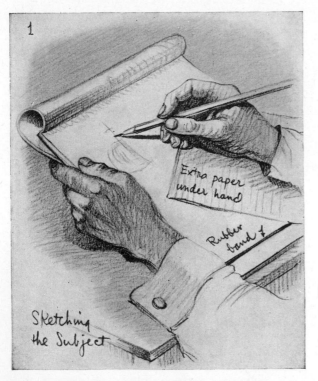

FIGURE 22 · MAIN POINTS LOCATED

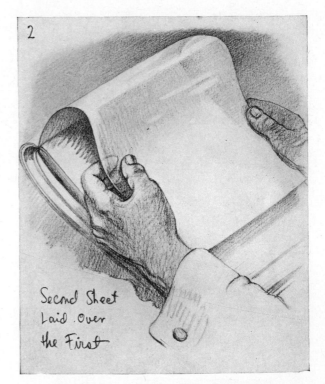

FIGURE 23 · READY FOR RETRACING

out the first, or shoves a sheet of bristol board or heavy paper between the two to prevent incorrect or superfluous lines from showing through to confuse him.

He now carries his second study as far as seems desirable, next lowering a third sheet into position and repeating the process of correcting, refining, and adding more detail. Thus he gradually makes as many studies as he requires — normally three or four — until at last after little if any erasure, and with a minimum of effort, he arrives at as perfect a layout as he is capable of making.

Line Drawing — If the final drawing is to be in line only, the artist is now ready to go ahead with it, as described in Chapter 19.

Studies for Values — Most pencil drawings, however, are in tone. For these, studies of the values of light and dark are usually made before the actual rendering is started on the final paper. Tracing paper is perfect for such studies. It is easy to make several, one over the other, then comparing the results so as to learn how next to proceed.

Final Rendering — Even the final drawing, whether in outline or light and shade, can be made on tracing paper, providing it has a suitable surface. When completed, such a drawing may be attached to heavier paper or cardboard by means of tape.

One unique advantage of tracing paper — especially in the making of studies — is that you can look through it from the back, defects becoming particularly evident when thus seen in reverse. (A similar effect can be obtained by reflecting any drawing — and the subject, too — in a mirror, a fault-revealing practice often utilized by professionals.)

Another use of tracing paper (for application in more advanced work) is this: The student can recompose his subject matter by tracing one portion from an original sketch, next sliding his tracing paper along and tracing another portion, and so on. Or he may trace from several sketches. For example, he may trace a tree from one sketch, a house from a second, and a roadway from a third. He must make allowances, of course, for any errors of perspective or scale which may develop. In fact, considerable skill may be required to bring such elements from different sources into close harmony.

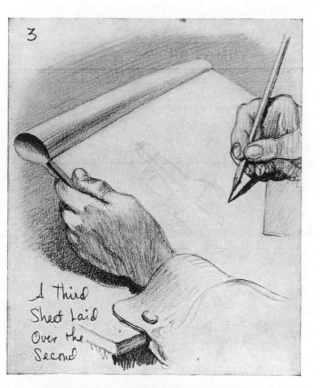

FIGURE 24 · GRADUAL REFINEMENT

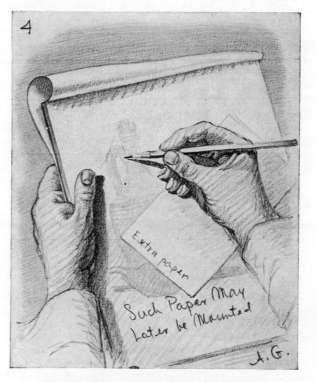

FIGURE 25 · READY FOR RENDERING

14

Constructing the Subject

Scribble, Spirals, and Such

While there is much to recommend the orderly step-by-step method of laying out the proportions of the subject which we have demonstrated in the last two chapters, the student commonly finds, as he gains increased facility, that he can quickly and accurately make his layout directly upon his final paper merely by utilizing a few light dots and dashes — or extremely delicate lines — carefully placed to locate the essential proportions.

It is a long time, though, before some students develop this skill. In fact, there are occasional individuals who find the construction of proportions a sore trial. For them, we include the following suggestions, and those which will be presented in the next two chapters.

The Scribble Method — In one approach (sometimes substituted for those already presented), the artist "feels out" his subject by scribbling away on his paper somewhat casually until, through the use of wandering strokes, he obtains at least a rough semblance of the matter before him (see Figure 26). In this process, he keeps his eye on the subject much of the time, shooting an occasional quick glance at his drawing. With his proportions reasonably well located, his next move is to darken lines here and there to define his forms with greater accuracy, after which he resorts to his eraser — kneaded rubber is good — in order to obliterate

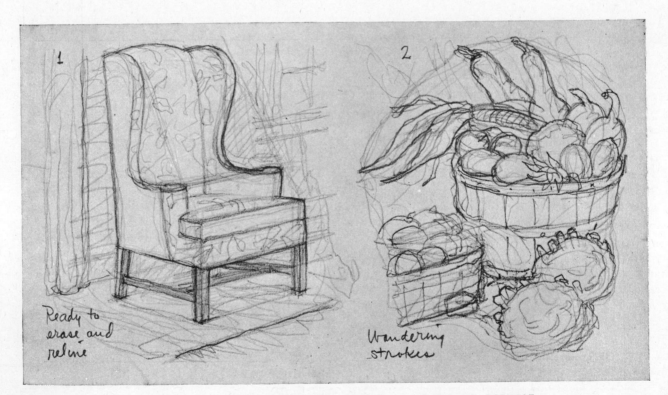

FIGURE 26 · "FEELING OUT" THE FORMS BY MEANS OF SCRIBBLE

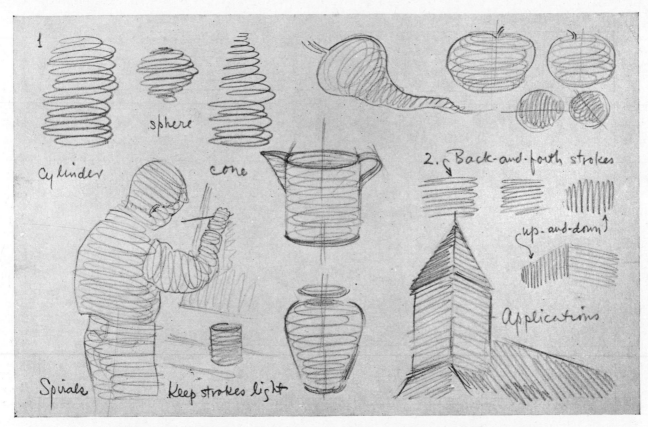

FIGURE 27 · THESE COULD NEXT BE DEVELOPED ON TRACING PAPER

the incorrect and superfluous lines. (Occasionally, these first free lines are left to show faintly in the final result.) Unless he can now discover errors in proportion which need attention, he is ready to render. This he can do on his original paper (unless it has been damaged by too much pressure), or the proportions may be transferred to a fresh sheet — see Chapter 18 for a discussion of making a transfer.

The Spiral Method — One objection which is now and then made to all of the foregoing methods of constructing drawings in outline alone is that the forms may have a tendency to look flat, lacking a sense of bulk or solidity. For this reason, some students like to construct their proportions so far as possible through the aid of quickly formed spiral strokes like those in Figure 27. Such strokes are especially helpful when rounded forms are concerned — fruit

and vegetables, animals and people. Where they are not adaptable, quick back-and-forth strokes (2) can often take their place, though these are less expressive of bulk.

No instruction seems necessary beyond stressing the obvious — that layouts utilizing this method are usually made very quickly, the spirals (or the back-and-forth strokes) being drawn with extreme freedom. If the first layout is not wholly satisfactory, tracing paper overlays permit the making, one atop the other, of as many more as may be needed. With the basic forms at length satisfactory, still another overlay sketch can be done, omitting all but the essential lines. After this, the shading would proceed in the usual way; the best direction of stroke to express the form can often be determined by reference to the preliminary sketches with their spirals and back-and-forth strokes.

45

15

Constructing the Subject

Tone Method

At last we come to a final method of constructing the subject — by no means a common method, but one of occasional value.

Now and then there are students who only with difficulty can see form (or even think of form) as if surrounded by outline. They see each area of the subject as a tone of a certain shape. Therefore, it is natural for them to try to interpret each such tonal shape by means of a pencil area of like shape. Outline to them is confusing and unnatural.

Graphite Sticks — A soft pencil, especially if bluntly pointed, will serve fairly well for creating these areas. Pencils with oversize leads — see page 114 — are still better, while another excellent instrument is the square crayon, pic-

tured on page 146. Crayons of this type come in graphite, carbon, wax, etc. Held on the side, they get over the ground amazingly fast (see Figure 28).

With the proportions thus blocked out, a sheet of tracing paper lowered over the rough layout will permit the making of corrections either in tone or line.

Such tonal studies, in addition to helping one to construct his forms, will aid him to plan his value scheme for his finished work. Even if he prefers to construct his subject matter in outline, it will still pay him (as earlier mentioned) to make trial value studies as an approach to his rendering. And for this, the square stick has real advantages.

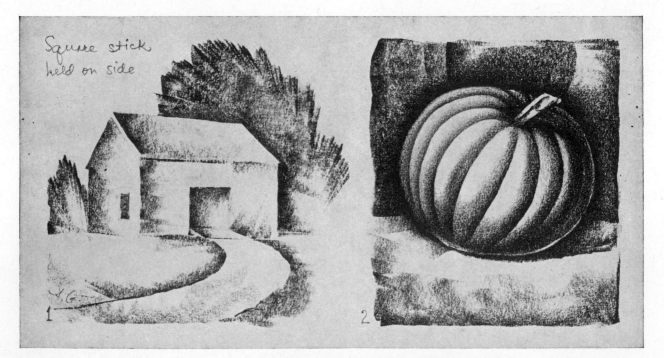

Square stick held on side

FIGURE 28 · SIDE STROKES PRODUCE SUCH EFFECTS RAPIDLY

Constructing the Subject

Tracing on Glass

For the student who has unusual difficulty in the layout of proportions, a few hours' practice in making tracings on glass may be of help in clarifying the relationship between natural appearances and methods of representation.

The procedure is simple: Hold an ordinary sheet of glass upright and, with one eye closed to prevent a duplicated image, look through the glass at some object. With a lithographic or china-marking pencil, carefully trace on this glass the main lines of the object. If you maintain your exact position, your finished result will obviously be a correct line drawing of the object as seen from that particular viewpoint. Repeat this exercise a number of times, washing each drawing from the glass with a damp cloth before going on with the next drawing.

Next, go to a window which permits freedom of vision and, keeping one eye closed and looking directly through the glass (not slantwise), trace upon it some outdoor object which has definite form. Practically anything will do which is at rest; a distant building is good because of its well-defined masses. Again, this tracing is a true representative drawing, in outline, of the object.

Tracing paper can be almost as useful as glass if you place it over a photograph and trace the subject's main elements.

Such exercises, at an hour of perplexity, can often drive home the point that every drawing is, in a sense, a tracing of an object.

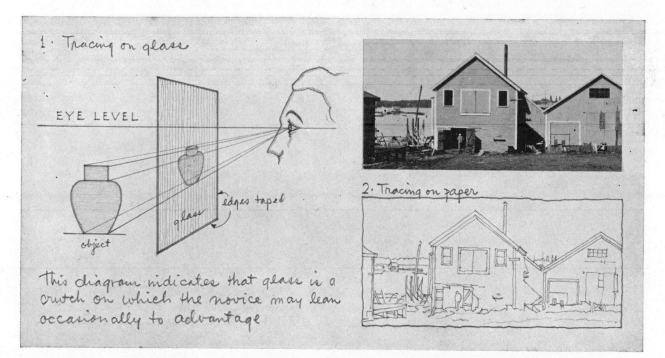

FIGURE 29 · A DRAWING IS BASICALLY A TRACING OF AN OBJECT

17

Testing Your Construction

The Eye Is the Best Aid

Constructing one's subject is usually the student's toughest problem. He wishes he might become infallible in his ability to draw true proportions. Perhaps some day he can, if he will work conscientiously.

But there are no short cuts to success; progress comes only through hard practice. As one gradually learns to observe correctly what he sees, he simultaneously develops the skill to record it faithfully.

While in the long run the student must depend on his own eye for judging the accuracy of his construction — it is by far his most reliable guide — here are a few simple aids which may sometimes be of help. First, if he is troubled as to how nearly vertical a certain line in a subject may be, the carpenter's plumb-line (see 1, Figure 30) can prove of value. Similarly, if he wishes to judge how nearly horizontal some line in his subject is, he can sight across the top of a carpenter's spirit level (see 2) at the line in question. A common way to estimate the slant of a line is to hold a pencil to the same slant (see 3).

Thumb Measurement — Sometimes one's pencil is used as a measuring stick (see 4). It is held vertically (point down) at arm's length between eye and object. With one eye closed, the top of the pencil is brought to coincide with a salient upper point of the object. Then, with the pencil kept in this position, the thumb is slid down until the nail marks some other vital point. With the pencil now measuring an important vertical dimension, the arm is rotated, pencil and all, to permit a comparison of the measurement just taken with some horizontal or slanting dimension. Similarly, any other dimensions of the object may be compared. Corresponding comparisons on the drawing are then made by eye.

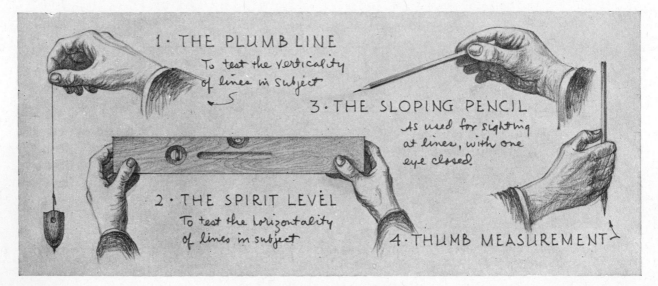

FIGURE 30 · A TRAINED EYE IS THE BEST TESTING INSTRUMENT

Making a Transfer

It's Really Very Simple

When one constructs his work directly upon bristol board or drawing paper, he sometimes makes so many needed erasures (or so damages the surface in other ways) that it becomes next to impossible to do a really good final rendering upon it. In this circumstance, the correct proportions can easily be transferred to a fresh sheet. (Such a transfer may also be in order if the student who uses the tracing paper method of construction decides not to make his final rendering on tracing paper.)

Here is the common method:

1. *Tracing the Subject* — Hold a sheet of tracing paper firmly over the matter to be transferred. With a sharply pointed medium pencil — HB, perhaps — trace with the utmost care every detail (see 1, Figure 31). (If your final construction drawing is already on tracing paper, this initial move is obviously unneces-

sary. You will start at once with Step 2.)

2. *Relining* — Turn your tracing paper over (face down) and, with a medium or soft pencil, sharply pointed, reline each line (see 2) — or rub graphite on any areas of the paper where lines will need to be transferred.

3. *Transferring* — Place your tracing paper, thus prepared, right side up on your selected drawing paper and, holding it firmly, reline each line with a medium-hard pencil, well sharpened. This will make a perfect transfer. (If you have not graphited the back of the transfer paper, you may merely rub its face with a knife handle, spoon bowl, or other suitable instrument — the lines on the back will make a reasonably perfect imprint on the drawing paper.) You are now ready to render.

(Don't use carbon paper, such as typists employ, for transfers. It will ruin your work.)

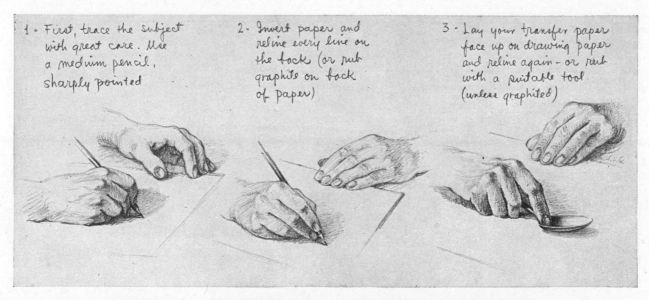

FIGURE 31 · PROPORTIONS MAY BE TRANSFERRED TO FRESH PAPER

19

Rendering the Subject

Outline Technique

Whatever method one may follow in constructing his subject, he will soon be ready to "render" it — to make the final lines or tones on which his ultimate effect will depend.

The simplest and most direct type of rendering — and the one for which the pencil is ideal — is outline. Therefore the student who has not yet experimented in this direction can advantageously do so now.

Outline a Convention — In nature there is no outline. One object is distinguished from another only because of contrasts of color or tone. (Some narrow bands of tone — shadows in cracks, for instance — may appear as lines, but obviously they are not true outlines.) When the artist uses outlines to interpret the various elements of his subject matter, he is therefore resorting to a man-made convention. It is a very natural convention, however — primitive people relied on it, apparently instinctively, as do children today. And outline is as expressive and as easy to use as it is natural.

Uniform Outline, One Weight — Of the several kinds of outlines, the simplest is exemplified by Figure 32, where all objects and their main sub-divisions have been bounded by lines of a single width and weight. An F pencil was employed.

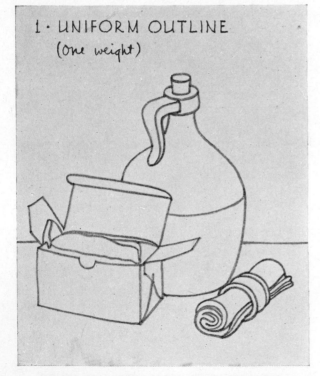

FIGURE 32 · TRY, ALSO, TWO WEIGHTS

FIGURE 33 · NOTE GRADED STROKES

Uniform Outline, Several Weights — Interesting effects may frequently be obtained through the use of uniform outlines of two or more weights. The leading object or objects, for example, may be outlined with dark or wide lines, and less important (or more distant) objects with lighter or finer lines. (Not illustrated.)

Varied Outline — Still more often, the artist varies his line from point to point in both width and value, thus making it as expressive as possible of the different parts of his subject matter (see Figure 33).

Accented Outline — Whether outline is uniform or varied, added accents of solid black may prove effective, as in Figure 34.

Broken Outline — Outlines need by no means be continuous. Often they are far more expressive if broken here and there, suggesting, rather than fully delineating, parts of the subject. Frequently, as in Figure 34, whole stretches of line can be omitted without harm; the spectator's eye will supply them.

Sketchy Outline — Extremely free, sketchy outline has its virtues, too (see Figure 35).

Though such line may give the impression of having been dashed in with great speed, this is not always the case.

Outline and Tone — Often the artist uses outline for part of his subject and tone for the rest. Combinations of this sort are endless. The tone may be in solid flat areas of gray or black; it may be uniformly graded; it may be freely drawn. There is no rule.

Our Examples — Why not turn through the pages of this book, and hunt up pencil drawings elsewhere, in order to discover how many types of outlines you can find? Copy bits of drawings here and there. Your purpose at the moment is (1) to learn of all possible types and (2) to become familiar with how artists utilize them in the rendering of numerous kinds of subject matter. Try a number of drawings of each of the accompanying types, varying your subject matter, grade of pencil and kind of point. Do some on tracing paper placed over your construction layout, and others on regular drawing paper.

In all of this, remember that basic form is more important than outline.

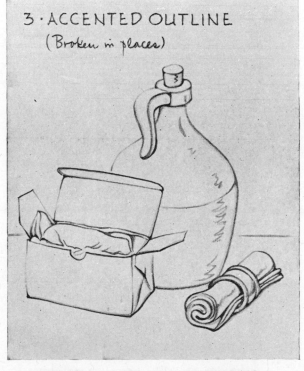

FIGURE 34 · SEE HINT OF SHADING

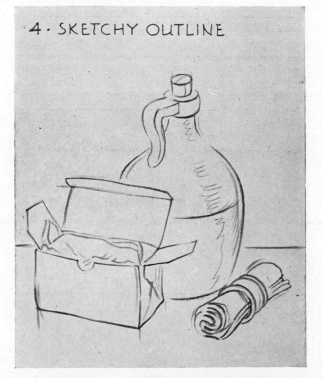

FIGURE 35 · VERY QUICKLY DRAWN

20

Rendering the Subject

Mass Shading Technique

Valuable though outline is, most pencil drawings are "toned" or "shaded." Of the various ways of accomplishing the toning or shading, perhaps the most natural for the beginner's first use is what might be called the realistic or photographic method. In this, the artist renders, by means of "mass" or all-over shading, every visible tone in his subject just as literally as he can in black, gray, and white alone — i.e., without the employment of color. Our illustrations at 1 and 2, Figure 36, fall into this class though, in these, the white paper was allowed to represent certain extremely light values in the subject — a liberty which the pencil artist commonly takes.

After the student has made a number of these realistic drawings — they require very painstaking handling, with considerable reliance on the sharp point — he will gradually discover that it is not only far quicker, but often more effective (and certainly more characteristic of his medium) to employ his pencil with somewhat greater freedom, allowing many of the individual strokes to count strongly enough so that his drawings will frankly reveal their pencil origin. (We shall deal with such work in the next section.)

Yet no matter how far the beginner may eventually wander from the type of realistic drawings at 1 and 2, Figure 36, we recommend that he make some of these, not only because such work involves excellent training in learning to observe accurately the different tones and textures in nature, but for the added reason that the mere drill of attempting to fill each area with the proper tone will in itself give him a good start towards technical mastery of the pencil.

Selecting the Subject — Even the simplest of subjects will create enough of a problem, so we urge the student to avoid things with intricate patterns or striking colors. Perhaps the best type of subject is still life — common objects varying in shape, size, value, and texture, such as are shown at 1 and 2 in Figure 36. For your first attempt, pick something which displays definite and pleasing contrasts of tone.

Posing the Subject — With promising subject matter chosen, arrange it to reveal its forms and values to advantage. The amount and direction of light is important; the objects should be well but not glaringly lighted, preferably with light from a single source, in order to avoid complexity of light, shade, shadow, and reflected light. It may help you to visualize your subject as a finished picture if you view it through a small rectangular opening cut through a sheet of paper or cardboard; this is called a "view-finder."

Blocking In — When your objects seem well posed, construct their forms on your paper by any of the methods already described.

Value Studies — Before attempting to render the finished drawing, make studies of the values. We have seen that it is easiest to do these on tracing paper placed over the layout. With a fairly soft pencil, carry out experiments to reveal exactly what values will depict the subject to best advantage.

Value Readjustment — Don't get the notion that values in nature are always ideal, for they are not. In the flower subject pictured in the photograph at 3, Figure 36, for instance, the values are confusing. See how, in the tracing paper value study at the right (4), adjustments have been made so that the complicated background is suppressed, throwing the flowers into sharper relief.

Final Rendering — With a reasonably satisfactory value study completed, set it up in plain sight and proceed with your final rendering based upon it. This may or may not come out well, but the only thing to do is try. Nobody can tell you exactly how to make each drawing,

and nobody can do it for you. Just do your best. (Chapter 29 offers many practical suggestions.)

Rest Periods — Get away from your work every now and then for, as earlier mentioned, once you have rested for a few minutes you can generally discover your noticeable faults and determine exactly how to correct them.

Use your pencil naturally. Don't be impatient — it takes perseverance to do mass shading expressively, with proper attention to the creation of the right values and appropriate tone edges. Do each drawing over several times if you think you can improve it. Save your drawings — even the poor ones.

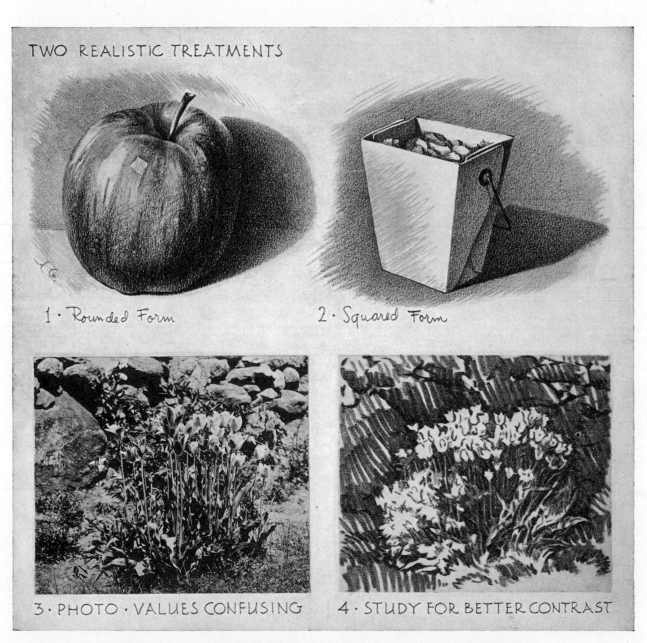

TWO REALISTIC TREATMENTS

1 · Rounded Form

2 · Squared Form

3 · PHOTO · VALUES CONFUSING

4 · STUDY FOR BETTER CONTRAST

FIGURE 36 · VALUE READJUSTMENTS MAY, OR MAY NOT, BE NEEDED

21

Rendering the Subject

Broad Line Technique

We now come to the making of what might be called typical pencil drawings — those done with the rather blunt types of lead shown at 1 and 2, Figure 7, page 23. In this broad line work, as mentioned in the previous section, some at least of the individual strokes are often plainly visible, so that the finished drawing frankly reveals its pencil origin. Yet there is no striving for effect; one honestly attempts to represent each form and texture by using the kind and direction of stroke which seems best adapted to his purpose.

The danger of this technique is that the lines may become *too* conspicuous, thus detracting from the general effect. Try to avoid this fault.

Translating Tone Into Line — If you have recently made drawings utilizing mass shading, a good starting point now is to place tracing paper over each of them in turn, attempting with a blunt point to translate your values into tones having linear characteristics. Don't be satisfied with your first results; make a number of trial drawings for comparison.

Direction of Line — One vital question is how to determine in each instance on the most natural and pleasing direction for your lines to take. There are no fixed rules, but it is logical always to strive for directions which will best express the forms and textures of each object. Most objects offer hints. See how, in the book in Figure 37, the edges of the leaves gave the cue for stroke direction at that point, while the slant of the cover suggested correspondingly sloping lines there. Vertical surfaces can generally be well-expressed with vertical strokes or, if the planes are foreshortened, by means of lines converging to the vanishing point of each plane. In drawing buildings, the courses of clapboards,

shingles, stone, and brick, often supply the key. In outdoor work, some strokes — perhaps those in the shadows — can take the same direction as the rays of light; therefore, before rendering each subject, it is well to determine this direction. For curved surfaces, curved strokes have much to recommend them; straight strokes tend to make curved surfaces look flat. In rendering growing things — plants, grass, tree trunks, leaves, fruit, vegetables — the strokes may often follow the direction of growth.

By trying different treatments of the same subject on your tracing paper, you will find that most surfaces can be rendered effectively by any of several stroke arrangements. Occasionally, strokes in two or more directions will overlap to form crosshatch.

Avoid stiff, mannered handlings. Usually quite a bit of variety is desirable, not only in direction of stroke, but in length and quality. You now have the quadruple task of representing simultaneously the correct value, surface form, and texture, while creating a pleasing technical result.

Another factor to keep in mind is that right-handed and left-handed people cannot easily swing the pencil in the same directions. You can generally tell whether a drawing was done by a right-handed or a left-handed artist.

Figure 37 reproduces typical broad stroke applications. The lead for these was first pointed as at 1 or 2, Figure 7, and then allowed to wear naturally. Occasionally, a sharper or blunter point was substituted. Note that some of the lead degrees have been indicated on the drawings. These broad leads, by the way, are especially appropriate for large areas — they quickly get over the ground.

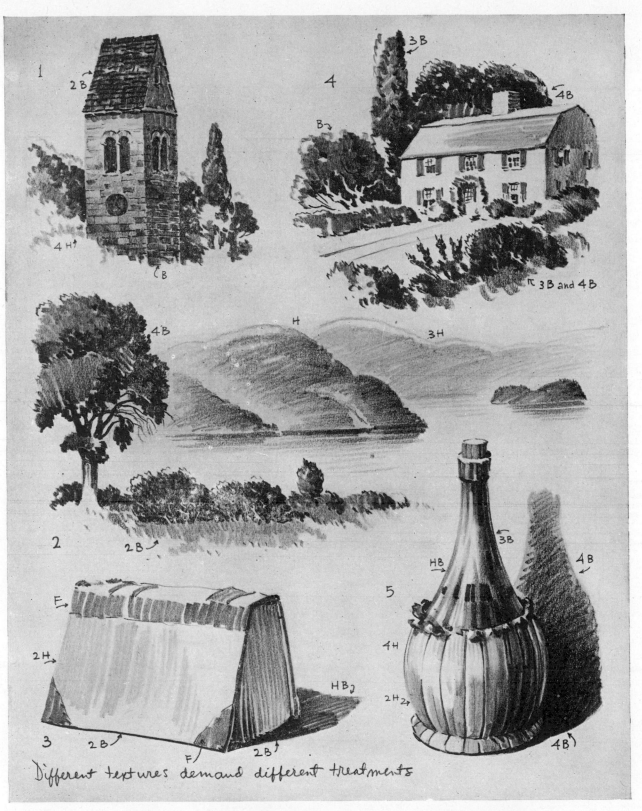

Different textures demand different treatments

FIGURE 37 · THESE WERE SOMEWHAT REDUCED IN REPRODUCTION

22

Rendering the Subject

Fine Line Technique

There are certain subjects in nature so delicate in their detail that they cannot always be rendered too successfully with broad pencil lines. Take the bare branches of trees in winter, for example, or the masts and rigging of sailing ships. Many architectural subjects, too, and numerous forms of ornament may demand fine strokes because of their intricacy. Obviously, it would be silly to try to interpret such things with a blunt pencil when a sharp lead can perform a much better job. (Never, in fact, is it art to "force" any medium to do that which it cannot naturally do.)

The use of the sharp point is not confined, however, to subjects which demand fine lines. The artist often turns to it through choice, for it creates effects which are otherwise unobtainable. Without question, the fine point permits far more individuality of style than the broad. And even when used for expressing a subject which could just as well be treated in broad line or solid tone (as at 5, Figure 38), the observer's sense of fitness is in no way disturbed.

Fine line technique does have limitations. When large areas are to be covered with tone, the sharp point is discouragingly slow because of the constant sharpening required and the hundreds of lines to be made. (The moral here is to avoid large drawings.) And, in any drawing, big or small, the sharp point can prove dangerous, for the artist may become so involved in the mere manual task of producing a multitude of strokes that his final result will be fussy or labored. Or, he may grow so overstimulated by the mere fun of discovering what intriguing combinations of lines he can produce that his finished work will border on the fantastic.

In short, one should never forget that it's always a question of choosing the right pencil — and method — for the task at hand.

Exercises — The beginner should start his fine line practice realizing that, inasmuch as fine line shading is fundamentally extremely linear in character, the manner of producing each individual stroke and the arrangement of these strokes to form tone are even more important than in broad line work. We therefore suggest, as in broad line work, that as soon as the student has carried out a fair amount of line and tone practice such as was recommended previously in Chapters 6 and 7, fine line experiments be undertaken on tracing paper placed over drawings previously rendered in mass shading. Or, for that matter, one can work to advantage for a short time by putting thin tracing paper over suitable photographs, seeing how well he can render, by fine line alone, the photographic tones which show through. He should also scrutinize many pencil drawings by other artists in order to learn how they have solved similar problems. He may want to copy occasional passages from these (or portions of pen drawings, etchings, or other types of linear work).

He should then be qualified to undertake original subjects. As soon as he has one blocked out, we suggest that he try, on tracing paper laid over his layout, a few quick sketches to help him discover, through comparison, the most favorable adjustment of his values. Such sketches should also indicate the kinds and dispositions of lines needed to interpret satisfactorily the forms and textures. With this work behind him, when it comes to the final rendering, he will not flounder around hopelessly, for many of his hardest problems will already have been solved. The rest should be easy.

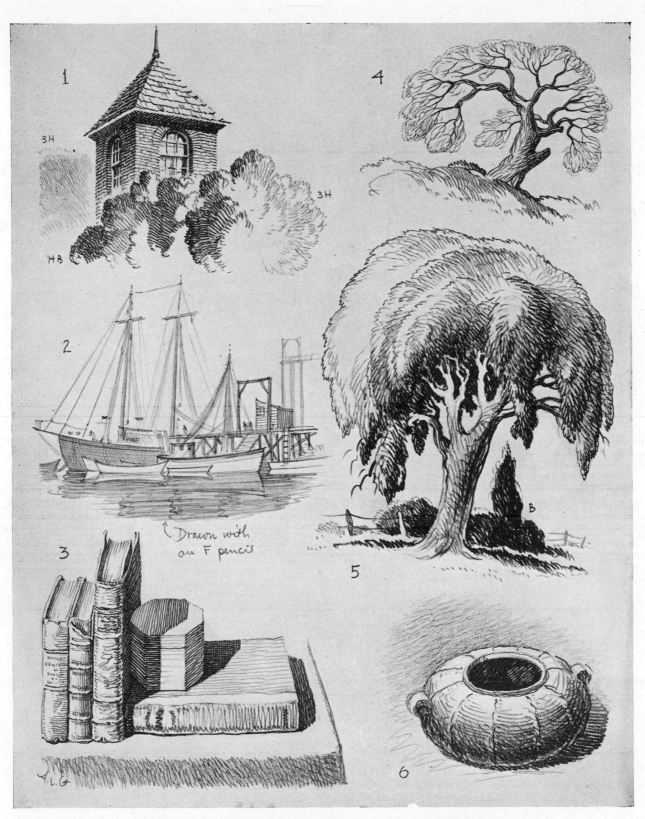

1

3H

3H

HB

2

Drawn with an F pencil

3

4

5

B

6

FIGURE 38 · FINE LINES CAN PROVE EXTREMELY EXPRESSIVE

23

Rendering the Subject

Combined (Mixed) Techniques

Helpful as it is to concentrate for a while on each of several techniques — as recommended in the last three sections — eventually you will have earned the pleasure of trying freer approaches, perhaps combining two or more techniques in a single drawing.

Occasionally, the subject itself dictates how such techniques should be combined. If certain areas are large and unbroken, with rather smooth textures, broad line work or mass shading may be best for them. If other areas call for fine detail or complex textures, fine line may be the thing. In the case of landscapes or marines where certain elements are in the foreground and others more distant, broad lines can logically be used in the foreground, medium lines in the middle distance, and fine lines at the horizon. Another similar subject, on the other hand, may be treated in reverse, the distance being represented in solid tone or broad lines, and the foreground, with its greater amount of visible detail, in fine lines, as shown in Figure 39, below.

So, we reiterate, there are no rules. When you have blocked out a subject, make studies on tracing paper, experimenting with what seems like sensible and pleasing dispositions of fine line, broad line, and tone. Then proceed with your final drawing, confident that you can develop a unified amalgamation.

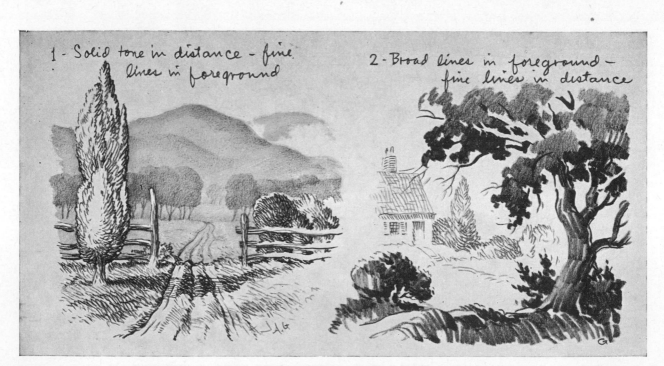

FIGURE 39 · SUCH COMBINATIONS HAVE MUCH IN THEIR FAVOR

FIGURE 40 · CHOOSE A TECHNIQUE SUITED TO YOUR SUBJECT

24

Principles of Composition

There Are No Definite Rules

No matter how much technical facility you may have acquired through such practice as we have so far indicated, many of your future drawings are quite certain to prove disappointing unless you already possess, or can ultimately gain, considerable mastery over the art of composition. If you are approaching this art for the first time, there is a chance that you may be one of those fortunate few who can compose well almost intuitively; otherwise, you are faced with quite a problem. For composition is not easily taught, especially through the pages of a book; one must learn mainly through the doing. As a compensating factor, everything which you do learn can be applied again and again to any type of subject matter and to any kind of drawing from the quickest sketch to the most highly finished rendering.

Definition — But what is this thing called composition? Webster defines the noun "composition" as "the art of practice of so combining the parts of a work of art as to produce a harmonious whole." The work so produced is also called a composition.

Selecting the Subject — Before one can combine parts harmoniously, he obviously must have the parts; the artist usually turns to nature as his source — or inspiration — whether his choice be persons, places, or things. It logically follows that if he is to develop an interesting composition, it must be based on interesting elements. If he can find such elements which in themselves are nicely related and already quite well organized, that is greatly to his advantage. Some students seem never at a loss when it comes to deciding on the right things to draw; others are in a quandary. Perhaps the latter see too much; they are simply overwhelmed by nature's lavishness.

The View-Finder — A little gadget which we have already mentioned can often prove of amazing service in selecting potentially suitable subject matter, especially if one is seeking it outdoors. Known as a view-finder, this is merely a cardboard, postcard size or so, pierced with a rectangular opening measuring, perhaps, 1½ x 2 inches. By holding the card upright and peeking through the hole, with one eye closed, the student can usually discover a wealth of good compositions, exactly as he might if using the camera view-finder. The cardboard finder also helps him to determine whether his subject should go on the paper vertically or horizontally, and precisely how much of it he can best include in his picture. (The finder has another use, too, for when one gets around to constructing his drawing, he can estimate the correct slope of any doubtful line by comparing the line with a vertical or horizontal edge of the finder. If made of white cardboard, the finder can even prove of some aid in judging the value of any given tone in the subject, the artist comparing the tone in question with the white of the cardboard.)

Principle of Unity — Once a subject has been decided upon (and the best point of view located from which to draw it; this is highly important from a compositional standpoint), an analysis should be made in which common sense should aid one's esthetic judgment in determining whether or not the subject contains elements which should be suppressed or even omitted. In other words, the principle of unity should now be observed; *each composition should be homogeneous, all its parts so combined or related that they form a single unit.* Unity in a drawing depends not only on the selection or rejection of material, but on its emphasis or subordination as well (we shall later return to this). Unless each detail is given attention proportionate to its importance, the composition will not count as a complete and satisfying whole.

Principle of Balance — Balance is closely re-

60

lated to unity — really a part of it — for by "balance" we mean, as the word implies, the equilibrium or restfulness which results when all of the elements of a composition are so adjusted that each receives its proper share of attention. Every element of a picture has a certain attractive force which acts upon the eye. In proportion to its power to attract, it detracts from every other element. If we find our interest in a drawing divided — if certain parts seem to fight other parts for supremacy — we say that the composition is out of balance, as well as lacking in unity. (It is especially important to avoid two violently competing major elements.)

As a drawing progresses, and one area after another is developed, the drawing temporarily goes out of balance again and again. The artist expects this, and each time takes prompt action to remedy it, usually by giving added emphasis to some other area, so that ultimately all parts are adjusted to receive from the spectator precisely the right degree of attention.

One excellent way of judging whether or not your drawing is in balance at any given stage is to reflect it in a mirror (or, if it is on tracing paper, to look through it from the back). If, when so viewed, some part or parts seem over-insistent or too suppressed in relation to the rest, the picture is out of balance and a way should be found to improve it.

The reader should realize, however, that there can be more than one proper composition for any given subject. If a dozen equally capable artists were to draw the same subject from the identical point of view, they might develop twelve perfectly satisfactory treatments, each strikingly different from the others.

Emphasis and Subordination — One of the beginner's common faults is that he overemphasizes things which at best can contribute little to the subject as a whole, while thoughtlessly suppressing things which might well be played up by means of stronger contrasts of tone, sharper delineation of form, or some other expedient. Particularly when working outdoors, each thing which catches the eye seems at the moment all-important, and it is easy to overstress it in one's drawing.

Center of Interest or Focal Point — It is better practice for the student, when analyzing a subject, to decide where he wants the observer's attention to be primarily directed in his drawing — whether to the foreground, the middle distance, or the far distance; whether above, at the center, below, or to the right or left. (Interest should usually be confined largely to areas at or near the center.) Having determined this, he can develop a "center of interest" at that point, making this area definitely "in focus" while deliberately throwing other areas "out of focus."

FIGURE 41 · DISTANCE SUPPRESSED

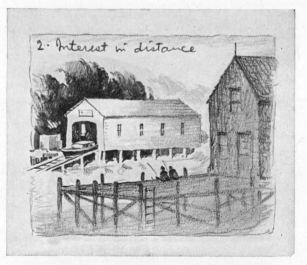

FIGURE 42 · FOREGROUND SUPPRESSED

61

Rhythm — This is another term relating to composition, for by *"rhythm" we refer to the regular recurrence of similar features* — bushes, buildings, or clouds, for example. As, with occasional exceptions, related forms tend to be more satisfying than unrelated forms, the artist often seeks or accents them. There can be rhythm of value, too.

Many other terms are also used in connection with composition — "symmetry," "repetition," "opposition," etc. The student curious to know their meanings, or to investigate further any aspect of this subject will find his time profitably spent if he refers to some of the many excellent books on the subject. Because of such books, we shall confine any further discussion to practice rather than theory.

Let us reiterate that the artist is a creator, not an imitator. He doesn't merely try to copy some bit of nature with photographic precision. Instead, while he may derive his subject matter (or, at least, his inspiration) from nature, and while he may attempt to follow natural laws in its interpretation, yet relying on his inborn esthetic ability as developed through experience, he will exercise artistic license to select or reject, to rearrange, to substitute, to stress or suppress — to compose, in other words — until he translates his bit of nature into a satisfying drawing which may or may not bear close resemblance to its natural prototype.

Doubtless the beginner will for a while choose to hold close to nature's appearances. He may rearrange minor details, and experiment with value adjustments such as we present in the section to follow, but that is about all. Gradually, his increased skill will add to his confidence until ultimately, when on an outdoor sketching trip, he may select a barn at the right, a hill at the left, a cow from the foreground, the clouds behind him, and recompose them into a picture. That is the artist's privilege. He may even compose from memory, far from the subject matter which he uses in his picture. But a knowledge of composition will still be an asset — yes, in a case like this last one, an essential.

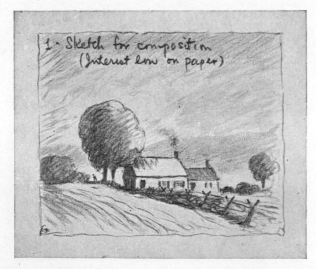

FIGURE 43 · MAKE MANY SKETCHES

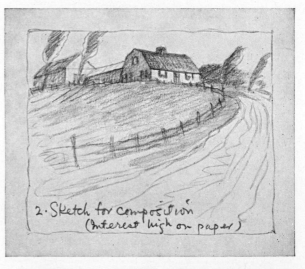

FIGURE 44 · NATURE SHOWS THE WAY

62

Value and Form Composition

To this point, we have tried to make clear a few pertinent facts about the pencil as normally used in representative drawing. As a preliminary to the main thoughts to follow, a word of recapitulation may be in order:

1. The artist commonly attempts to obtain in his work at least a semblance of naturalism.

2. To accomplish this, he customarily constructs the proportions of his subject matter — at least of individual objects — quite realistically. (This is particularly true in figure work and portraiture, for here mistakes in the delineation of form are very conspicuous.)

3. Color, as a rule, is either entirely ignored — consider, for example, outline drawing — or interpreted in terms of the white of the paper, plus gray and black pencil tones. (Rarely does the artist utilize colored pencils.)

4. The grays and blacks can be built up in many ways through lines or tones; thus one's values and textures are simultaneously expressed.

5. While the values are usually so employed as to *look* convincingly true to nature, actually the artist, instead of striving for photographic accuracy, manipulates these values somewhat so as to gain the esthetic effect he desires. In doing this, he stresses those features of his subject which seem to him important, while restraining or omitting less pertinent ones.

Value Recomposition — This matter of value adjustment is so vital that some amplification of our previous discussion now appears to be advisable.

Perhaps the best way in which the student can come to realize how many liberties can be taken with values is through a comparison of such pictorial demonstrations as we offer in Figure 45, reinforced through practice of his own along similar lines. In our illustrations, we show six of many possible arrangements of the values of a single subject; note that in all of

these the forms remains substantially the same. In Sketches 1, 2, and 3, the tonal differences were based on normal fluctuations in the direction and intensity of light as they take place at various times of day. In Sketches 4, 5, and 6 the differences result primarily from arbitrary readjustments of the local values — the artist merely lightened some tones and darkened others because he wanted to, and thought it would look all right. Many additional arrangements could utilize both of these procedures; in other words, the artist could deliberately manipulate, according to his own fancy, both the local tones and the values representing light, shade, and shadow.

Conventional Values — We must not forget to mention those cases — somewhat uncommon, yet by no means rare — in which purely conventional values are employed, perhaps in combination with outline. In these, little if any resemblance to tonal truth is sought. The artist, instead of working for reality, might be said to be creating a design. For, even if he holds to natural proportions, the exact values in composition, are dictated largely by esthetic considerations. Figure 46 shows one of these highly conventionalized drawings.

Value Studies — Only after you have done quite a bit of sketching from nature, however, will you acquire both the confidence to take liberties as drastic as some of these, and the ability to do so convincingly. There is no reason, though, why you should not now start to experiment in this direction.

One of the best approaches is to place tracing paper over a photograph, next drawing upon it (with the photograph showing through as a guide) a series of experimental studies somewhat like those in Figure 45. Then repeat the exercise with other photos. Try exterior subjects, interiors, still life — anything you like. Just as the organist pulls out different

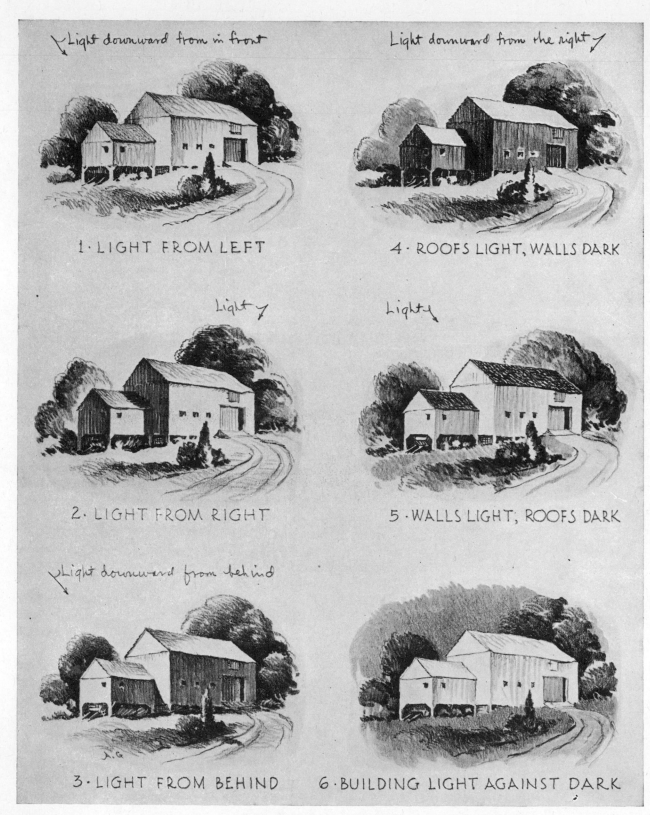

Light downward from in front

Light downward from the right

1·LIGHT FROM LEFT

4·ROOFS LIGHT, WALLS DARK

Light

Light

2·LIGHT FROM RIGHT

5·WALLS LIGHT; ROOFS DARK

Light downward from behind

3·LIGHT FROM BEHIND

6·BUILDING LIGHT AGAINST DARK

FIGURE 45 · A SINGLE SUBJECT PERMITS MANY VALUE SCHEMES

64

stops in order to diversify his effects, this is your chance to pull the stops of white, gray, and black. Grade some tones; keep others flat. And as you work, give thought to texture indication, particularly if your drawings are fairly large.

When you have repeated this experiment with a number of photographs, substitute some of your own earlier drawings, again placing tracing paper over each in turn in order to see how many effective value arrangements you can discover.

Then, when next you work from nature, apply the same method by laying tracing paper over your construction layout when completed, doing upon it a series of trial sketches in which you substitute, for some of the values before you, others of your own choosing. Try at least three or four such sketches for each subject; then select the best as a guide for rendering.

Form Recomposition — Returning to the matter of form, we implied at the opening of this chapter (see 2) that few liberties can be taken with form representation. We added that this is especially true in the case of certain types of subject matter such as the human face or figure. (To illustrate this latter point, to do a recognizable portrait of George Washington, you would scarcely elect to use the proportions of Abraham Lincoln!) With living subjects, errors in proportion are usually all too noticeable; they may even result in unintentional and unwanted caricature.

Granting, then, that if the artist wants his drawings to give the true appearance of par-

ticular objects he can usually do less recomposing of forms than he can of values, he nevertheless can often rearrange separate parts of his subject matter, one in relation to another, without stretching the credulity of the spectator. He may even take liberties with the sizes of individual objects. And if there is no reason for holding to the original shapes of objects, he can likewise alter them. If, in drawing a still-life composition, for instance, he feels that a jug, a box, or a book is of the wrong size or shape to suit his purpose fully, he is usually free to alter it. Similarly, if he is drawing from landscape, he can shrink or expand a mountain, or he can change the shape of a tree, or add a chimney to a house and so long as his final result looks soundly constructed, he is well within his rights. (An exception is when he is making what might be called a true portrait of some particular scene — possibly a noted landmark.)

By way of emphasis, in Figure 72, page 92 we see in the various sketches that the trees and hills — yes, even the buildings — have been recomposed in both forms and values. (In such instances, though, each object must not only be convincingly proportioned in itself; it must also be harmoniously related to everything else in the composition.)

When you have the courage to attempt such readjustment, whether of form, value, or arrangement, go to it! You are not competing with the camera now; by being creative, you are doing something which the camera cannot do. Tracing paper, as usual, will afford the means for your experimentation.

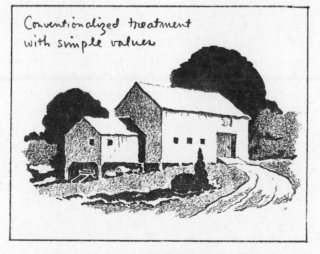

FIGURE 46 · A POSTER-LIKE SCHEME

26

More About Value Composition

The Artist's Tour de Force

As the observing student conducts such experiments as were recommended in the previous chapter, he is almost certain to make valuable discoveries which he can later put to use again and again in his drawings. If, for example, he chances to surround a small and clean-cut area of pure white paper with a very dark tone, he becomes aware that, because of the contrast thus created, the white area actually looks whiter than white.

Whiter Than White — In order to give emphasis to this very important point, we submit the little white disk at 1 (A), Figure 47. Doesn't this actually appear whiter than the rest of the paper? The fact that the surrounding dark tone has been brought into crisp contrast with the disk, and has then been vignetted away from it, adds to the apparent whiteness of the disk.

Only by trying this on your own paper will you discover the extent of your ability to make things look whiter than white. Apply the idea to small circles, triangles, and squares, as well as to irregular shapes. You will soon see that it isn't the shape which counts but only the dramatic contrast of light against dark.

At 1 (B), Figure 47, we offer, in simple sketch form, an application of this white-spot type of composition to the drawing of a house. Here the building, together with a bit of the lawn before it, forms the white spot, almost as though a spotlight had been thrown upon it. Surrounding this spot is an irregular ring or band consisting of black and gray tones, enough of them brought into sharp relief against the building and lawn to emphasize their whiteness. At the outer edges, the sketch vignettes into the paper just as did the spot at A. This vignetting is vital, as it prevents the eye from being drawn away from the planned contrasts nearer the center. From this we derive a helpful rule: *With rare exceptions, omit or suppress any rendering at the corners of your drawing.*

(For other simple applications of this rule, and of the white-spot arrangement in general, see Figure 51, page 71.)

Interpretation of Sunshine — This white-spot type of composition is especially applicable to the rendering of light-toned objects — such as this building at 1 (B), Figure 47 — as seen in bright sunshine. It should be self-evident that one's white drawing paper, as normally viewed in shade, can never look as light as a white wall (or other similar surface) exposed to the sun. One of the few ways in which the artist can make such a sunlit wall *look* sunny in his drawing is by forcing some of the adjacent dark areas into strong contrast with the wall, even if this calls for (a) representing the darks darker than they really are in nature, and (b) making their edges, as they come against the white, abnormally decisive.

Blacker than Black — Just as a white area surrounded by black (vignetted to gray) appears whiter than white, so a black area thrown into sharp relief against white looks unusually black. The effect of this contrast will be heightened if the white area against which the black is placed is surrounded by a soft-edged tone of gray. At 2 (A), Figure 47, is a demonstration of this. Note what a striking contrast the scheme engenders. Take your own pencil and try the thing; this will dramatize it and fix it in your mind. At 2 (B) we utilize this basic principle; many so-called silhouette effects fall into this class of composition.

Modifications — Inasmuch as few subjects have large areas of either uninterrupted white or black, very rarely do we see in their pure form either the white-against-dark composition, or the dark-against-white composition. Just as the white spot of the little house at 1 (B) has been punctuated by the grays of door, windows, and roof shadow, so almost all light and dark spots are broken by the artist by means of at

least small areas of contrasting tone. We have demonstrated this at 3 (A), where a white disk like that at 1 (A) has been pierced by a black accent. Observe what a forceful composition this gives us; at 3 (B) we have a simple application. Similarly, blacks are often pierced with white; see the disk at 4 (A) with its white accent, and the application of the same scheme at 4 (B).

Contrasts fundamentally like those at 1, 2, 3, and 4 are unlimited in kind and number, being subject to endless combination and adaptation. In fact, such vigorous utilization of black and white might be said to constitute the pencil artist's tour de force. Sometimes it is in his entire composition that he adapts the basic plan of light against dark or dark against light; again, he reserves such striking contrasts for those particular portions of a composition which he feels call for special attention.

In the former connection, in an amazing number of cases the very same subject may be treated successfully either as a light spot against dark or a dark spot against light. Compare, for instance, the two chimney drawings in Figure 48. Note in these, however, that there is little solid black. This illustrates another modification: The artist seldom needs such extreme contrasts of light and dark as we have used for our demonstrations in Figure 47; almost invariably where dark is desired a deep gray will serve one's purpose better than pure black. Similarly, one's white can sometimes be toned down advantageously, though in pencil work this is less often true.

Center of Interest or Focal Point — Returning to the matter of centering the interest, if one's subject for a drawing is simple (as in the case of the chimney just pictured) or small, the spectator's eye easily takes in the whole thing and there is seldom any serious compositional problem; the composition almost automatically develops perfect unity. If, however, a subject is large or complex — perhaps made up of several unrelated or even incompatible elements — the artist must be very careful (as earlier pointed out in discussing the principle of balance) not to set up in his drawings an opposition of two

FIGURE 47 · ARTIST'S TOUR DE FORCE
Important basic truths.

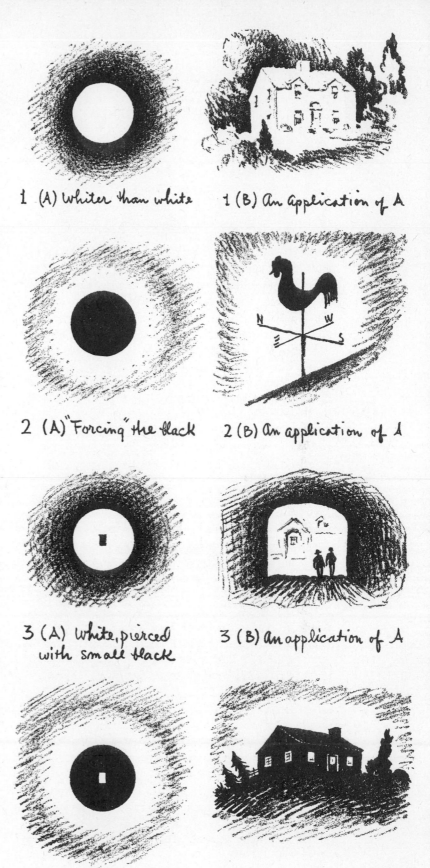

1 (A) Whiter than white 1 (B) An application of A

2 (A) "Forcing" the black 2 (B) An application of A

3 (A) White, pierced with small black 3 (B) An application of A

4 (A) Black, pierced with small white 4 (B) An application of A

or more major centers of interest. For in such a composition there could be only disunity or chaos. (Such a scheme of clashing elements might conceivably be useful only in one of those rare compositions designed to interpret violent action, turbulent strife, or clamorous sound. This proves there are exceptions to all rules.)

If a subject is large or complicated, the artist is usually wise to focus attention on some limited area, just as in viewing a scene in nature he often concentrates, for a moment at least, on a given spot. In order thus to focalize his attention, he creates some of his strongest contrasts within the chosen area, perhaps calling into play either the white-spot motive or the dark-spot motive. Then he is careful not to employ equally strong contrasts in other parts of the drawing to cause competition.

In Figure 49 we see at 1 and 2 how the artist can focus almost at will on any given area of a subject by strengthening his value contrasts in that area, while simultaneously restraining his contrasts in such other areas as are assumed at the moment to be out of focus. Figures 41 and 42 further illustrate this point.

(Perhaps we should mention, in connection with Figure 49, that if the observer were to focus his attention first on the top of the lighthouse (1) and next on the facade of the appended building (2), the perspective in the two drawings would not remain identical, as here drawn. For our purpose, however, it seemed best not to make the very slight perspective adjustment which such a distant subject would call for.)

Means of Gaining Attention — While our main emphasis in this section is on the attractive power of extreme value contrasts, the artist is by no means wholly dependent upon them for the creation of a center of interest. Here are some of the many other ways in which he can direct the spectator's eye wherever he wishes:

1. *Through the choice of subject matter.* Any living subject — a person or an animal — catches the eye more more quickly than an inanimate object. A few figures in front of a house, for instance, will draw attention to that area (see 1, Figure 50). Interesting or unusual things, whether animate or inanimate, have more power to attract than do commonplace

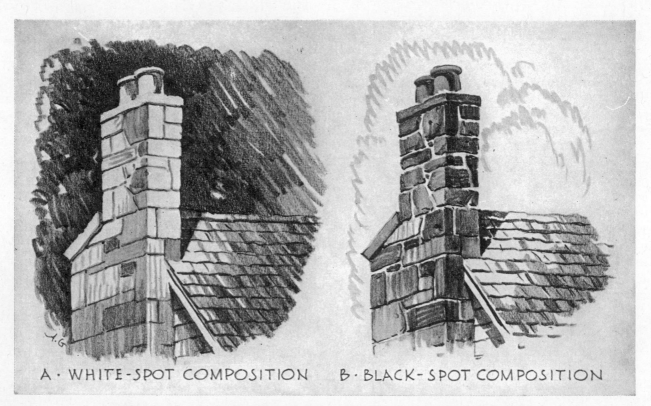

A · WHITE-SPOT COMPOSITION B · BLACK-SPOT COMPOSITION

FIGURE 48 · VALUES CAN BE RECOMPOSED WITH GREAT FREEDOM

things. A bear in front of the house would be more compelling than the figures (see 2, Figure 50). Subjects of striking or restless shape will also draw the eye. A star-shaped mass, for example, or a triangle, teetering on one corner in suspended animation, attracts us more than a square or rectangle (see 3, Figure 50).

2. *Through unusual arrangements of subject matter.* A man standing on his head, or walking on his hands along the ridge of a house, will gain our attention far more effectively than the same man normally occupied. An automobile wrong side up in the street will quickly catch the eye (see 4, Figure 50). In short, many of the things which are conspicuous in scenes in real life are equally so in most representative drawings.

3. *Through expressions of extreme activity.* A man running will be noticed more quickly than a man walking or at rest.

4. *Through vigorous or unusual technical handling.* Bold strokes, or highly individual arrangements of strokes, stand out plainly. Extreme means of representing textures serve to draw the eye (see 5, Figure 50).

5. *Through particularly detailed handling.* If some parts of a subject are treated more fully than the rest, they may become more noticeable (see 6, Figure 50).

6. *Through the addition of color.* Even a single small spot of color seen in the midst of neutral surroundings is a great attention getter.

Often several of these devices are used in combination. Advertising artists in particular, whose drawings frequently are forced to compete with other art work on the printed page, need to learn many ways of making their results conspicuous. They don't merely seek to reinforce a center of interest; they wish their

FIGURE 49

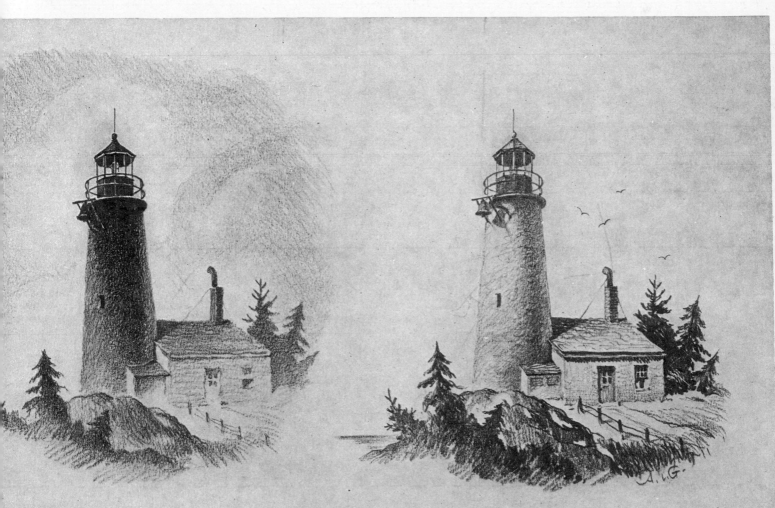

1 · FOCUS AT TOP OF LIGHTHOUSE 2 · FOCUS AT BASE OF LIGHTHOUSE

MEANS OF GAINING ATTENTION

1. Living subjects, especially when in motion, catch the eye far more quickly than inanimate subjects

2. Unfamiliar subjects demand far more attention than familiar things

3. Subjects of striking or restless shape draw the eye

4. People (or objects) seen in unusual positions or circumstances exert a strong attractive force

5. (A) Vigorous technique gains attention

5. (B) Extreme means of portraying textures are very conspicuous

6. Detailed treatments have a power to attract.

entire work to have strong pulling power. Students interested in this angle should analyze advertisements in order to discover how many means there are of creating eye catchers.

Exercises — Returning to our main consideration of white-spot and dark-spot compositions, we urge the student to make numerous experimental studies — they may be very small — in which to learn at first hand how much power he has to dramatize his subject matter through deliberately playing one value against another. In Figure 51 we reproduce (at the exact size of the originals) a number of spottings to suggest to the reader some such possibilities. These have purposely been made extreme as to value contrasts; the basic idea would of course apply equally well to more restrained tonal schemes.

Further practice can be had from trying, through the use of small sketches like these, to isolate and record the basic value schemes of such drawings by professionals. Forget all the small details and subtle variations of tone; merely see if you can reduce each composition to its simplest terms of black and white, or black, white, and gray.

In the light of your recently acquired knowledge, repeat your former practice of selecting photographs of different types of subject matter, and of recomposing their values through the aid of tracing paper. You will find that you can soon gain considerable command over this art. Try a number of comparative sketches of each subject, varying the tone composition.

We all know that professional photographers, in order to arrive at the best possible composition, like to study a subject from many viewpoints before snapping the camera. Realizing the frequent need for dramatic tonal relationships, they often "frame" a subject by viewing it through an archway, from between trees or, perhaps, from beneath a bridge. Or they may wander about until a branch is found which effectively hangs from above to give distance and to break their otherwise blank sky areas.

The artist does such things, too, though he has even more freedom as he can manipulate to greater degree both forms and values, at the same time moving objects from place to place almost at will. Like the photographer, the artist

FIGURE 50

FIGURE 51

often finds it advantageous to create frames — perhaps of extremely dark tone — on the order of those at 4, 5, and 6 in Figure 51. Such contrasting frames are particularly suitable when viewing subject matter at some distance. As dark frames are very conspicuous against the light tones beyond, they must be designed with great care. In fact, whenever the artist uses strong contrasts of tone, any unpleasant tonal relationships will be far more prominent than when contrasts are less evident. In other words, to use strong contrasts takes courage and skill.

Some Practical Pointers — In terminating this present discussion we offer these eight things to keep in mind when making a drawing. Though not all of them relate directly to composition, they nevertheless should be grouped together for obvious reasons:

1. In the typical pencil drawing, try to find an opportunity in the outline before you to create a leading dark area. (There may of course be many subordinate dark areas.)

2. Strive, also, for a compensating large light area. (Often this and the leading dark area will be adjacent.)

3. Employ at least three distinct values — white, gray, and black (or very dark gray) — but avoid too many scattered contrasts.

4. Even if you are working for a very realistic final impression, don't be afraid to manipulate your values.

5. In building your tones, attempt to obtain not only appropriate values, but also a proper expression of surface directions and textures.

6. Use in general a free spontaneous technique so that your completed work will express your confidence.

7. Stop when you arrive at a reasonably satisfactory effect. Many drawings are ruined through overwork.

8. If your final result is disappointing try the same subject again.

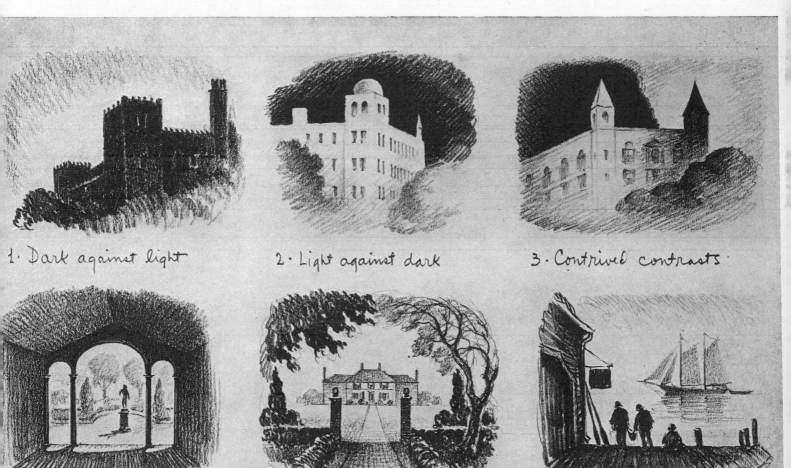

1. Dark against light 2. Light against dark 3. Contrived contrasts

4. View through archway 5. Frame of planting 6. A half-frame will do

TYPICAL DRAMATIC SPOTTINGS OF LIGHT AND DARK

27

Some Uses of Graded Tones

Their Potentialities Are Amazing

Fundamentally, there are but three kinds of tones which the pencil artist can make: tones which are flat (uniform) throughout; tones which are graded (graduated) from dark to light or vice versa; and those many types of variegated tones which, for lack of a better term, might be called hit-or-miss as they seldom are based on any organized plan.

While either the flat or the hit-or-miss tones can often well serve the needs of the pencil artist, at times he finds himself relying to quite a degree on graded effects, as an examination of the illustrations of this book will affirm. Some of his grades are gradual, some sudden; many are simple while others are complex. A majority apply to limited areas, a few to entire compositions.

Already we have seen several uses of gradations: (a) In shading rounded objects, for example, graded tones are practically indispensable; one could scarcely do a figure drawing, a portrait — or, for that matter, a study of a jug or a simple sphere — without them. (b) Shadow (or other) edges which tend to become too conspicuous, are frequently softened by gradation. (c) In focusing attention on a center of inter-

est, great reliance is placed on gradation — witness the lighthouse in Figure 49, page 69 which at 1 grades from light below to dark above, while at 2 the gradation is reversed. (d) All of the white-spot and black-spot types of composition discussed in the previous section largely depend on gradation for effectiveness.

Yet this frequent application of such modulations is not all an artist's whim. He is borrowing a lesson from Mother Nature, who generates tonal gradations of every sort with the utmost prolificacy. If you have never observed this, look about you!

The present section, however, deals less with such naturalistic gradations than with certain rather arbitrary uses of grades which the artist has learned he can beneficially make. He even finds it advisable, on occasion, to substitute graded tones for some of the flat ones in nature, as he can thus obtain certain desirable effects by the simplest and quickest means.

Substituting Graded for Flat Tones — To turn to a specific example, we see at 1, Figure 52, a plain barn rendered largely in flat tones, much as it appeared in nature. At 2, graded tones were substituted in such a way as to

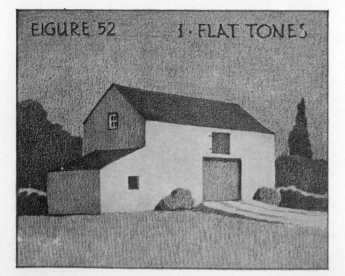

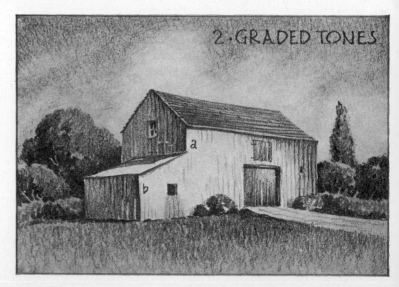

emphasize value contrasts where most needed to express the subject effectively — as at "a" and "b" where light and shadow planes meet at right angles. (In drawing the grades in the sketch at 2, greater technical freedom was used than in producing the flat tones at 1; hence the grades have more character. But that's another story.)

Often, to repeat, the artist is able through such tonal adjustments to gain the desired contrasts with a minimum of rendering, employing tone only where it will help him to express his forms and textures, leaving large areas of his paper white. So treated, even these barren areas can convey to the observer an illusion of tone.

We have slightly exaggerated the values of the square plinth in Figure 53 (1) in order to emphasize this point. Here, the entire top (A) was left white but, to bring it into relief, a limited area of gray background tone was purposely placed behind it (B), vignetting into the paper. Also the lighted front of the plinth was darkened slightly towards the top (C) so as to indicate clearly the sharp change in plane between top and front. Toward the bottom, the front was left pure white (D), the white being set off by the gray tone (E) — which was purposely created on the supporting plane — and by the dark tone (F) on the shade end of the plinth. This shade area was so graded in turn that at the further end (G), it is actually pure white (though it gives the illusion of possessing some tone). The shadow on the horizontal supporting plane was graded from sharp-edged dark gray at H to soft-edged light gray at I.

A dozen other value schemes could be created for this simple form, but this one is enough to suggest how the artist, according to his desire or need, can build contrasts of light against dark and dark against light almost at will throughout any drawing.

There's a Danger — Yet one must be careful lest exaggerated grades cause flat surfaces to look curved, a thing which can all too easily happen, especially when the graded areas are not bounded by straight lines.

Detachment — In nature the observer seldom experiences any trouble in perceiving whether or not one object or surface is more distant than another, or detached from it. A hundred things aid his perception, including the fact that he (and sometimes the object) is in at least moderate motion. Colors and textures, too, help to differentiate one object from another. In photography, some of this detachment is lost unless exceptional skill is used; one tone is all too likely to merge with another. The artist has better control than the photographer; unless he wants tones to merge — which is sometimes all right either in art or photography — he is able to make an object project distinctly in front of others behind it by taking certain liberties, the most common of which is an adjustment of values such as we see in somewhat exaggerated form in Figure 53 (2). Here the roof grades down to nothing from a clean-cut ridge line. The chimney also grades down from dark to light so that it disappears behind the contrasting ridge.

As another example, we refer to Figure 53 (3) where the tree trunk was made dark against the sky but was graded to light as it passed before the darkness of the bushes.

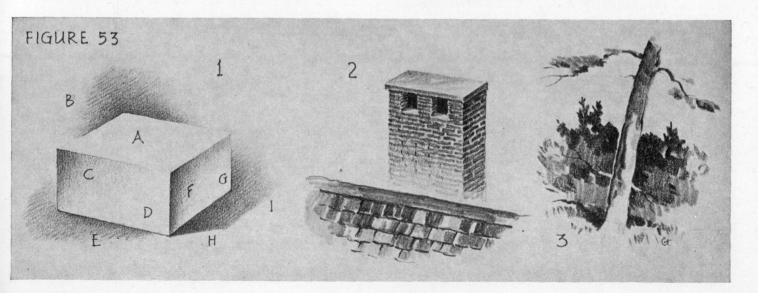

FIGURE 53

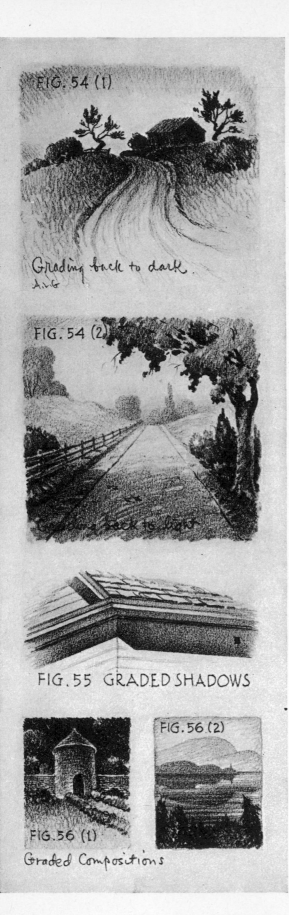

FIG. 54 (1)

Grading back to dark.
And

FIG. 54 (2)

back to light

FIG. 55 GRADED SHADOWS

FIG. 56 (2)

FIG. 56 (1)

Graded Compositions

Grading into Distance — One of the tough problems of the artist, due to having to work on flat paper, is to get an adequate effect of distance to lead the eye back and back and back. Here, again, gradations can help him in innumerable ways. In Figure 54 (1) the road and the roadside grass were made darker and darker as they receded into space, so that the spectator's eye is led to the center of interest about the distant house and trees. In Figure 54 (2) the scheme is reversed, the road, fences, and bushes lightening as they disappear in the distance. Study the work of other illustrators and you will find many similar uses of gradations. Ultimately, you will see how the artist, through his use of grades, leads the eye almost anywhere he wishes.

Graded Shadows — Shadow tones as seen in many drawings (and in thousands of photographs) look too black — utterly lacking in transparency. The experienced artist learns that he can often grade many of his shadows so that they appear crisp and black against sunlit areas but lighter and more transparent elsewhere. One illustration of this will be found in Figure 55; the drawing explains itself. If occasionally a small area of black is introduced within this shadow — some detail, perhaps — this will add greatly to the transparency of the shadow, as Figure 55 indicates.

Graded Composition — While most gradations of tone are confined to more or less restricted areas (so that we may discover many gradations within a single composition), occasionally we see entire compositions which grade in one direction or another. Our little sketches in Figure 56 are adequate to make the point clear; at 1 the whole composition grades from extremely dark pencilling at the top to white paper at the bottom, while at 2 the reverse is true. Similarly — though more rarely — compositions may grade from left to right or right to left.

* * *

And So It Goes — We might go on and on with such demonstrations, but our purpose is not so much to show the student exactly what he can do as it is to direct his thinking along explorative lines. We hope that this section will make him more observing both of the many ways in which nature employs gradations and of the diverse uses of graded tones by artists.

Let's Loosen Up!

Spontaneity; Speed; Indication

During such periods of intensive study and experimentation as we have so far dealt with, many of the student's drawings are quite certain to be rather cut-and-dried in appearance when compared with the freer, more facile results of the professional. The harder the student tries, the greater the probability that his work will lack the dash and vigor which is perhaps the most pleasing characteristic of much of the best in pencil representation.

What is the student to do about this? How can he interpret the sound basic knowledge which is now his in terms of greater facility of expression?

Quick Sketching — Probably the best means of "loosening up" is to make innumerable quick sketches such as we have already recommended from time to time, perhaps alternating them with more serious studies. For each type of work has its place. If one did nothing but quick sketching he would be unlikely ever to gain more than a superficial mastery over his medium while, on the other hand, if he did nothing but deliberately drawn studies, his style could easily become too photographic and static — wholly lacking in spontaneity.

Analysis of Subject — Perhaps the chief advantage of quick sketching is that it not only forces one to size up his subject quickly as to what is and is not essential, but it also drives him into recording the essentials with such speed that the drawing, in spite of minor faults which may develop, takes on the appearance of having been accomplished effortlessly yet with authority. The observer likes effects which look decisive, direct, and facile; he doesn't enjoy evidences of indecision, fumbling, or struggle.

And it is through the making of quick sketches that one is likely ultimately to develop a truly individual style. When he draws deliberately, he is more likely to ape the styles of other artists, but when forced to rush through his job he gives his subconscious mind freer rein in controlling his pencil, so that the resulting work is generally his own natural and individual expression.

Quick Sketches Based on Studies — It's good practice to make quick sketches now and then directly from previous studies, trying to retain all of their better elements while interpreting them with greater zip and go. Don't think too hard about anything as you work — just plunge ahead with a sort of reckless abandon, snapping in some of your lines swiftly, and getting good crisp black into your work. You may surprise yourself with the increased facility which this courageous approach can soon lead to.

Quick Sketches from Nature — In the long run, however, nature usually proves your most capable teacher, so sooner or later you will want to make numerous quick attempts directly from both animate and inanimate subjects. Make several sketches of the same subject. Compare. Which is the best? Why? Don't expect too much perfection — just do as well you can in a short time.

Sketching from Moving Vehicles — Did you every try sketching from a moving bus or train? It's great fun! With every fresh jolt, your pencil point flies this way or that. Therefore, you can't expect to record much of value, yet in some ways there's no better practice. The author, like many other artists, has frequently made travel sketches from such vehicles; also from ferry boats, motor boats, even canoes. The results on paper — hardly more than scribbles — usually have had little to recommend them but, as a drill in observation and in memory retention, the practice has much in its favor. And the sketches themselves are by no means worthless. Sketches made by the author in Italy long ago became, years later, the inspiration for finished drawings which, though they probably don't look much like the

original subject matter, at least caught its essence.

Quick Sketching from Memory — Speaking of memory training, after you have drawn a subject from nature, it is often the best of practice to try the same thing from memory so that you are forced to work rapidly as you concentrate on the essentials. Or select a subject which you have never drawn. Study it a minute, turn your back to it, draw as much as you can and then turn to it again, repeating the process over and over. Using this same method, attempt to draw some person you know well. Take a look, turn away and draw again. You will probably discover that your memory is not as good as you thought. If you want to test it, attempt right now, without reference to the subject, to draw some supposedly familiar object — a cow, a vacuum cleaner, your favorite chair, a rowboat. This may prove that all your life you have been very unobservant; most of us are.

In such effort, try in particular to memorize the sort of subject matter which relates most directly to your regular (or intended) work. If you plan to be an illustrator, for example, store away definite mental images of all sorts of things; you never can tell when they will be useful. The architect's needs are more specialized; he should be able to sketch any type of structure from memory, along with its furnishings and surroundings. The painter has his own problems, too, as does the worker in any other specialty.

Time Sketches — In doing quick sketches, it is an interesting challenge to set a definite time limit for some of them. Determine to accomplish all that you possible can in, say, ten minutes, five minutes, even one minute. When your time is up, stop. The speed which you thus acquire will prove invaluable when later you wish to record moving subject matter or ephemeral effects.

Line — When you draw under pressure, you are almost certain to rely largely on line, for there simply aren't minutes enough to build much tone, unless of the crudest sort. We have already seen that line can be amazingly expressive, either by itself or in combination with tone.

Quick Drawn Tone — Where some tone is essential to bolster up your line — perhaps to convey an expression of weight and substance, or

to interpret textures adequately — you will soon learn a few quick and easy ways of covering your areas, perhaps with a sort of scribble, or a back-and-forth or up-and-down motion. Use these, but vary your effects enough so that all your tone doesn't look alike. If your drawing is small, it is surprising what you can do in a very brief period. For example, Sketch 1, Figure 57, was made in three minutes. In such work, you may find your finger or thumb a handy instrument for rubbing tone together, thus simplifying and unifying it. Sometimes a graphite-coated finger is all the tool that is needed for the instantaneous "painting" of an area with an effective smooch of gray. Jumbo pencils or large graphite sticks are time savers, too.

Shadows Only — If a subject is in bright sunlight, often the quickest way to gain an impression of reality is to draw its shadow tones only, reinforced, perhaps, by a bit of outline. In the sketch of this type at 2, Figure 57, almost no drawing was done beyond direct indications of the shade and shadow forms. Note how well even some of the minor shadows, such as those in the door panels, and those cast by the trim on the serrated shingle courses, reveal the forms.

A good way to approach this matter of expression through shadows only is to experiment first by placing tracing paper over a photograph which shows distinct shadows, then quickly indicating the shadow masses in pencil while ignoring, or practically ignoring, the local values, (sketch 4, Figure 57). A bit of supplementary outline, plus a minimum of tone where particularly needed, will round out the whole. A little of this practice from photographs, and you will be ready for subjects in nature.

Figure and Animal Indication — In rapid sketching or landscape, street scenes, and architectural exteriors and interiors, one will frequently need to suggest animals, people, and vehicles. A very slight indication, which might not stand up well under critical scrutiny, can often prove more satisfying for this purpose than a labored study. Look out of the window and watch people walking up and down the street; observe them everywhere as they go about their tasks, whether singly or in crowds. If they are at some distance, all the better. Then try to suggest them in the quickest possible way. Forget exact proportions, and give no con-

76

scious thought to technique. Don't even worry whether or not you sketch all visible hands and feet! Just let yourself go in an effort to express living action, (Sketch 5, Figure 57).

Pencil Indication — Through all such practice you will gradually develop a sort of short-hand method of indication — one kind of symbol for this and another kind for that. You will discover that a particular type of stroke will suggest hair or grass; another, water or glass; still another, the bark of a tree. These symbols can prove useful forevermore.

Accidents — In quick work, you will fall short of perfection of a detailed kind but, by way of compensation, certain favorable accidental effects — "happy accidents," they are sometimes called — will materialize. Consider yourself lucky and leave them alone!

FIGURE 57 · QUICK SKETCHING (INDICATION)

three minute sketch (at this exact size)

3.

4.

Not so sketchy, but done simply, with shadows only

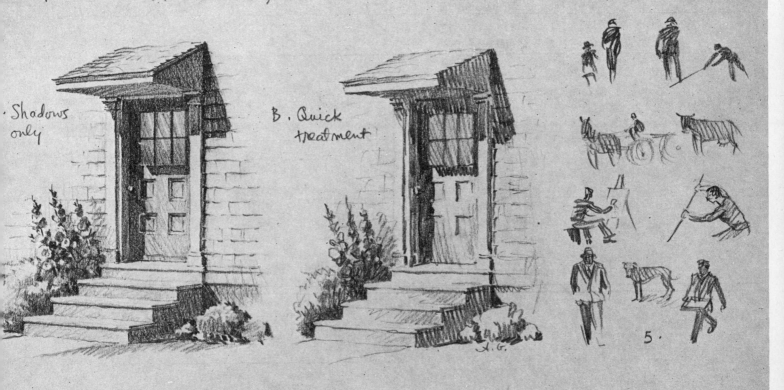

Shadows only

B. Quick treatment

5.

29

More About Still Life

And a Step-by-Step Demonstration

We now come to a series of chapters, each designed to demonstrate quite fully the representation of a particular type of subject matter. These chapters will not only offer certain new points — some of them vital — but they will serve to review and correlate much of our previous content. Any repetition is, in other words, intentional.

In the present chapter, we shall take a fresh look at still life, as it is a most valuable kind of subject matter — one which, from the time of the old masters, has been recognized as affording the best means of acquiring an understanding of the basic principles of representative drawing. In short, from no other subject matter can the beginner so quickly and easily learn so much.

Not that still-life drawing hasn't its faults. Some teachers complain that too much of it gets the student into certain fixed habits of deliberate thinking and doing which make it difficult for him — when ultimately he turns to the living subject — to work fast enough to catch the proportions and action in the limited time at his command. Even worse, there is danger that he may so represent his figures that they appear to be inanimate dummies instead of living people.

There's something to this negative argument. Cast drawing — which is obviously one type of still-life drawing — is quite generally in ill repute now for the main reason that casts stay still too long; are too inanimate. Yet, within reasonable limits, cast drawing has much to recommend it, as many a lesson in form and value can be far more easily learned from the cast (which presents no disturbing color or texture — not to mention mobility) than in any other way.

So let's learn what we can from still life — even casts, if we wish — and then go on to other subjects, including living ones. The knowl-edge thus acquired can later be applied to the representation of every sort of subject, as everything in nature follows the same fundamental laws.

Indoor Still Life — Objects, posed indoors, serve especially well for the student's early subjects, and for a number of reasons: First, they are already at hand — almost anything around the house will do. Second, such objects are familiar — one knows from long association about what they look like. Third, they are small enough so they can be drawn without too much reduction in size; consequently one doesn't have the problem of shrinking huge things to fit small paper areas, as when doing landscape, street scenes, or buildings. Fourth, objects of still life stay in place as long as needed; one draws without the nervous tension which he may feel when working from living subjects with their tendency to move. Fifth, indoor light is relatively stable; hence one doesn't get his shadows half drawn only to find that the shapes have altered because the source of light has changed position — one of the annoyances of outdoor work. Values indoors remain relatively constant, too, particularly when no direct sunlight is entering the room. Finally, when drawing indoors one can work in a comfortable seated position; his materials are conveniently at hand; there are no mosquitoes or flies — and preferably no fellow humans — to interrupt.

So don't shun ordinary objects. Simple as they are, they will tax your skill.

Selection of Subject — It doesn't really matter too much what you start with, though objects which are light in tone and not so shiny as to offer complex reflections, or so colored as to pose special problems, are very good at first — dishes, cardboard boxes, books, etc. Avoid "pretty" things, though — cut glass, beads, fancy things generally; it is hard to learn sim-

ple principles from complex subjects. Single objects may be selected — a good idea at the outset — or a number of things (perhaps two or three) can be grouped. To gain the most profit from still life practice one should gradually vary his subject matter so that sooner or later he does objects large and small, smooth and rough, rounded and squarish, light and dark, dull and shiny, in bright light and soft light. One reason why it is sometimes well tỏ do two or more objects at a time is that the student thus learns, through direct comparison, the appearance of different types of things. Incidentally, though there is of course no fixed rule, things related by use are often chosen; thus each composition has at least this one unifying factor.

For our demonstration (Figures 58, 59, and 60), we have selected an antique copper measure, an old power horn, ancient books, and a round ornamental dish.

Composing the Objects — Experts at still life sometimes take great pains to arrange their chosen objects to best advantage pictorially, so that they form a pleasing mass, with interesting contrasts of shape, tone, and texture. You, too, will doubtless try to compose your objects attractively, picture making being one of the things which you need to learn. You may plan for either a vertical picture or a horizontal one. Occasionally a square or round picture is made. The objects themselves should be located far enough from the eye so they can be judged easily, yet not too far — perhaps five or six feet. Often they can be most conveniently placed slightly below the eye level, as upon a table across which a cloth has been laid to hide the otherwise conspicuous table legs, and top. Some compositions, however, should be above the eye. As a vertical background, a contrasting cardboard or cloth is good, placed just behind the objects. Thus the artist is free to concentrate on the subject matter without the conflict of neighboring distractions.

Lighting — The illumination of the objects, and of one's drawing board, is all-important — read what we said about this in Chapter 1, Section 3. It is best, for a time at least to exclude direct sunlight from the room, as its patches will frequently change in form and intensity and may, therefore, prove confusing. Above all, light should not come from different directions

(as from several windows or large reflective surfaces) to create complex values and to cast a multiplicity of bewildering shadows. It is best not to have to shift from daylight to artificial light as the work progresses; stable light means constant values and a simpler problem.

(Sooner or later, you will want to try some drawings of still life posed under artificial light. It's a profitable exercise. And why not try to draw a lighted lamp or a burning candle to see if you can record it convincingly?)

Procedure — With your objects well arranged under proper lighting — study them through your view-finder as a final test — and with your board and other materials in place for comfortable work, you are ready to block in the subject to the right proportions (see 1, Figure 60). You know all about this by now, though we might point out that if you can get a clear understanding of the location of your eye in relation to your objects — how far your eye is above or beneath them — this may help you to draw them correctly. With your layout done, and repeatedly tested and corrected — don't neglect to get away from the work once in a while to rest the eye — decide on your value arrangement. You may intend to hold close to the values as you see them; that's the best thing to do for a time. Very well. Examine the objects. Which is the lightest? The darkest? Where can you discover the lightest light? The darkest dark? Of exactly what values are the intermediate tones? Hold up a sheet of white paper followed by another of black paper — or a value scale, if you have one — to aid you to judge the values. And what of textures? Are some rough and some smooth? How about the light? Does it come from the right or the left? From high or low? Is it bright or soft? Does it, or does it not, create definite divisions between light and shade? And note well the shadow edges — are they distinct or indistinct?

Trial Study — By making a trial study on tracing paper placed over your layout, you can settle many of these points (see Figure 59). Even though you plan to hold rather close to nature's values for a while, if you are convinced that some readjustment will make for a better picture, now is your chance.

In this trial study, you can also decide on your technical approach — what areas to fill with tone and what areas to leave blank; what

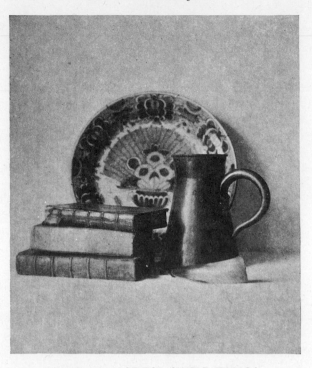

FIGURE 58 · SELECT SIMPLE THINGS · · · · · · · · FIGURE 59 · A GUIDE FOR LATER WORK

pencils to use; what sort and direction of strokes to make; and all that.

Simplify — As you focus your eyes carefully on each part of your subject in turn, you will perhaps discover innumerable tiny variations in tone. Often it is well to forget many of these lest, in your attempt to picture each one, you fail to obtain a convincing expression of the whole. Don't, in other words, break up your light areas with too many minor darks, and vice versa. Be especially careful not to exaggerate reflected lights or other minor value contrasts within your shadow areas. Tone them down. Restraint is the thing.

With your trial study completed, place it upright in plain sight, as a guide for your final effort.

Final Drawing — Don't hurry this; take your time. Analyze each portion of your subject matter and try to interpret it expressively. Work for a feeling of modelling, of relief; part of your art is to give your objects a three-dimensional appearance. They should also seem to possess weight, and to rest firmly on their support. (A tiny line of shadow under each one sometimes accomplishes this latter result.)

Don't make the all-too-common mistake of completing one part at a time (unless it is some area — perhaps a glassy one — which for technical reasons you believe must be dashed in quickly). In other words, keep the whole thing coming, working a bit here and a bit there so that the entire composition always remains in balance.

The Mirror; Tracing Paper — As your drawing develops, periods may come when you wonder what to do next. In this event, don't forget to reflect your drawing in a mirror. Seen thus in reverse, your next move will probably be indicated. If not, place tracing paper over the drawing and experiment. Try toning together and confusing values. Define that essential object with outline or with stronger contrasts of tone; see if you can bring it forward.

80

Attempt anything, in short, which suggests itself as a possible improvement.

Finishing Touches — Changes or additions indicated by such mirror reflections or tracing paper studies should now be accomplished on your drawing. Then a few last adjustments can be made: Soften that obtrusive edge; subdue that complex background; lift a bit of graphite with your kneaded rubber from that over-dark tone, and clean up the soiled areas.

You Aren't a Camera — May we again remind you that it's not your aim to turn yourself into a first-class camera to record to the last detail everything that you can see in the material before you. What the student needs to accomplish, through his own observation, analysis, and practice, is (1) to learn what things really look like, (2) to discover why they appear as they do, (3) to gain mastery over the representation of their shapes and values and the interpretation of their colors, and (4) to lay away in his mind such accurate mental images that, if he were ever so unfortunate as to be cut off for the remainder of his life from all contact with suitable subject matter (an impossible condition, of course), through all of his combination of skill and knowledge he could nevertheless make thousands upon thousands of convincing drawings of all manner of things — even things of his own invention.

Examples — The step-by-step illustrations which accompany this chapter (Figures 58, 59, and 60) explain themselves. Such serious studies are usually far less spontaneous and sparkling than are pencil drawings which are dashed off with greater speed and freedom. May we repeat that it is therefore a good thing, following the completion of such a study, to try a bolder interpretation of it. And never forget that drawing from memory can be very helpful, too.

Fixatif — To preserve your drawing — particularly your careful study — you may want to "fix" it. Unless you have already learned the use of fixatif, now is a good time. (Of the various types on the market, the transparent one for pastels is usually considered the best.)

The method of application is simple: Lay

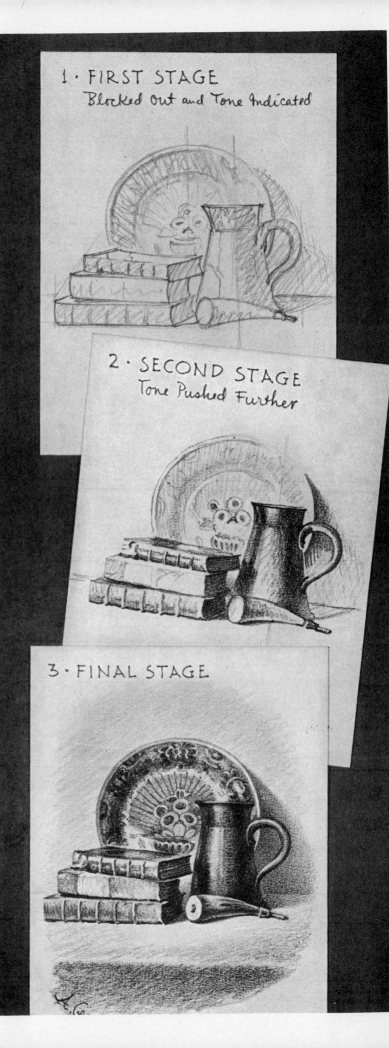

FIGURE 60 · PROGRESSIVE STEPS

your finished drawing on the table or floor (with newspapers spread about to protect the surroundings), or fasten it upright on the wall or easel. Spray your drawing from a distance at two or three feet, covering the surface uniformly by keeping the container constantly in motion (a back-and-forth sweeping motion is best), taking care that no large drops fall on the paper to create spots. Stop the container from time to time to allow the fixatif to dry. When dry, test the drawing with the finger. If it rubs too easily, apply still more fixatif. Be cautious, though, for too much fixatif causes the paper to shine and, sometimes, to look yellow. Unless you allow the fixatif to dry between applications, it may even act as a solvent to soften and blur the graphite unpleasantly. It should therefore be used sparingly. Some artists never fix their work, feeling that the fixatif does more harm, esthetically, than it does good as a protective agent. Instead, they frame, mat, or passe partout (a kind of framing in which picture, mat, glass and back are held together by strips pasted over the edges) their important work as soon as completed, or protect it with a covering of cellophane or other plastic sheet, or by laying it in a portfolio or between the pages of a book.

FIGURE 61 · TOO MUCH FIXATIF WILL CAUSE SHINE

Interiors and Furniture

These, Too, Are Still Life

Here is a type of subject of the utmost importance, inasmuch as many an artist earns the major portion of his living portraying room interiors, furniture, and furnishings. Witness, for example, the thousands of advertising drawings in our magazines and newspapers. Illustrators of stories likewise use interiors as the settings for their figures; they would be handicapped indeed if they lacked the ability to do them well. Architects, decorators, and designers are among the many others who have particular reason to delineate room interiors and their accessories, including furniture.

Many of these professionals — whether they work in pencil or some other medium — utilize certain conventions of representation which have gradually been developed. Fundamentally, however, these representations must of course be based on the natural appearances of actual interiors, so the student should first become fully acquainted with these appearances.

Interiors are Still Life — It is obvious that interiors are but an enlarged type of still life; therefore few problems are involved that we have not already touched upon. Complete interiors are much bigger than most still-life subjects, however, and thus demand a greater knowledge of drawing, and particularly of the principles of perspective.

Perspective — When the artist draws the customary type of still life, the entire subject falls completely within his range of vision; it is not necessary for him to shift the eye in order to take it in. In dealing with any major portion of a room, on the other hand, he normally is forced, as he draws, to shift his gaze from moment to moment, as he cannot possibly see the entire subject distinctly at one time. So first he looks at some particular part and draws that, and then he looks at another and draws that, and so on. As a result, unless he is so familiar with perspective appearances

that he can reconcile in his drawing all the conflicting shapes which will materialize under such conditions, he is quite likely to develop, in the end, a sort of composite effect which may be all wrong. He is therefore much wiser to work into the matter gradually, by selecting as the subject of his first drawing only the corner or some other limited area of the room; then in subsequent drawings he can gradually take in more and more until at length he feels qualified to embrace as much as could normally be viewed from any one point. If, in such work, perspective problems arise with which he feels unable to cope, he should interrupt his drawing practice long enough to acquaint himself with the laws of perspective and their practical application.

Lighting — Indoor lighting is quite different from outdoor lighting. In the open, the light normally comes from a single source — the sun — in rays which can be considered as parallel, so if the artist locates that source and realizes that all light rays will come from it in a single direction to cast shadows which are also consistent in direction, his problem is half solved. Indoors, on the contrary, even in those cases where actual sunlight is pouring into the room through one or more apertures, a great amount of light will radiate at divergent angles, only to be reflected from surface to surface in complicated fashion. In short, indoor lighting effects can be extremely complex. Shadows in particular will show great variety in value, form, and direction; therefore, in this latter connection, a good foundational course in perspective is again indicated, for this subject normally deals with lighting.

Many interior drawings fall into one or the other of two categories: those in which the artist stands with his back to the light, drawing a lighted area before him (such as a room corner away from a window), and those in

which the artist faces the light. This second condition usually results in more dramatic compositions, for not only are the window sashes, frames, etc., often thrown into sharp silhouette against the light, but objects near the window will exhibit striking contrasts of light, shade, and shadow.

These two basic conditions are illustrated by Figures 62 and 63. In the former, we are looking into a room corner in somewhat subdued light, while in the latter the tonal contrasts are extremely vigorous. Note also, in the latter, how the table top mirrors the light; it is shown practically white.

Textures; Details — Aside from such basic considerations, there are many secondary problems to which, one at a time, the student should give his attention. Take textures, for instance.

Interiors offer an amazing variety. We have the roughness of stonework and brickwork, the smoothness of mirrors, window glass, and other glossy surfaces. We have the endless woven fabrics: rugs, upholstery, hangings. In brief, the artist doing interiors must be prepared to portray nearly every material in almost every form. The student could therefore advantageously do a series of drawings deliberately planned to acquaint him with a reasonable number of these appearances. In one, he might picture a leather chair; in another, a polished floor, with reflections; in a third, floral window draperies, or a flounced bedspread. Night effects should be tried, too; a fireplace with open fire; light streaming in from the next room through an open door; a twilight impression, with subdued illumination from a window.

FIGURE 62 · LIGHT BEHIND ARTIST

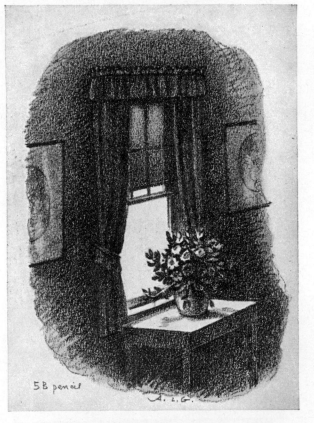

FIGURE 63 · LOOKING TOWARD LIGHT

84

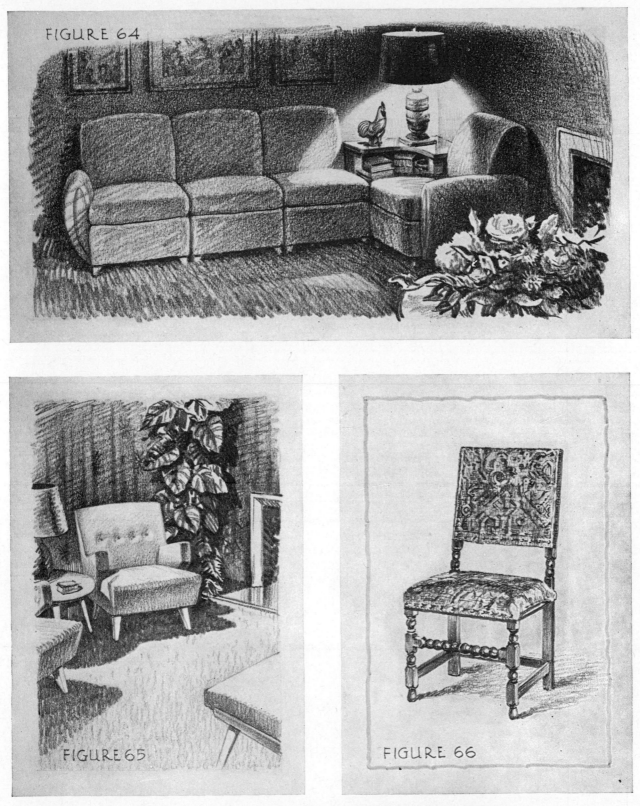

FIGURE 64

FIGURE 65

FIGURE 66

INDOOR LIGHTING IS VARIABLE IN DIRECTION AND INTENSITY

31

Outdoor Still Life

And Some Details of Buildings

By way of preparation for such landscape work as is described at some length in the section to follow, a little transitional practice in drawing still life in the open might prove expedient. Such practice will introduce you gradually to quite different conditions than exist indoors.

As to subjects, things normally associated with the shed, carport, garage, or garden are appropriate and offer a real challenge. Among these are cartons, baskets, watering cans, flower pots, jugs, wheelbarrows, bird houses, benches, lawn furniture, tools, and toys. At the shore we find dozens of such things as boats, fish traps, lobster pots, net reels, and buoys. All of these may be drawn singly, or grouped into compositions.

Eye Level — So far as construction is concerned, when starting to work out-of-doors it is very important to try to determine at once on the height of your eye in relation to your subject matter. We remind the perspectively informed reader that receding lines below the eye (for example, the edges of a box) appear to slope upward toward the level of the spectator's eye; if parallel, and if sufficiently ex-

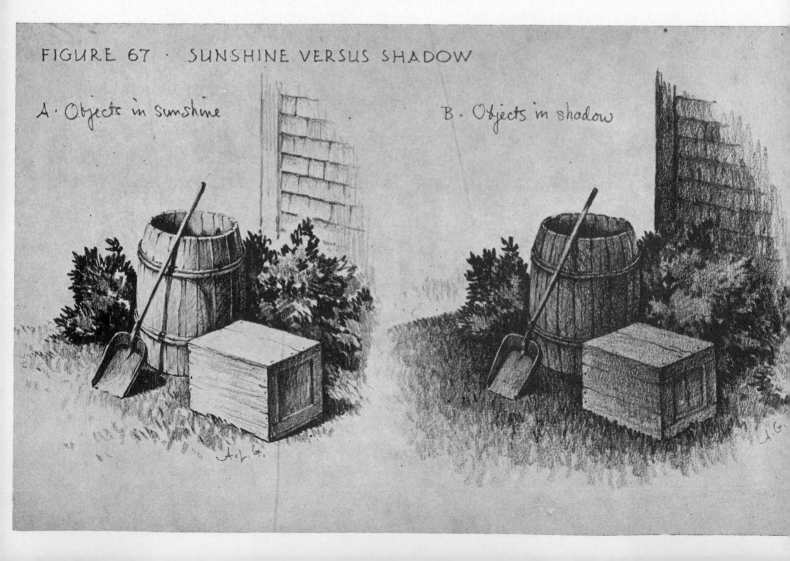

FIGURE 67 · SUNSHINE VERSUS SHADOW

A · Objects in sunshine

B · Objects in shadow

tended, they will meet at a vanishing point on the eye level. Similarly, receding lines above the eye (like those of a bird house) seem to slope downward; if parallel, they, too, will meet at a point at the eye level. The perspective appearance of an object varies greatly according to whether it is below the eye, at eye level, or above the eye. What we are leading to is this: If the artist can draw on his paper a horizon line to represent the eye level (or at least, can determine it in his mind), it may help him to construct correctly any objects which have definite geometric form — those based on cubes, pyramids, cylinders, etc. The main thing, though, is to make sure that whether objects are actually quite a distance below the eye level, at the eye level, or above it, they are so represented as to give that impression (see Figure 68).

Lighting — Two types of exercises may profitably be carried out, one in which the objects are in full sunshine, and the other in which they are placed in shadow — perhaps in the shadow of a house or under a tree, as at B, Figure 67. We might even suggest a third type, done on a rainy or misty day, with the objects exposed to the elements. (The artist can of course keep dry by drawing through a window or from a porch.)

Outdoor Objects in Shadow — For the student familiar with indoor appearances, outdoor objects in shadow have more the appearance of indoor objects than do objects in sunshine, so they afford a logical starting point. Their lighting — and hence their shade and shadow tones — will be governed largely, of course, by the nature and direction of the light reaching them. Such light may be reflected onto the objects from the sky or from some neighboring light surface, or it may be filtered through the trees. Because of possible reflections, there may be evidence of light from more than one direction. On the whole, however, you will discover in these outdoor objects in shadow much the same variety of light, shade, and shadow which normally prevails indoors. In your drawing, one of your jobs is to try to give the impression that the subject matter is in shadow. From the standpoint of truly realistic representation this might seem to call for graying your entire paper surface somewhat in all shadow areas, though the artist seldom does this. Only the conditions

Outdoor Still Life

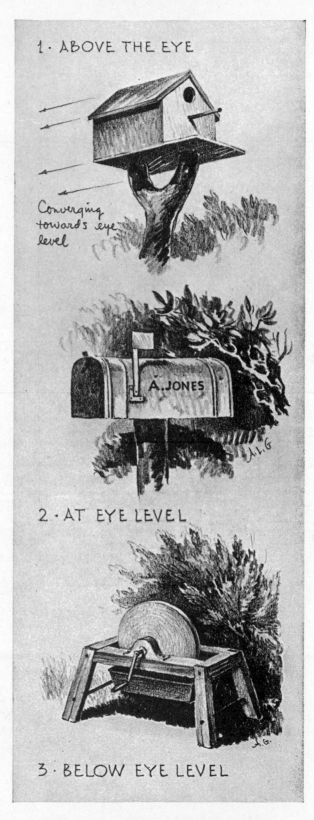

FIGURE 68 · WATCH YOUR EYE LEVEL

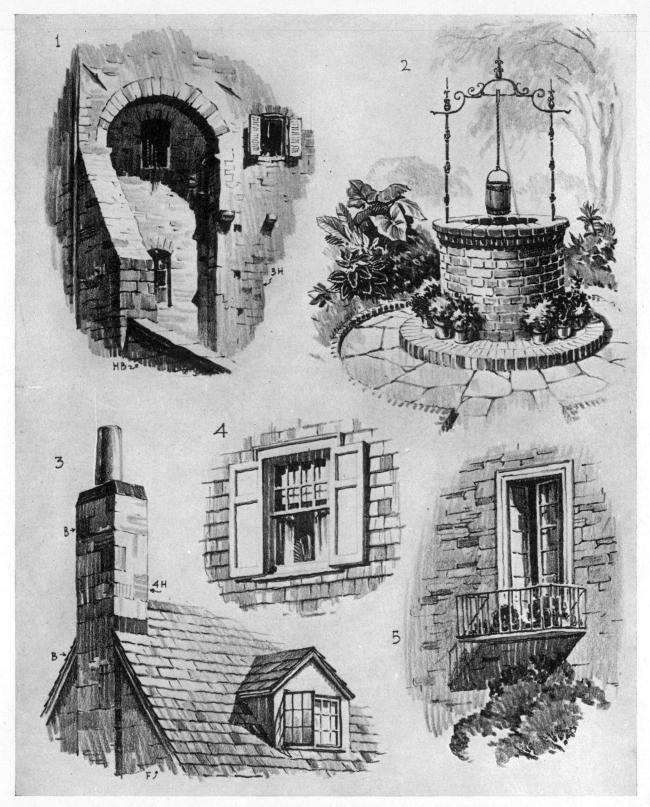

FIGURE 69 · ALL SORTS OF STRUCTURES PROVIDE SUBJECTS

under which you draw, and your own feelings in the matter, can guide you.

Outdoor Objects in Sunshine — Objects in direct sunshine pose new problems. As we saw with the geometric solids in Chapter 10, the subtleties observed indoors are missing. The light, shade, and shadow areas are clean-cut, with shadow edges sharp, and the light so glaring that the shadows, in contrast, look very dark. Reflected lights, however strong (like those thrown onto your subject from the sunny wall of a near-by white house) will seem relatively dark when compared with areas exposed to the sun (see A, Figure 67).

Direction of Light — As soon as you have arranged your objects in the sunshine and are ready to draw them, glance at the sun so as to get in mind the direction of the light rays, as this direction is obviously expressed by the pattern of light and shade in your subject matter. It follows that you are more likely to represent your light and shade well if you keep in mind, as you work, this direction of the light rays. Remember that those rays which come to the objects the most directly will create the lightest tones.

Study your sunlit objects for a time before you draw them; then proceed much as you would indoors. Work faster, though, for the shifting sun is a hard task-master; his shadow shapes will change frequently. If clouds keep passing over the sun, the lighting effects — especially the degree of intensity — will be particularly inconstant. Whatever the conditions, don't try to keep up with every change in light or your work will never be done.

It is perhaps just as well that one can't work too deliberately outdoors. His haste results in spontaneous, vigorous effects, with emphasis on the essentials, and with non-essentials omitted or held down. There is no time to fool with fancy technical effects — for a swapping of pencils for the making of special points, or the drawing of studied line or tone. One soon learns that he may be forced to quit at any time — perhaps unexpectedly. Therefore he tries to keep the whole thing coming.

Accidents — Let us repeat from an earlier chapter that, as one draws (especially if he works with considerable freedom), certain chance effects will develop which can sometimes prove very pleasing. That is part of the charm of the pencil — its strokes and tones can become very interesting in themselves. Unless such accidental effects are too conspicuous, don't suppress or obliterate them — be thankful for them and leave them alone, undeserved but not unappreciated.

From Still Life to Landscape — Once you get out-of-doors, you won't be long content with drawing inanimate objects. You will see a cat go by, and you'll try to record her, or you will be intrigued by an old man relaxed in a lawn swing, and you'll drop your still life in a hurry. That's quite all right. Who cares? You'll probably want to turn to larger subjects, too: that boat drawn up beside the wharf, that mountain in the distance, that elm tree hanging over the neighbor's garage. So go to it! You've had the patience to acquire the necessary background and can now begin to have some real fun and see some worth-while accomplishment.

Building Details — Though not commonly so classified, buildings are, in a sense, still life. In all probability, the reader will sooner or later turn to them and find them fascinating. Before trying to draw entire structures (as dealt with in the following chapter), a gradual approach is recommended by way of such details as doors and windows, steps and chimneys.

It is important to learn the appearance of bricks and stones, shingles and slates, stucco, clapboards, glass — a hundred things — as they appear near-by and in the distance, in sunshine and in shade. Don't confine yourself to new structures or to those of architectural significance, for a larger number of valuable lessons can often be learned from quaint old shacks and outbuildings, dilapidated barns and silos, decrepit warehouses, humble back doorways, tumbling down fences, and all that. Not only do new things look too new — too slick and prim — but often they lack the charm of the old. Old things have more textural interest, too.

The illustrations shown in Figure 69 are typical of what we have in mind. They explain themselves. As we shall see in the next section, it is easier to do such details when viewed from some distance; so viewed, perspective appearances are far less acute, and unimportant shapes and tones are seen in their true relationship, so that the artist is free to concentrate on the real essentials.

32

And Now Comes Landscape

Including a Practical Demonstration

The novice at landscape drawing often finds himself in a bewildering world. First, Mother Nature offers an over-abundance of subject matter from which to choose; there's generally enough in sight for a thousand drawings. How is the artist, faced with all this embarrassment of riches, to decide on a single subject? Also, unless the artist is wise enough to choose a subject at some distance, he is in danger, as he draws, of focusing first on one detail and then on another with the result that he may develop the same sort of perspective inconsistencies which we mentioned in connection with room interiors. And each detail in turn may seem so important that he is likely to over-render it. Thus his final drawing may not only be out of perspective, but it may have a number of focal areas competing for attention.

Mother Nature is very capricious, too. In an hour, the shifting of the sun can wholly alter the shapes of the areas of light, shade, and shadow, as well as the intensity of the light. Other changes in effect may be instantaneous, as when a cloud obscures the sun, or mist blows in from the sea. During sunrise and sunset hours, it is next to impossible to catch one of nature's moods on paper before it has mysteriously merged with another quite different one.

Again, unlike typical still life, most landscape subjects are huge compared with one's paper area. This means that the artist must learn to indicate on a few inches of paper a whole mountain, a majestic tree, or a large farm building — a fact which creates a series of new problems.

FIGURE 70 FIGURE 71

And there are sure to be minor annoyances; one finds, perhaps, that he has left his favorite pencil at home; a sudden shower comes up; hunger calls him from his work; people gather to watch; the wind rips the paper from the board; the sun invades his shade or gets in his eyes; he is accused of trespassing.

Does all this sound like an argument against outdoor sketching? It's not supposed to be. You shouldn't let a few things like these discourage you, for to most people outdoor sketching offers far more fun than drawing indoors. But it is just as well to be realistic in approaching your problems — the main point we are trying to make is that things are not all going to be rosy.

Choosing Your Subjects — You may become tired of our constant admonition, "Pick a simple subject," but it's sound. Once you turn to subjects larger or more complicated than the outdoor still life discussed in the previous section, limit your viewpoint; don't try to get all outdoors in your first sketch. Satisfy yourself with a single tree or group of shrubs; a bit of road or a path with the immediate surroundings; a quaint house or an old barn — even the barn door, for that matter.

The Right Time of Day — One thing to remember always is that the typical outdoor subject will reveal less interesting light and shade contrasts in the middle of the day, when the sun is directly overhead, than in early morning or late afternoon.

Station Point — When you find something appealing, look at it through your view-finder. Walk around; study it from different angles. Finally, pick a spot where you can sit and work unmolested, without a glare of light on your paper or in your eyes.

Don't forget our advice not to establish yourself so close to your subject that you can't see it all as one unit without shifting the gaze. A little distance will simplify your perspective problem (the perspective of distant objects is far less acute than in things near at hand), and will keep you from seeing — and so trying to indicate — every leaf in a tree, every stone in a wall, every shingle on a roof.

Thumbnail Sketches — If ever preliminary sketches are helpful, now is the time. As soon as you have found what looks to be a promising subject, try immediately a number of quick, small sketches, each perhaps only an inch or two in size — that's why they are called "thumbnail" sketches. They may indicate that you can get a better result if you shift your position somewhat. In selecting the point of view for the subject herewith, for example, the author wandered from place to place — he also visited the scene at different times of day. Then a number of thumbnail sketches were made (Figure 72), followed by somewhat larger sketches as experiments in recomposition.

Final Drawing — When you have made at least one promising thumbnail sketch, lay out your subject at final size on your selected paper. While you don't want to feel cramped, you can doubtless express most subjects well on an 11 x 15 sheet. Larger paper gives almost too much surface to cover when time is limited. The final drawing (Figure 73) was done on kid-finished bristol of 11 x 15 size. The pencilling extended nine inches across it.

Tracing Paper Again — After you have thus constructed your subject, you may want to determine on tracing paper the most effective value arrangement, and the best directions for your lines. But don't spend so long in planning that you can't get around to drawing before you are forced to leave!

Recomposition — When you portray a well-known subject — perhaps some historic building or noted landmark — it is inadvisable to wander far from its true appearance. Any recomposition may be limited to value adjustments. You may make a light roof dark, for instance, or take liberties with the tones of the grass and trees. Landscapes or buildings of no marked individuality permit far greater alterations — trees and bushes may be moved about, or made larger, smaller, or different in form. As your experience grows, you will seldom be contented to leave any subject exactly as you find it; no matter how pleasing it is, a creative urge will cause you to change it.

Nature not Perfect — While many of nature's details are pictorially very acceptable, this is not always true, as we demonstrated in Figure 36, page 53. And when it comes to larger compositions, nature can often be improved upon. A quaint old house may have a too-perfect young maple tree near it. The artist may prefer to substitute a more harmonious tree — something rugged and wind-blown — or omit the tree altogether. For that matter, al-

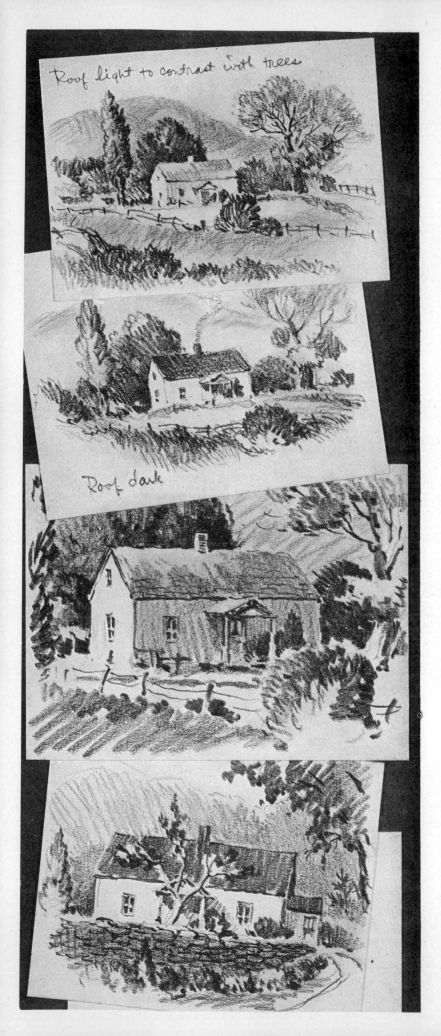

Roof light to contrast with trees

Roof dark

ways remember that undesirable details can usually be dropped or subordinated in your drawing.

In the accompanying demonstration, a comparison of the final drawing (Figure 73) with the photograph (Figure 70), taken at the exact spot from which the drawing was made, will show quite a number of readjustments. As the photo indicates, for instance, the roof of the house and the trees beyond were so nearly the same in value that they practically merged. For a more dramatic effect, in the drawing the roof was made lighter so that the house would count as a light spot surrounded by dark. The hill, trees, road, and fields composed rather well, so only incidental changes were required; had these masses not been reasonably satisfactory, they could easily have been altered. The ledge in the foreground was pushed nearer to the house and made somewhat more rugged, with foliage added.

This subject has a major light area (almost surrounded by gray and black), and a leading dark area. Its values include white, near-black, and various tones of gray. An attempt was made to create an all-over pattern of pleasing shapes and tones, while employing lines well adapted to the proper expression of both tones and textures. The vignetting shows variety, and is designed to keep the eyes out of the corners.

Technique — We have already seen that, when working outdoors, one seldom has time to think much about technique. He simply expresses his subject as directly and speedily as possible, knowing that the light and shade effects are changing every minute.

That's a good method. Important as it is for the beginner to acquaint himself, in his first preliminary practice, with all natural means of drawing lines and tones, the less conscious thought he gives to such things later, the better. Many artists — practically all — become at one time or another too technique-conscious, their work growing mannered and strained. This doesn't mean, of course, that a drawing shouldn't have technical excellence — it should. But technique should be subservient, used to make subjects appear convincing. Rocks should look heavy and solid; foliage, soft and yielding; skies, distant and ethereal. It doesn't take long, though, to acquire the knack of rendering all such things without much conscious effort.

FIGURE 72 · PRELIMINARY SKETCHES

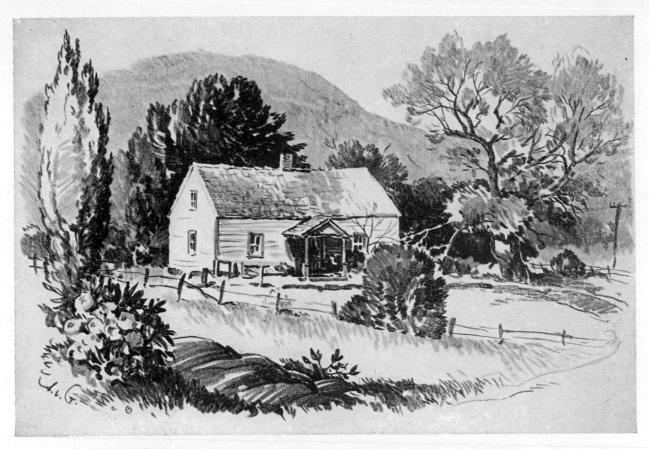

FIGURE 73 · THE FINAL SKETCH AS TOUCHED UP IN THE STUDIO

Taking Snapshots — One never knows when he may be forced to stop working on some particular sketch before it is finished, so he should take a few snapshots of each subject; then if later, in his studio, he decides to utilize the subject, he will have an adequate record.

Memory Sketches — After any outdoor sketching expedition, it is excellent practice — as with other types of subject matter — to try a memory sketch or two, for, to repeat, it is highly important to learn to retain in the mind as many impressions of nature's effects as possible; memory sketching affords one of the best means.

Varying Your Subjects — After you have sketched for a while from general outdoor subject matter (or, possibly, even before this), you should plan a definite course of study to acquaint you in a logical order with nature's appearances. For example, on a sunny day, concentrate for a few hours on striving to get a feeling of bright light. Make quick sketches rather than finished drawings. As we said in our discussion in Chapter 28, striking results can be obtained by drawing shadows alone. Another day may be dull or foggy; see if you can express this condition. Or perhaps the wind is strong: draw trees as they bend, or attempt to catch the movement of rustling grass, or seek ways to indicate blowing smoke, or driven waves, or clothes flapping on the line — even people leaning against the wind or hanging onto their hats, their coats whipped into action. Or, from your window or an automobile, attempt to interpret rain or snow. Draw a wet street, a snow-covered roof. Skies with and without clouds will give you work for many an hour. Sunsets are hard to handle successfully, but don't fail to try them — you will profit from the exercise. Coming chapters will deal with some of these things, but the practice is up to you.

33

On the Representation of Trees

Nature's Leafy Challenge

Usually the student of outdoor sketching finds that trees are one of the most difficult landscape features to draw. They call for a somewhat special delineative knack. The first step in learning to draw them well is to get to know them well. Study some of the many books on the anatomy of trees and on drawing them. They point the way to the student's observation, analysis, and interpretation.

Silhouettes — With rare exceptions, every type of tree has an easily identifiable characteristic form. As is indicated in the top row of Figure 74, this form can often be expressed through silhouette alone. It's not a bad start, working from trees outdoors, to select typical examples of different species — preferably in the distance where little but the silhouette is visible — and to interpret them as simply as in the sketches at 1.

Skeletons — The thing primarily responsible for the form of each of these recognizable silhouettes is the skeleton of trunk, boughs, branches, and twigs — yes, and roots. (Never forget the roots; from their hiding place beneath the ground they support and nourish the visible parts above. As you work, always remember that a tree is a living, growing thing; it comes from the ground and it reaches for the sky.)

As to deciduous trees, the best time to study their skeletons is obviously in cold weather when the leaves are off. Not often do we see the complete skeletons of the pines, hemlocks, spruces, and other coniferous evergreens, though parts of these are generally visible through the dark surrounding masses (see 1, B in Figure 74). In summer one can find plenty of bare skeletons of dead trees of all types. He should sketch some of these both in sunlight and in shadow (2, F and G), not only for their basic growth — every tree is consistent in growth throughout — but in detail.

Some bark is smooth, some rough. Some is light in value, some dark. The shadows which limbs cast on other limbs or trunks (as indicated at 3, H and I) are very expressive, also, as are the shadows cast on trunks and branches by foliage masses.

Foliage — When you have sketched some basic silhouettes and skeletons, the time has come to concentrate on foliage representation. Here you face a complex problem, for not only does each tree have a multitude of leaves, but each leaf has a number of shade and shadow areas, so if you stand at all close to a tree you can find these millions of tiny lights and darks very confusing. For this reason, you will be wise — at least for a time — to study each specimen from a hundred feet or so away; at this distance, instead of being acutely aware of these myriad details, you will notice primarily the larger masses of light and shade which give the tree its three-dimensional form. For we know that a tree is not flat; it radiates in all directions from its axial trunk. Though it is a growing, yielding thing, far from solid, in one sense we can think of it as not wholly unlike a huge potato — perhaps a sponge offers a better simile — stuck up on a crooked stick (see 4, Figure 74). One side, or the top of this basic mass faces the light and so (as with the spheres of our earlier discussions) appears relatively light in value. Areas turned away from the light look darker. Certain parts, and especially cavities among the leaves where the light can penetrate but little, will seem black.

But to get this over-all effect one must, we repeat, stand back, yet not so far back — at least at first — that the tree begins to flatten out. (In the extreme distance, trees often look almost flat, as though cut from paper; see 10, Figure 75.)

Indication — Even at a moderate distance, you will doubtless see so much detail in a single

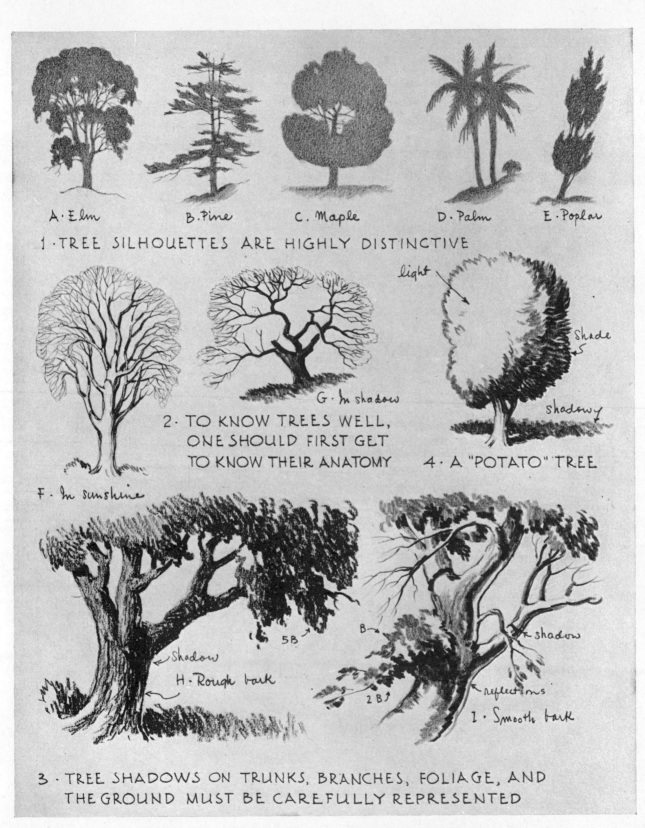

A. Elm B. Pine C. Maple D. Palm E. Poplar

1 · TREE SILHOUETTES ARE HIGHLY DISTINCTIVE

F · In sunshine

G · In shadow

2 · TO KNOW TREES WELL, ONE SHOULD FIRST GET TO KNOW THEIR ANATOMY

light

Shade

shadowy

4 · A "POTATO" TREE

Shadow

H · Rough bark

5B

B

shadow

reflections

2 B

I · Smooth bark

3 · TREE SHADOWS ON TRUNKS, BRANCHES, FOLIAGE, AND THE GROUND MUST BE CAREFULLY REPRESENTED

FIGURE 74 · TREES DEMAND A SPECIAL DELINEATIVE KNACK

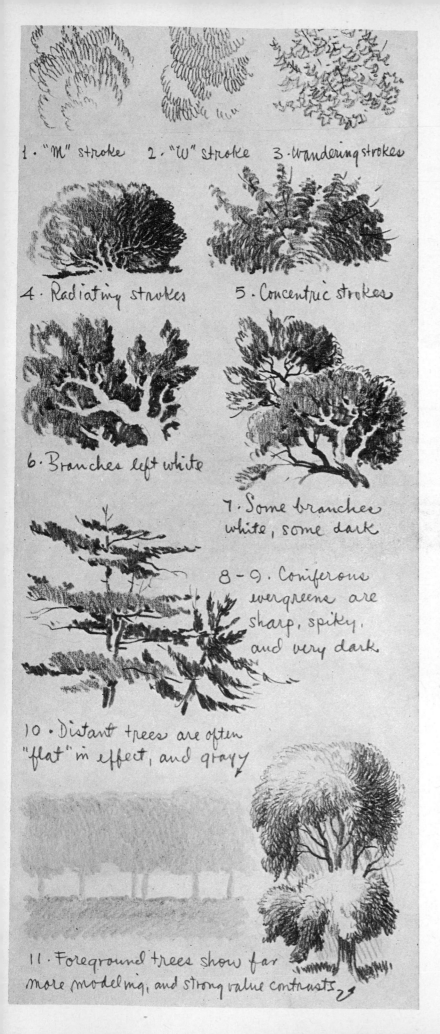

1. "M" stroke 2. "W" stroke 3. Wandering strokes

4. Radiating strokes 5. Concentric strokes

6. Branches left white

7. Some branches white, some dark

8 - 9. Coniferous evergreens are sharp, spiky, and very dark.

10. Distant trees are often "flat" in effect, and grayy

11. Foreground trees show far more modeling, and strong value contrasts

tree that were you to try to picture it minutely and realistically, you would require an enormous sheet of paper and days of time, no matter how indefatigable a worker you may be. So, your paper being small and your time limited, you must learn to suggest — to indicate. After a while you may discover that one type of stroke is especially effective for one species of tree, another for a second, and so on.

You must vary your strokes according to distance, however. (Compare those used at 10 and 11, Figure 75.) When you have acquired reasonable mastery over trees at a moderate distance, try some close at hand and others in the far distance where, as we have just said, they tend to flatten. Use in each case the stroke which proves most effective. The greater the distance, the less the visible detail, and the more suitable the broad stroke or solid tone.

Tree Shadows — As already indicated, you must give great attention to shadows — the shadows of limbs on trunks or other limbs (3, I, Figure 74); the shadows of foliage masses on other foliage masses or on the "bones" of the tree skeleton (3, Figure 76); the shadows of one tree on another tree, the ground, or some neighboring building (2 and 3, Figure 76). These tree shadows are very characteristic; their shapes, values, and textures need particular study.

Partly because trees are largely made up of rounded forms, and partly because of refraction (the deflection of light rays), the shadows cast on the ground or on neighboring buildings by foliage masses which are located a number of yards away — those towards the top of a tree, for instance — are often more or less rounded. If we study these shadows in detail, we will sometimes observe that they consist (in part, at least) of diffraction-created disks, many of them foreshortened to appear as ellipses, and overlapped and interwoven into highly complex patterns which, as the wind stirs the leaves above, live but a moment, only to be replaced by others equally complex and fleeting. Look for such shadow details (Figure 76, 1) when you are under the trees, but

FIGURE 75

don't confuse your delineated effects by playing them up too prominently.

As in the case of all other shadows, tree shadows help to express the contours and textures of the surfaces on which they fall. Tree shadows on a concrete walk may look smooth and simple; on a lawn, they will break to follow the inequalities of the cropped grass; in rough grass, they will assume still more ragged contours which will again be dictated by the grass itself. The values of tree shadows, too, depend largely on those of the surfaces on which these shadows fall, being dark on dark rocks, moderately gray on grass, and light gray on concrete or white woodwork.

Study Figures 77 and 78 and the many other tree delineations scattered among our pages. Then practice over and over the treatment of such subject matter. For a time, you may feel inclined to agree with the student who once paraphrased Joyce Kilmer by saying, "Only God can draw a tree." But persevere; ultimately you are almost certain to acquire reasonable skill in even this difficult work.

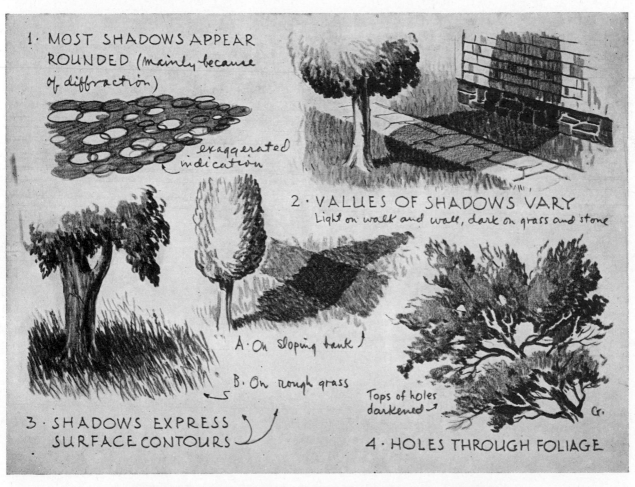

FIGURE 76 · TREE SHADOWS REQUIRE PARTICULAR ATTENTION

97

Tree Representation

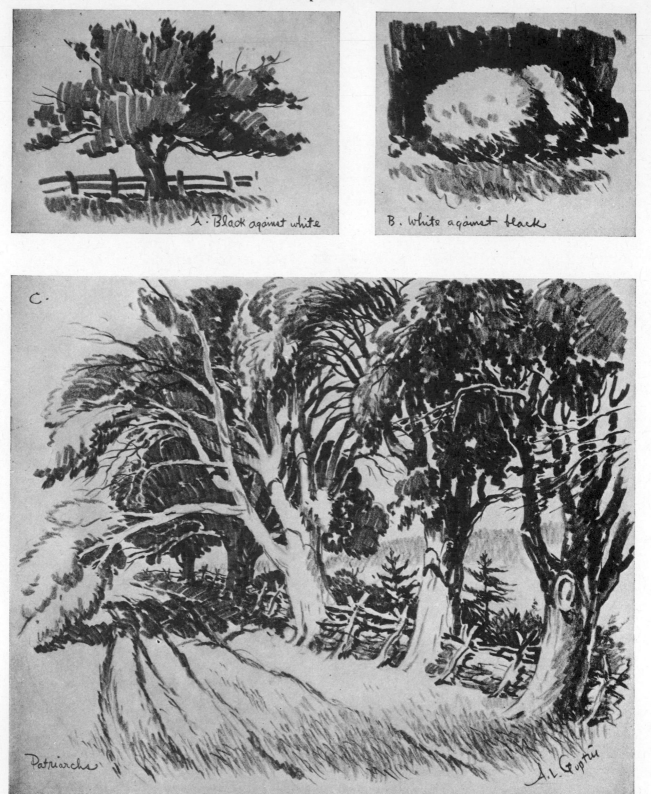

A. Black against white

B. White against black

C.

Patriarchs

FIGURE 77 · STRAIGHTFORWARD SKETCHES DRAWN OUTDOORS

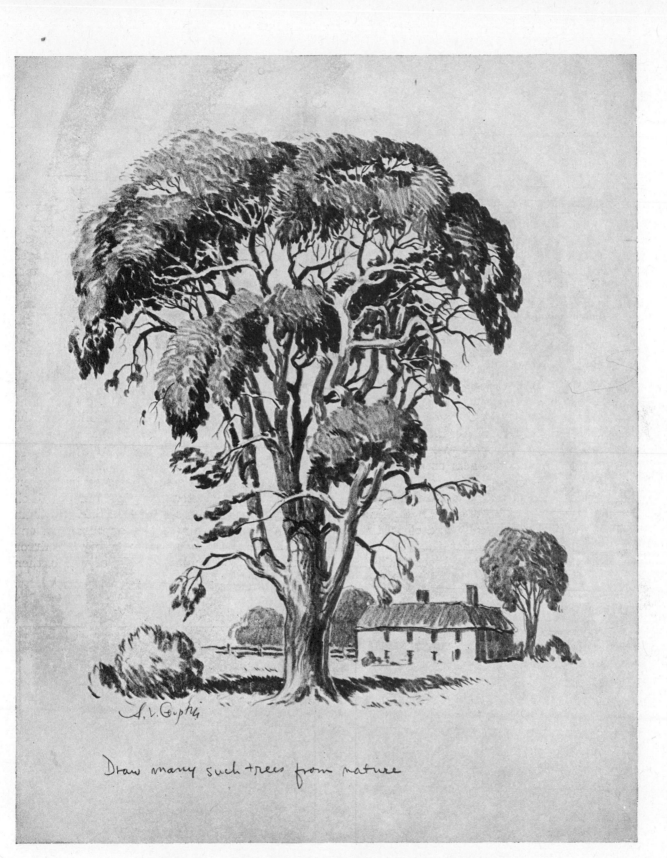

FIGURE 78 · EACH SPECIES DEMANDS ITS OWN TREATMENT

34

Water, Fog, Skies, and Snow

Learn Your Landscape Details

Important as are trees, obviously they are not the only landscape details which demand attention. Grasses and many like forms of vegetation are a constant challenge, while flowers alone could keep one busy for a lifetime. Water, both in motion and at rest, also presents many problems, as do skies with their clouds. Then there are fog and rain, smoke and steam, snow and ice — in short, a host of things. So why not concentrate for a time on some of the more important of these, according to your personal interest? As an introduction, let's take a look at a few high spots.

Calm Water — We might expect that calm water would be easy to represent, but this is not always so. In fact, calm water can prove very difficult, for it often acts as a mirror to reflect the sky, near-by trees or buildings, boats, people — a hundred and one things each of which demands to be drawn in duplicate. If the water is perfectly calm and clear, these reflections may be so distinct that they can prove as hard to do as the objects reflected

— possibly harder, for perplexing perspective problems are often involved, the reflections seldom being *exact* facsimiles of the objects reflected (Figure 79). Such inverted images must be represented with a certain dash, too, in order to indicate the flatness, smoothness, and liquidity of the water. Sometimes horizontal strokes seem called for, as they tend to indicate the flatness of the surface; see Figure 81. Again, vertical lines can prove successful; see Figure 82. In the latter case, a few horizontal pencil lines or erased streaks (to interrupt the reflections slightly) can hint at both the flatness and the mobility of the water. As to values, reflections sometimes match almost exactly the objects reflected (Figure 80), yet more often they are slightly darker (Figure 79); occasionally they may be lighter.

Although the customary way to master such reflections in calm water is by sketching them out-of-doors, certain basic appearances can first be learned indoors by laying a mirror horizontally to simulate a body of water, then

FIGURE 79 · NO WATER MOVEMENT

FIGURE 80 · SLIGHT WATER MOTION

placing small objects upon it and studying the shape and values of each object and its reflection. Sometimes the serious student makes a rather realistic model, using sand, wax, plaster — anything at hand.

Our little sketch at 1, Figure 83, is typical of smooth water indications. Here the reflection of the wooden pile was mainly drawn with slanting strokes, while the water as a whole was dashed in with horizontal strokes or bands (done with both pencil and eraser) to represent the surface.

Ruffled Water — The minute the least bit of movement is set up in water, reflections become distorted much as they would be in a series of slightly curved mirrors. Yet such reflections are far from quiescent, being constantly in a state of flux. Often they appear elongated and curved, yet they never twice assume the same identical form. One must learn these complex appearances directly from the moving water.

At 2, Figure 83, is recorded one aspect of the reflection of our pile, the water now being slightly disturbed. The endeavor was to suggest the mobility of the water yet with a minimum of modulation in the surface flatness. Note that the total vertical length of the reflection has become longer than previously.

In proportion to any acceleration of the water movement, distortion increases, and changes from one effect to another become more rapid. Often the wind creates sudden and short-lived ripples which, as they scurry over the surface, briefly corrugate the elongated distortions. (Such ripples may of course affect calm water also.) If tiny waves start to form — waves not large enough to destroy the reflected images entirely — some of them may be so tipped as to catch momentary reflections of the sky or distant objects. These new reflections, merging with the old, can easily result in a sort of jig-saw puzzle of variegated and constantly altering patterns. It is much as though several series of flexible curved mirrors were rhythmically tipped first in one direction and then in another.

Waves — As water breaks into waves, any

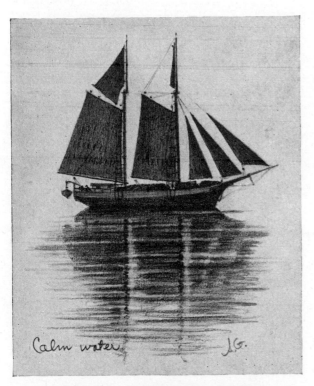

FIGURE 81 · HORIZONTAL STROKES

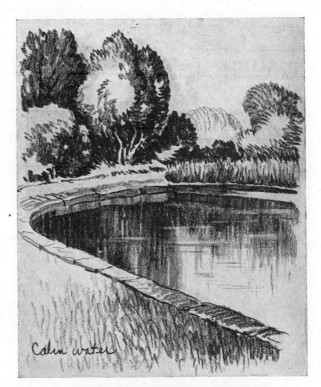

FIGURE 82 · VERTICAL STROKES

101

Reflections

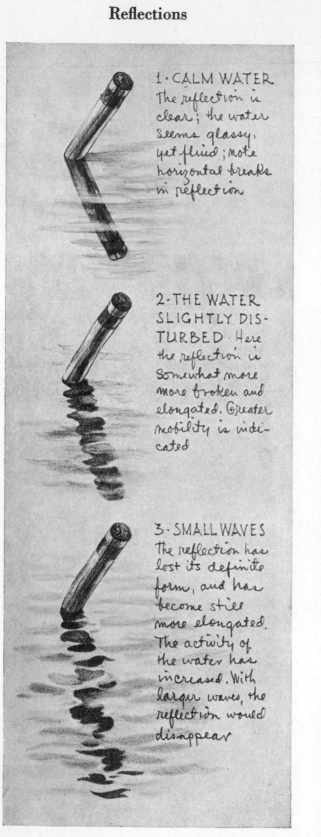

1. **CALM WATER** The reflection is clear; the water seems glassy, yet fluid; note horizontal breaks in reflection

2. **THE WATER SLIGHTLY DISTURBED** Here the reflection is somewhat more more broken and elongated. Greater mobility is indicated

3. **SMALL WAVES** The reflection has lost its definite form, and has become still more elongated. The activity of the water has increased. With larger waves, the reflection would disappear

FIGURE 83 · COMPARATIVE STUDIES

definite mirrored images of near-by objects tend to fly to bits. The wave masses now grow conspicuous; each wave comes into being only to vanish again, its form, as emphasized by light and shade, constantly varying throughout the wave's brief existence. Not that the water ever wholly loses its reflective quality during this process, for its general values (and color) will still be affected by such influences as the sky. While there are exceptions, according to the angle of illumination, waves are quite certain (despite their light and shade) to appear generally dark when heavy clouds hang low, light when light clouds float high, and brilliant as sunlight itself when direct sunlight is mirrored. But any definite reflections of near-by objects, such as exist when water is calm or slightly ruffled, make way, as soon as waves form, for indefinite, broken — perhaps kaleidoscopic — reflections which alternately merge with and separate from the ever-changing tones of the waves' light and shade. (At 3, Figure 83, we have one expression of wave formations.)

It's Not Easy — Does all this sound complex? Well, it is complex. But we aren't through yet. Water, whether rough or smooth, also has its own intrinsic tone — its local value. And, when water is shallow, things beneath may show through to modify it. Thus, complexity is added to complexity. In brief, so many factors are involved in this entire matter that you can't learn much about it from words such as these, or from teachers, or even from studying work by other artists. Instead, you must rely on your own keen observation of water itself, coupled with a lot of practice in its representation.

True, you may chance to be one of those rare persons who, without much practice, can acquire a certain knack at making water look convincingly real. All power to you! If, on the other hand, your progress seems slow, you can perhaps take some consolation in the fact that the marine painter, with a full gamut of pigments at his command, sometimes strives for a lifetime to master water of every sort — waves in sunlight, at sunset, in moonlight, beneath the clouds, dashing into spray, breaking on the beach — and still feels that he has a lot to learn. In fact, in the whole field of representative art there is perhaps nothing more difficult than water, for it is not enough to portray its surface as it may appear at some one

moment; one must strive to suggest the mighty power of the shifting mass beneath, as well as its weight, its depth, its fluidity, its rhythmic motion.

Running Water — Here, again, one must observe for himself rapids, waterfalls, etc. Usually swift water can best be interpreted with quickly drawn strokes, dashed in to suggest the rapid motion. At 1, Figure 84, we see a simple demonstration.

An Interesting Trick — In rendering this drawing, incidentally, a little technical trick was utilized which has many applications. In order that the water should appear clean-cut against the background beyond, a sheet of heavy tracing paper was cut with a curved edge to fit curve "a" exactly; this was then laid over the water area as a shield, and the pencil lines used to build up the background tone "b" were drawn off over the edge of this shield, which was protecting the water area underneath. A similar shield was next fitted to curve "c," and tone "d" was drawn. Thus, by the simplest of means, the water was made to stand out sharply against its background.

Wet Surfaces — The pencil artist is concerned not only with mobile bodies of water like the lake, sea, or stream; he must picture all sorts of wet surfaces. A wet sidewalk, roof, or awning takes on much the character of a mirror — see 2, Figure 84. The problems involved are basically the same as have already been discussed under calm water, though in the case of the awning in our little sketch, the tipped canvas introduced a new perspective consideration in that the reflections tip accordingly.

Fog — We all know that when mist (or smoke) veils the landscape, the thicker the mist, the less the eye can penetrate it; therefore, as objects become more and more distant they grow progressively less and less distinct until, when wholly enveloped, they disappear from view. Such objects as are visible through mist (or smoke) show no strong contrasts of value. And the greater their distance, the lighter they become, and the flatter in effect. Their edges are soft and blurred, scarcely distinguishable, in fact.

Our little sketch at 3, Figure 84, gives a simple exemplification. In making this, powdered graphite (scraped from the pencil) was first rubbed into the paper with the finger. (A

Water and Fog

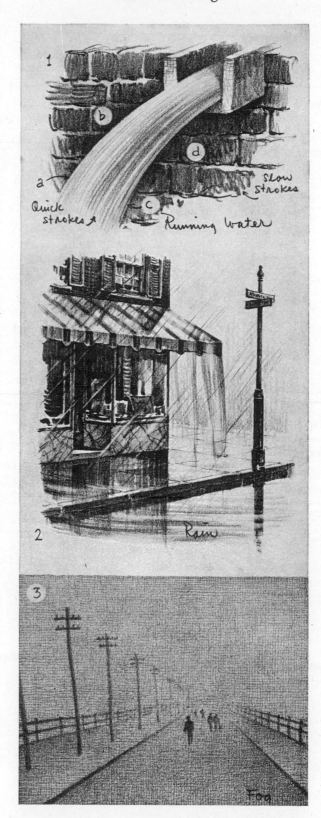

FIGURE 84 · LEARN NATURE'S MOODS

103

stump would have been good — see page 128.) Then the pencil was used for the detail, care being taken to keep all objects — particularly those receding into space — light and indefinite.

Skies — As a light sky is far more brilliant — far lighter — than the whitest drawing paper, the pencil artist soon becomes aware that he cannot possibly more than hint at such brightness. Often he chooses to ignore the exact tone of the sky, leaving white paper for all sky areas. He realizes, however, that a clear blue sky, no matter how luminous, gives the impression of being darker than a white house, a sail, or some other light object. Cloudy skies of course vary greatly in tone from the extreme lights of sunlit white clouds to the near-blacks of heavy storm clouds.

In brief, skies are so variable that the artist can safely utilize them according to his purpose. That is, if it pleases him to use a dark sky tone behind a light building, in order to throw the building into relief, he feels free to do so (1, Figure 86). If a light sky will better serve his purpose, he has no hesitancy in omitting any dark clouds which his subject may exhibit. If part of a subject is light and part dark, he may deliberately place dark sky or clouds behind the light areas and vice versa (2, Figure 86). Even smaller subjects are often shown against a background of contrasting sky tone (3, Figure 86).

Clouds — The person who is something of an expert on cloud formations, and who doesn't realize that the artist is allowed considerable license, is sometimes amazed — or, possibly, amused in a superior sort of way — at the artist's flaunting of natural laws. In fact the artist undoubtedly should learn more of clouds than he normally knows, especially if he plans to draw skies conspicuously again and again. (There are numerous sources of information, such as those used by the weather bureau and in aviation.) On the other hand, there can be danger in knowing too much about clouds and other sky effects unless one learns to control them in his pictorial compositions so that they nicely complement his other types of subject matter.

When it comes to drawing clouds, they are admittedly hard to do, as they move so fast and change their shapes so often, even melting away before the eyes. Many artists — particularly in the commercial field — therefore work up at leisure some good sky effects (perhaps based on photographs), keeping them at hand for incorporation into any serious pencil drawings done, perhaps, when sky effects are not too favorable.

(Skies and water, incidentally, must always be consistently related for, as we have already seen in discussing reflections, water almost invariably reflects to some extent the sky above, whether clear or cloudy.)

Technique — When the pencil artist represents clouds, he may possibly choose to rely, in part at least, on the convention of outline. In such a case, he will generally be wise to avoid black, ink-like lines (though much will of course depend on his technique throughout the drawing) ; gray lines are customarily better. Tone is often superior to even the grayest of lines, with soft, light effects of tone less obtrusive than bolder ones. Medium or fairly hard pencils (used with firm pressure) are generally one's choice, as the granular quality of a soft lead is far from ideal when trying to express either clouds or water.

In concluding this matter of skies and clouds, we might point out that in pencil work as a whole we see far less attention given to sky and cloud effects than in painting — hence the beginner may concentrate for a while on other more pressing problems, leaving white paper, or using simple tones, for much of his sky area.

Exercises — Why not go forth for a day or two, determined to master at least the rudiments of sky, cloud, and water interpretation? At the very least, you will thus become conscious of these problems; later, through observation and experimentation, you will gradually work towards their solution.

Snow and Ice — A leading painter, prominent for his landscapes, once confessed that although he had often tried to paint snow scenes he had never had the slightest success. Certain other painters, on the contrary, have built their reputations on their portrayals of winter.

To the pencil artist, snow representation should be easy — at least in theory — for all that he has to do is to leave his paper white — or nearly so — wherever snow is to appear, drawing elsewhere only such things as are not covered with snow. In practice, it's not that simple. In fact, in one respect the snow painter has the better of the pencil artist, for just as

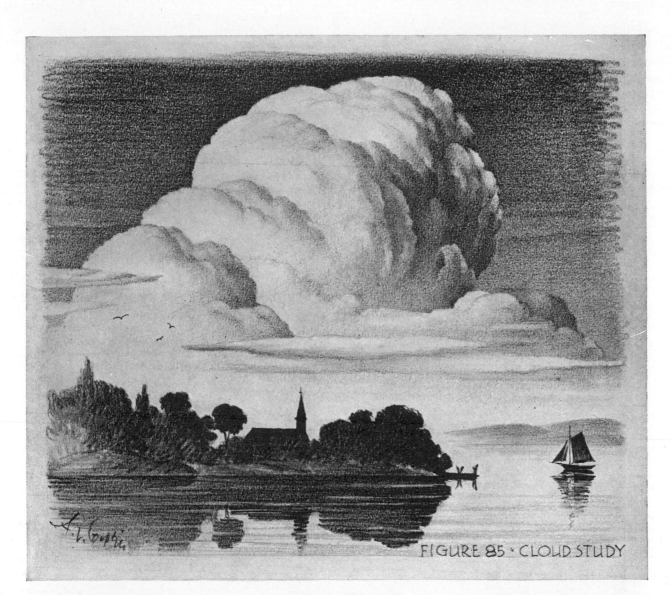

FIGURE 85 · CLOUD STUDY

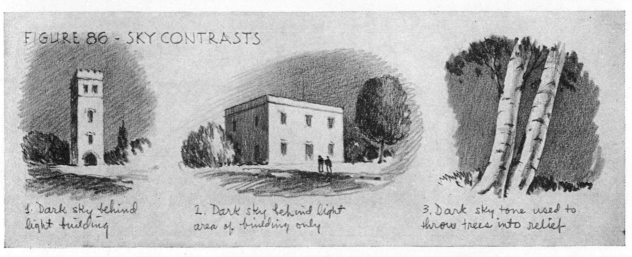

FIGURE 86 - SKY CONTRASTS

1. Dark sky behind light building

2. Dark sky behind light area of building only

3. Dark sky tone used to throw trees into relief

SKIES, WITH THEIR CLOUDS, VARY CONSTANTLY IN EFFECT

Mother Nature lays her snow onto the earth, so the painter can brush his white (or light) pigment onto his canvas; the pencil artist, on the contrary, is forced to work in reverse by leaving his paper white, or light, for snow, fitting all of his other tones around these snow areas.

The beginner's most common fault, though, is that he makes too prominent his individual pencil strokes which are intended to represent snow. The natural tones of snow are by no means linear in effect, so it is hard to interpret them in line. Therefore, some of the best interpretations utilize tone. This is either built up with extreme care — often with a sharp point, which gives it a desirable vibrant quality — or rubbed in with the finger or stump (page 121). In Figure 87, for instance, a portion of the snow was "painted" in with a stump which had previously been rubbed on a black-

ened sandpaper pad. The lights were then erased with a kneaded rubber. When lines are used, broad strokes of fairly hard pencils, touching or overlapping so as to minimize their linear quality, are generally the best.

A second fault of the beginner is that he often thinks of snow as pure white in value. While in the sunshine snow may be dazzlingly white, in shade and shadow it may appear surprisingly dark. Therefore a full gamut of tone may be needed for its proper expression. But try it for yourself, either from the photograph or, better yet, from nature.

Ice, whether solid or broken, offers relatively simple problems, for there is normally no restless movement to demand the almost superhuman delineative skill required by water in its liquid state. Smooth ice exhibits reflections; these are customarily somewhat indistinct and diffused.

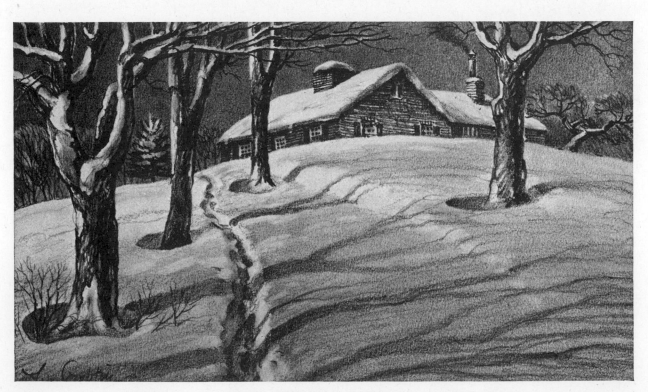

FIGURE 87 • A "PENCIL PAINTING," EMPLOYING A PAPER STUMP

The Living Subject

New Problems, New Solutions

At long last, we now come to the most important type of subject matter: living creatures — such as people, animals, birds, and fish. Most of us would far rather draw these — especially people — than the inanimate subjects with which we have so far dealt. In fact, so great is the beginner's desire to try to portray his family, his friends, or his favorite movie star, that he finds it hard to stick as long as he should to subjects more easily within his capacity.

Not that there's any harm in an occasional premature fling at drawing people. Probably all youngsters experiment at times along such lines. But any art student except the genius — and there are few geniuses! — will find himself decidedly handicapped if he tries to portray the human face or figure convincingly without proper preparation through some such progressive course as we have here prescribed.

In other words, before seriously tackling this most difficult type of subject, most of us are wise to master thoroughly the fundamentals of drawing. If we turn prematurely to portraiture or figure representation, our work will plainly reveal our lack of foundation — it will look noticeably amateurish. However, the student who has followed from the start our recommended course — or its equivalent — should now be qualified (if he is ever going to be) to embark on the study of living subjects.

Probably his first choice will be figure drawing or portraiture. What is the best approach to these? Must he attend a class, or can he manage by himself? And what of the books on the subject. Can these prove helpful? Of course, but books, no matter how helpful, are not enough. Books can give useful advice, can cover many practical points — especially of a technical nature — and can deal with numerous generalities with which the reader should be familiar as a part of his background. But the thing which books obviously cannot do is to offer one the specific individual help that he needs exactly when he needs it — the precise answer to some troublesome question, the personal criticism on some particular drawing, the analysis of his talent or of his progress to date, the word of encouragement when he is feeling low. Therefore, if at all possible every student should join a class. And he shouldn't wait too long, lest he fall into faulty habits of seeing or drawing which may later prove next to impossible to break. One of the greatest values of a class is that a somewhat competitive spirit is almost certain to prevail. Therefore each student not only learns from his teacher, and from the work which his fellow students are doing, but he is inspired to try his best to equal or better their accomplishments.

Classes in life and figure drawing — portraiture, too — are numerous. Often they are held in the evening, so can be attended without interference with one's daytime occupation. Tuition is generally reasonable, and individual courses not over long. On the whole, teachers are very capable. If, however, one finds that a teacher is offering some tricky "system" in place of sound, basic training, the worth of the course is open to question.

Life Drawing — Drawing from the nude is the usual starting point, and such work is of inestimable value. Over a period of time, models should include both sexes, and individuals of every race, type, and age — not overlooking the very young and the extremely aged — so that the student can eventually become familiar with the greatest possible variety of appearances. Poses should be varied, too, so that the student can learn to draw the model in every normal position, both at rest and in action. (In the latter connection, slow-motion moving pictures are sometimes profitable as they can effectively demonstrate through repetition cer-

tain actions which could not possibly be assumed or held by the posed model.) While many poses must of necessity be long — each perhaps lasting for an entire evening, broken up into half hour poses with five minute rest periods between — others should be so short as to permit the making of numerous quick sketches of five or ten minutes each, as well as a fair number of memory sketches.

Anatomy — Teachers are not in accord as to the amount of human anatomy the student should learn, but as a minimum he should become familiar with the basic structure of the human figure as a whole and in its most conspicuous details, as it appears both in action and repose. A course in artistic anatomy could well follow or accompany one on life drawing.

The Costumed Figure — Once the basic structure of the human figure is reasonably well understood, and a fair facility at drawing from the nude has been acquired, the next step for the student is usually to join a class in the costumed figure. Here, as before, every type of model should be posed in numerous positions, and costumes should be of every sort. This latter point is especially important if one is studying to become an illustrator or a mural painter, for eventually he may be called upon to picture all kinds of people, representing every period of history, and doing an endless variety of things.

The Portrait Class — If one's interest is broad, sooner or later he will doubtless want to follow up his figure work with the study of portraiture. Particularly if he is ambitious to become a painter or illustrator, will he find such work essential, for it gives him an opportunity to concentrate on such details as the head and hands — details which customarily play but a secondary part in life and figure classes.

Self-Study — In view of the accessibility of so many classes, and plenty of good books covering every phase of life, figure, and portrait work, we shall here offer only a few somewhat general observations designed mainly as a guide to the student who is forced to struggle along by himself.

The Posed Model — Perhaps his handicap will not be too great, especially if he can prevail upon his friends and members of his family to pose for him from time to time. If he has done his still-life exercises well — particularly those involving such rounded objects as jugs

and bottles — he shouldn't have any serious difficulty when he turns to the living model, for the same familiar procedure can be followed. He must, however, somewhat readjust his mental attitude, for no longer is his subject a hard, inflexible, inanimate thing, but a soft, yielding, breathing, living person. It is this state of aliveness — this potentiality of action which is constantly present even when the figure is in repose — which the artist must try to suggest. And usually he must catch this in a limited period, for no model can hold even the easiest of poses for long.

The student's problem will be somewhat simplified at first if he has his models assume natural poses which they can keep for at least fifteen minutes each — better yet, a half hour. This period should mainly be spent in attempting to record the fundamental form quite faithfully, sweeping in the main or "action" lines of the figure first, then the major subdivisions, and lastly, time permitting, the smaller subdivisions. One shouldn't yield just yet to the temptation to draw the head and hands in detail; that can follow when the figure as a whole has been fairly well mastered. Nor should one think too much about the light, shade, and shadow; usually he should go just far enough with tonal distinctions to reinforce effectively his linear expression of form. As to such things as textures of clothes, he must forget them for a while; right now he has other more important matters to concentrate upon. He must also neglect the subtleties of technique, generally doing each drawing very directly with a single pencil.

The Head and Hands — When the time finally comes to give undivided attention to the details of the head and figure, no change in basic approach is necessary. The head as a whole should first be constructed again and again, as viewed from every angle. The eyes, nose, mouth, ears, and hair should now be made the subject of conscientious practice. Next, a natural consideration would be the attachment of the head to the body by means of the neck, not to mention all such details as the hands, feet, elbows, knees, and shoulders — even the items of clothing.

Mirror Drawing — Many a student has found his best model in his own reflection in the full-length mirror. Here's a chance to try any number of nudes, costume sketches, por-

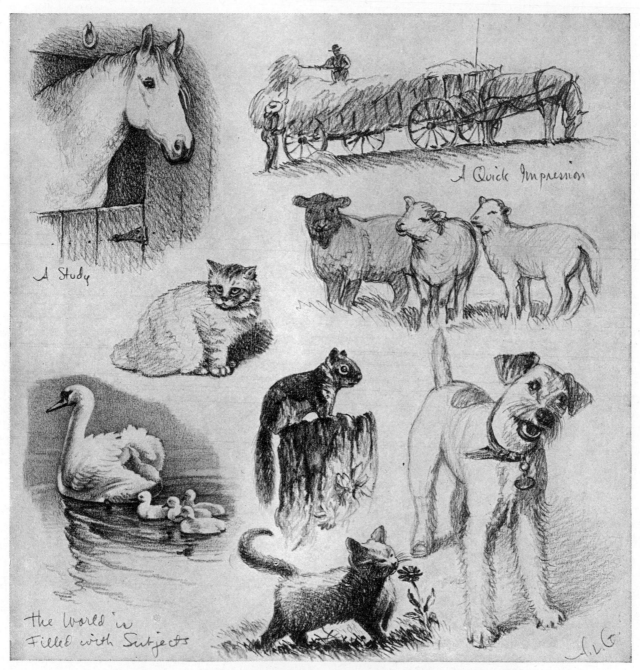

FIGURE 88 · SKETCH CONSTANTLY — ANIMALS, PEOPLE, EVERYTHING

A Typical Sketchbook Page

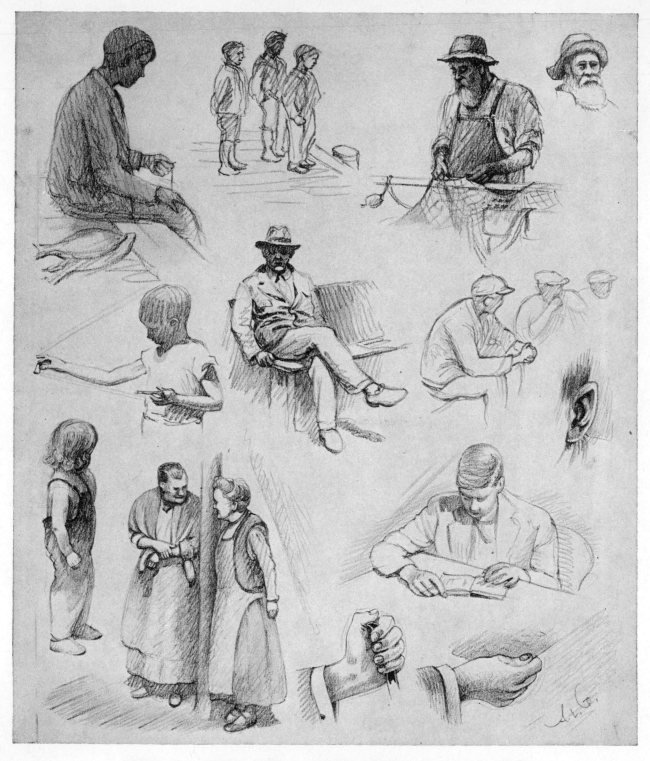

FIGURE 89 · SKETCH, SKETCH, SKETCH, OBSERVING ALL THE WHILE

We can't repeat too often that there is no quick road to pencil mastery.
At best, progress often proves discouragingly slow.

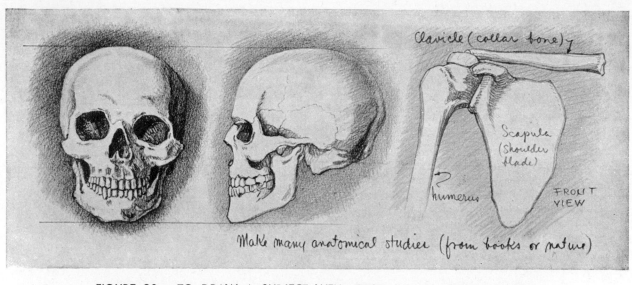

FIGURE 90 · TO DRAW A SUBJECT WELL, FIRST, GET TO KNOW IT WELL

traits, and studies of detail.

Sketchbook — Top-ranking artists often assert that they have gained more knowledge of drawing from doing innumerable sketches in sketchbooks or on odds and ends of paper — anything at hand — than in any other way. In fact, some artists make thousands upon thousands of these. They are not necessarily confined to people, but cover everything within one's entire range of interest. The pencil is an ideal instrument for such work, whether one employs a small pocket sketchbook — which he can take with him wherever he goes — or a larger one. We heartily urge the student to keep a sketchbook constantly on hand so as to seize every opportunity to try his luck at people, animals, places, things.

Animal Drawing — The delineation of animals is too specialized a subject to deal with at any length here. The interested student would do well to obtain a book which contains, among many other things, considerable information on animal anatomy.

Animals are almost always in motion, which makes them hard to do. For this reason, sleeping animals afford the best models at first. Domestic animals will answer as well as any; one doesn't have to go far to find a dog or a cat. The cow is a good model, being slow moving, and assuming the same poses again and again. If one wants more variety than can be found in these domestic creatures, the zoo is a wonderful place, though spectators can prove annoying until one becomes used to them.

By the time animals are mastered, birds and fish can usually be managed fairly well. Each species offers particular problems which can be solved only through first-hand study.

Part II
SOME SPECIAL
MATERIALS AND TECHNIQUES

Preface

The Possibilities Are Unlimited

Throughout Part I, our main stress has been on the customary or orthodox methods of drawing with the graphite pencil — methods which have so long prevailed that today they are accepted in almost all circles without question or comment.

Part II is a logical extension of Part I, its primary aim being to offer an assortment of supplementary suggestions designed to aid the reader in acquiring increased technical virtuosity. Most of the techniques and materials here presented are commonly known to professional artists; others are but rarely employed, though, if capably handled, they have intriguing possibilities; a few are admittedly on the "tricky" side, more fascinating than useful.

The suggested experiments will lead the reader in four somewhat different, though parallel, directions:

First, Part II demonstrates that Part I by no means exhausted all of the possibilities of graphite as a drawing medium. We shall now see graphite in new forms — oversize leads, flat leads, and powder — and in novel applications: scumbled in place, "rubbed" over rough surfaces, applied with a solvent, and combined with wash and watercolor.

Second, we shall be introduced to a number of pencils and crayons which contain little or no graphite, being of carbon, wax, or other materials. Hence, they possess individual characteristics which call for appropriate handling.

Third, we shall briefly discuss various colored pencils: (1) those which, being water-soluble, are sometimes called "watercolor" pencils, and (2) the more common types which are insoluble in water.

Fourth, we shall demonstrate such unusual drawing surfaces as Ross board, media paper, papers which are excessively rough, and colored papers.

In our drawings made to exemplify all these diversified media and methods, we shall vary the subjects as to kind, size, and handling. It is hoped that the reader will thus be encouraged to undertake equally contrasting explorations, for far too many pencil artists fall into ruts, their work becoming stereotyped. The illustrators and advertising artists are the ones most inclined to investigate any new possibilities which come to their attention for, in their field, work exhibiting a fresh slant often brings a premium price.

In the following chapters we by no means touch on all such treatments. On the contrary, the inventive artist will ultimately discover many things for himself. The author has seen interesting drawings made on window shade fabric, sandpaper, sheet metal, plastics, and glass. Novel results may likewise be obtained by drawing on the back of translucent tracing paper (with either black or colored pencils), so that the work appears softened when finally viewed through the paper.

Finished drawings may also be varnished, waxed, or oiled — always try a sample first! Or they may be spattered or sprayed with opaque white or color. If done on smooth paper, finished drawings may be run through the pebbling and deckling machines used by printers; this will give them any of several rough surfaces: eggshell, canvas, ribbed, etc.

Not all experimental results will be good, of course, but if one plays around long enough he is almost certain to find ways and means adaptable to his own requirements. And there is many a thrill in the search!

36

Some Special Graphite Pencils

Large Leads, Flat Leads, Holders

Although the artist does most of his pencil work with the regular drawing pencils described on pages 17 and 18, he should have at least a speaking acquaintance with certain other graphite pencils, notably those with unusually large leads, generally soft. Practically all manufacturers offer such pencils. As typical examples, we picture at actual size at "a" in Figure 91, A. W. Faber's 2526 "Lay out" (note the 1/4" lead), and at "b" the Eagle "Alpha," 245 B. Somewhat more unique is the 2040 "All-kore" by Hardtmuth (Koh-i-noor), indicated at "f," for in place of the customary wood casing this has a plastic covering to give the 5/16" solid stick of graphite added strength. Another highly practical Hardtmuth item is the No. 48 "Universal" Mechanical Holder shown at "g," designed to accommodate huge leads.

In addition to all of these round leads, there are pencils with flat leads, such as the chisel-pointed Eberhard Faber "Vandyke" (not pictured). Some makes of these flat leads are mammoth, 1/4" or more in width. Often they are encased in wood which is hexagonal or oval in form, as shown at "d" and "e." (The first of these, the Eberhard Faber 777 "Plumb Line," is of the type generally referred to as carpenter's pencils.) One oval pencil with an unusually wide lead (5/16") is made by General; they call it "Sketching Pencil 529."

FIGURE 91 · SUCH LEADS ARE AT THEIR BEST FOR LARGE WORK

Typical Strokes

Tiles

Single Strokes

Bricks and Stones

Shadows added

One stroke for each board and each pane of glass

a minimum of broad strokes

ABCabcd

Single strokes, chisel point

Lettering, too

Quick, single strokes, used for advertising layouts, etc.

FIGURE 92 · RESULTS ARE OBTAINED WITH A FEW WIDE STROKES

These examples merely hint at the many possible applications of the flat-lead pencils pictured on the facing page.

37

The Carbon Pencil

Its Characteristics and Uses

Despite the popularity of the various graphite pencils with which we have been chiefly concerned until now, there are numerous artists who for one reason or another prefer other types. We shall therefore deal with some of these in the present chapter.

The leading objection to graphite work seems to be its shine. Not only is this shine considered by many to be unpleasant in appearance, but when the work is for reproduction the shine can actually fool the camera, sometimes causing a given area to reproduce lighter than it should, because this area catches and reflects the light.

Among the mediums capable of results which are free from this objection, two are outstanding: charcoal (see next section) and carbon. The latter is a greaseless medium which comes in leads of different sizes and degrees of hardness, making possible a full range of tones up to an exceptionally deep jet black, as well as an impressive gamut of lines and textures. Being somewhat charcoal-like (though less brittle),

carbon is amenable to stump work and smooching with the finger — see Chapter 42.

The carbon pencil which has probably been best-known to American artists over the years is the "Wolff," of British manufacture. In its natural cedar form, it has been a familiar sight in the studio and drafting room for so long that the terms "Wolff" and "carbon pencil" have become almost synonymous. Actually, however, nearly every pencil manufacturer offers a satisfactory line of carbon products. General, for example, has a "900" line of carbon black drawing pencils in five degrees. Hardtmuth (Koh-i-noor) offers not only small leads to be used in mechanical holders for drafting and detail work, but also a line of wood-cased carbon pencils, as well as square sticks measuring ¼" by 3" (see Figure 93).

No special instructions seem to be needed for this pencil.

Work done with carbon products can be injured all too easily unless sprayed with several applications of fixatif.

FIGURE 93 · CARBON COMES IN VARIOUS CONVENIENT FORMS

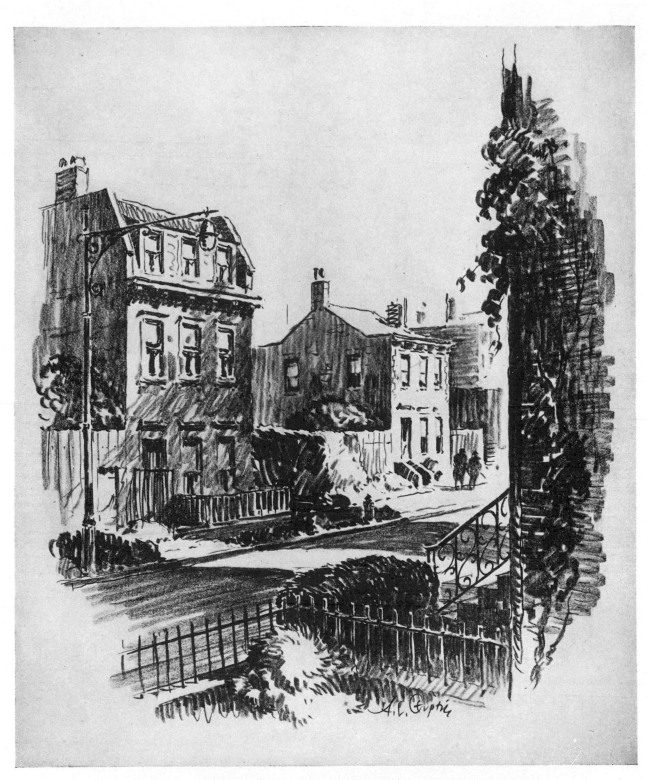

FIGURE 94 · DRAWN ON MEDIA BOARD WITH A BBB WOLFF PENCIL

*Whether soft, rich grays are wanted, or bold, contrasting blacks, the
carbon pencil is effective. It has no shine.*

38

The Charcoal Pencil

At It's Best for Large Work

Like the natural vine charcoal, which has long been favorably known as a drawing medium, such manufactured points as we picture in Figure 95 can prove very useful. They are so similar to the natural product that those familiar with it need no further description.

We have seen that work done with charcoal reveals no shine, so it is well suited to reproduction. Such work rubs or dusts off all too readily, however, so if it is to be exposed or handled it must be sprayed generously with fixatif. In doing such spraying, it is advisable to proceed slowly, allowing a few minutes for drying between applications. An unpleasantly mottled effect can result from applying the fixatif too freely and quickly.

Like the natural charcoal, such points as we picture are so soft that they wear down rapidly; hence they require frequent sharpening. While the harder grades may be employed for linear work, this must usually be at large scale. (For fine line work, the carbon pencil is often substituted, as it holds its point much better.) It is in tonal work, done at fairly large size and either unsmooched, or smooched with stump or finger, that this medium is most useful. It gives off its black freely, and large areas can be covered far more quickly than with either graphite or carbon.

The several points shown in Figure 95 are all reproduced at actual size. At "a" we see a large stick of compressed charcoal, manufactured by Hardtmuth. This comes in five degrees, and will do for any type of work for which natural stick charcoal would normally be chosen. It has the advantage of being uniform in quality and free from knots or other defects such as the stick charcoal so often possesses. At "b" we have a wood-cased charcoal pencil by General Pencil Company, while the paper-wrapped pencil at "c" bears the distinguishing imprint "Blaisdell." The latter was chosen for Figure 96, which was done on charcoal paper and sparingly smooched.

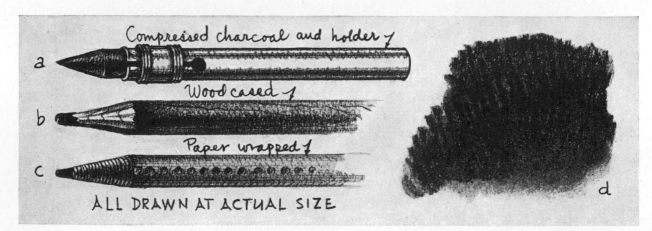

FIGURE 95 · SUCH MEDIA ARE EXCELLENT FOR TONAL EFFECTS

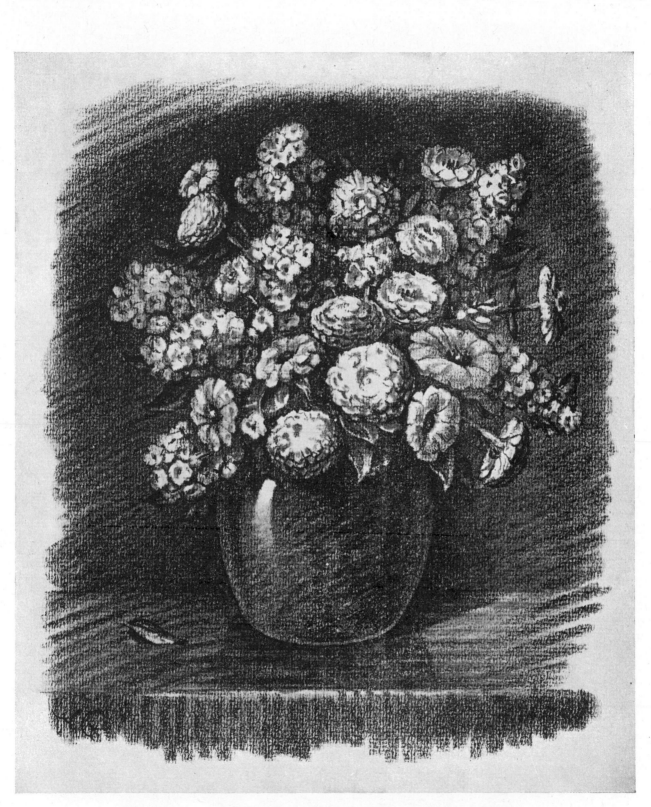

FIGURE 96 · DRAWN WITH A PAPER-WRAPPED CHARCOAL PENCIL

This was sparingly smooched here and there, and then touched up again.
The original was slightly larger than shown.

39

The Lithographic Pencil

A Favorite with Many Artists

Sooner or later, almost every artist becomes fascinated, for a time at least, with the lithographic pencil, a unique drawing instrument which we have pictured at "a" and "b" in Figure 97 at actual size in its two common forms. Both are available in several rather soft degrees, and bear the maker's name, William Korn.

This pencil was originally developed for drawing on the lithographic stone, a purpose for which it is still commonly used. Its chief function in this connection is to create on the stone a sort of grease spot which is indispensable to the lithographic process. Because of its soft consistency, the lithographic pencil, when used on paper, very freely gives off rich blacks — so freely, in fact, that it is hard to maintain a sharp point, especially if the paper is rough. Little soapy particles work up, too, which should be removed with care lest they cause trouble if the hand happens to rub them across the paper. A razor blade will remove them.

One virtue of the lithographic pencil is that it will mark on almost any surface, no matter how smooth. It will work on porcelain, on plastics, on glass. (From any of these it can easily be washed away.) Because of this characteristic, artists often use it on very smooth papers — shiny bristols, "coated" stock, etc. It is frequently employed on scratchboard — see page 140. The author likes Media paper for lithographic pencil work, as exemplified in the drawing, Figure 98. As this pencil is hard to erase, a bit of scraping with the razor blade will sometimes serve; whites can be drawn with the blade almost at will.

When drawing with the lithographic pencil, keep an absolutely smooth support beneath your paper at all times or every fault will be revealed. The medium is so unusually sensitive in this respect, especially if held sidewise, that even old thumbtack holes sometimes show through.

As a rule, work done with the lithographic crayon requires little or no fixatif as it seldom smooches noticeably.

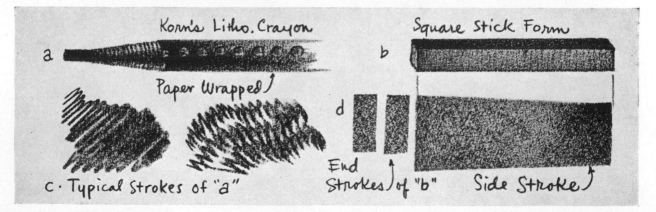

FIGURE 97 · THIS MEDIUM IS CAPABLE OF VERY DENSE BLACKS

FIGURE 98 · DRAWN ON MEDIA PAPER WITH A KORN CRAYON

*Far stronger contrasts are obtainable if desired. Note occasional
knife scratches — for example, the hanging rope.*

FIGURE 99 · DRAWN WITH A DIXON'S "BEST" SEPIA PENCIL, NO. 335

*From the time of the Old Masters, single colors have been used by
innumerable artists. The browns are favorites.*

Colored Pencils

Their Uses Are Varied

No description of the pencils employed by the artist would be complete if it failed to mention the various colored pencils which are at his command. True, there are purists who insist that only the vulgar would resort to this medium — that the only proper pencil drawing is in black and white. While it must be admitted that there is occasionally something in this argument — for undeniably much of the most distinguished pencil work is without color — there are times and places where at least a minimum of color is almost essential.

Let us consider, for instance, the traveller desirous of recording in his sketchbook quick color impressions — perhaps of transitory effects — without the need of resorting to the far less convenient watercolor or oil. And let us think of the architect, with his constant need to represent elements which are colorful — building materials, fabrics, trees, and flowers in bright sunshine — and which therefore often call for color for adequate protrayal. Let us also remember the illustrator, dashing off preliminaries for final interpretation in watercolor or oil, as well as the art editor or art director, preparing quick visuals of work to be assigned to others. To all these people, and many more, the colored pencil, with its remarkably complete gamut of hue, its ability to hold a sharp point, and its constant readiness for action, can prove a valuable ally indeed.

If one plans to experiment with this versatile medium, we advise him, before he buys, to investigate the market fully so as to compare the various products which are offered in profusion. He will discover that colored pencils are not only of many makes but also of several kinds: some soft and some hard; some with thick leads, some with thin; some with water-soluble leads, others with leads which are waterproof. The thick-lead pencils are usually the softest, and therefore the best for covering large areas; the thin-lead pencils are better for instrumental work and the interpreta-

tion of intricate detail. The water-soluble leads, by the way, have an obvious disadvantage in case of the accidental wetting of a finished drawing; also, they are easily damaged by moist hands. Yet they possess the virtue — if it be a virtue — of producing work which can be gone over with a wet brush to create so-called "watercolor" effects. (For that matter, work done with most of the waterproof pencils can be treated similarly with some such solvent as benzene or carbon-tetrachloride.)

Practically all colored pencils may be purchased singly or in sets; in at least one make, as many as 72 carefully graded colors may be had. (Some such colors also come in giant leads and in stick form.)

Inasmuch as requests to the larger pencil companies will bring full information, there seems little point in doing more here than list a few of the standard products of which descriptions chance to bet at hand as this is written.

* * *

Thick-lead Pencils
(Most of them insoluble in water)
Dixon Best
Eagle Turquoise Prismacolor
Hardtmuth Koh-i-noor Polycolor
A.W. Faber Castell Polychromos
General Multichrome
Eberhard Faber Rainbow
Cumberland Derwent

FIGURE 100 · COLORED PENCILS MAY BE USED IN MANY WAYS

*Sometimes tonal effects are sought; again, a linear approach is
made, or line and tone are combined as in this case.*

Medium-lead and Thin-lead Pencils
Dixon Thinex
Eagle Verithin (waterproof)
Venus Unique (waterproof)
Venus Coloring (water-soluble)
Dixon Anadel (water-soluble)
Eagle Copycolor (water-soluble)
A. W. Faber Commodore (water-soluble)
Koh-i-noor Mephisto (water-soluble)
Eberhard Faber Mongol (water-soluble)
Swan Othello (water-soluble)

* * *

Many of the so-called copying pencils are water-soluble, though most of them become waterproof once they have dried.

As to methods of using colored pencils, space limits us to only a few hints. First, remember that one's technique should never be too conspicuous, so avoid separate strokes of so many colors that the effect becomes chaotic. Second, if your pencils fail to give off their color freely, try rougher paper. Charcoal paper is good, as are some of the pastel papers. Third, tinted papers — ivory bluff, light gray, light blue, etc. — seem particularly sympathetic. Black paper is also capable of striking results. Extremely effective impressions are sometimes obtained by doing the colored pencilling on the back of transparent tracing paper, so that it shows through. Fourth, black and one other color often combine amenably, as do black and two or three colors. For that matter, some of the most distinguished results are achieved with a single color (see Figure 99). This is particularly true of such of the browns and brownish reds as are somewhat similar to the sepia, sanguine, and bisque of the Old Masters.

Some years ago, certain manufacturers made a big point of water-solvent pencils, referring to them as "watercolor" pencils, and claiming that by washing water over the pencil work pleasing results could be obtained. While it is true that some satisfactory work has been produced by this means, on the whole results are quite likely to be disappointing. Not only do certain colors run and streak badly when wetted, but many of them change radically in hue, growing brighter and quite displeasing in quality. Some colors also dissolve more readily than others. So if this method tempts you, practice awhile before undertaking any important work. Your time will be well spent.

You will play safer if, instead of expecting too much from the watercolor pencils, you use watercolor itself in connection with some of your waterproof pencils, either black or colored. Here your control — and hence your chance for success — is much greater. One good rule is to use your watercolor sparingly, perhaps in the form of transparent tints over portions of your pencil work. A contrary rule is to let the watercolor predominate, with the pencilling playing a definitely subordinate part. If both media are made equally prominent, one may fight the other, though sometimes the two can be blended so skillfully that no conflict develops — they become as one.

Drawings done in colored pencils are usually considerably smaller in size than watercolor paintings, though there are occasional exceptions. Most finished work is on paper not larger than 11″ by 15″, though much depends on the type of subject. Architectural renderings, and renderings of gardens and like landscape features, are sometimes much larger. Colored pencils, incidentally, are ideal for studies of gardens, with their multicolored flowers, leaves, and grasses. Pastels are also well suited to such work.

We offer herewith two examples done in colored pencil, hardly enough to more than hint at the possibilities. The first of these, Figure 99, was drawn on Media paper with a Dixon Best Sepia Pencil, No. 835. (The result might have been even more harmonious had paper of a warm tint been used — a creamy charcoal paper, for example.)

Figure 100 was also drawn on Media paper, using Eagle Turquoise Prismacolor pencils, about 20 hues being employed of 36 which were at hand. One way of utilizing the colored pencil medium is to make each touch of the pencil crisp and clean against the paper, obtaining any desired blended effects through placing lines or dots of color side by side to be merged by the eye. A more common and natural way of working — and the one mainly relied upon in Figure 100 is to go over any given area repeatedly with as many pencils as seem needed to achieve the desired hue, value, and intensity. There are endless possibilities.

It is not customary to fix colored pencil work as it rubs but little.

41

Wax Pencils and Crayons

Tools Worthy of Consideration

In addition to the graphite, carbon, and lithographic pencils already described, various other pencils are manufactured which, because of their smooth-working leads and the gloss of each stroke or tone (unlike that of any other medium), are usually referred to by artists — sometimes rather loosely so far as their actual composition is concerned — as wax pencils.

Among the author's favorites in this general category are the Hardtmuth Negro (pictured at actual size in Figure 99 — note the large lead) and the Dixon Best Black 331. There are, however, many other similar pencils. Some of these wax pencils, including this Dixon point, the Eagle Prismatic Black 935, and the slender-leaded Eagle Verithin Black 747, are from sets of colored pencils.

Wax pencil leads vary greatly in degree, some giving off their substance very freely, thus creating extremely black tone, while others are relatively hard. Some are soluble in water (and hence are tricky if used in conjunction with wash or watercolor) and others are insoluble.

It should be plain from the above that the only way for the reader to learn much about pencils of this type is to buy an assortment and try them on all kinds of paper. He may find that he dislikes the resultant shine (many consider it less objectionable than the shine of graphite); he may feel that the resultant tones are *too* black; he may discover that erasure is more difficult than with graphite. On the other hand, he will learn that drawings made with most wax pencils are sufficiently resistant to rubbing to require little, if any, fixatif.

Wax pencils are especially liked by layout men in art studios and advertising agencies, where contrasting effects which won't rub too easily are often wanted. Many artists prefer wax pencils for use in conjunction with wash.

What we have said of wax pencils largely applies to wax crayons as well. Even the common ones — the ten cent store variety — have their uses, especially for covering large areas quickly. We picture a typical crayon at "b" in Figure 101, and a bit of its tone.

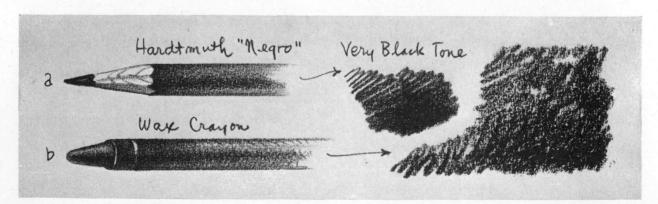

FIGURE 101 · THESE ARE TYPICAL OF MANY SIMILAR PRODUCTS

FIGURE 102 · DRAWN WITH A NEGRO PENCIL ON MEDIA PAPER

This rendering is representative of many made by the architect and landscape architect. It reveals scratches here and there.

42

Stump Technique

Smooching, Scumbling, and Such

We have learned in earlier chapters that at times pencil drawings may be rubbed (smooched or scumbled) to advantage by means of the finger or one of the tortillon (twisted) stumps made for the purpose — usually of paper or chamois. Sometimes, though rarely, such stumping is carried throughout an entire drawing; again, it is confined to very limited areas. Like magic, this practice can frequently simplify or pull together over-complex or spotty drawings; it can also help the artist to represent certain hard-to-interpret textures or to cover large areas quickly; it is especially useful in representing things with soft edges or subtle gradations, such as clouds and snow. The beginner sometimes becomes over-fascinated by this scumbling technique, however, using it where other techniques would better serve. Having mastered it, he would do well to hold it in reserve for those peculiar conditions which especially call for it.

Smooching works well with such media as graphite, carbon, and charcoal, particularly when the grades are soft; drawings in wax pencil or lithographic crayon obviously do not smooch to advantage.

The common procedure is to bring a drawing practically to completion in pencil before picking up the stump, which is then applied sparingly here and there, after which the pencil may be used again for touching up. More rarely, the pencil and stump are used almost simultaneously, the artist working for a moment with one and then with the other. The latter procedure was used in Figure 104, which was drawn with a soft carbon pencil, each area being stumped immediately. A few details were drawn almost the last thing with a harder carbon pencil.

The erasing shield is never more useful than in stump work. The kneaded rubber is the best eraser, whether one wishes to remove the tone from an entire area, pick out a small high light, or "lift" enough tone to lighten a value somewhat. In occasional instances, the artist actually draws with his eraser. In short, he employs three drawing tools: his pencil, his stump, and his kneaded eraser. They form a practical trio.

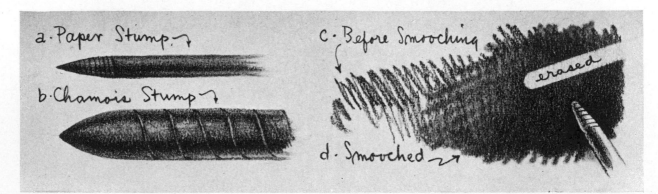

FIGURE 103 · THE STUMP AND ERASING SHIELD USED TOGETHER

FIGURE 104 · CARBON PENCIL SKETCHES, FULLY SMOOCHED

*The stump was freely employed as the work proceeded. Highlights
were picked out through the use of kneaded rubber.*

43

Powdered Graphite

Rarely Used, But Sometimes Valuable

While we shouldn't overstress this novel medium, powdered graphite, as it is relatively unimportant, it at least deserves this passing reference as it permits the natural extension of the stump methods.

We can perhaps best demonstrate the normal means of application by describing the procedure followed in making Figure 105. (The same method would work equally well with powdered carbon or charcoal.)

The paper selected was kid-finished bristol board; a rough surface is essential. This was first entirely coated with powdered graphite, transferred from a much-used sandpaper pad

by the finger, and vigorously rubbed in with the same useful tool until a reasonably uniform gray tone was created. A tortillon stump was next utilized as a sort of paint brush for transferring still more powder from the sandpaper to such areas as called for even deeper tone. Kneaded rubber was now chosen for removing the surplus tone from such areas as seemed too dark. For a part of this work, the erasing shield proved a convenient accessory. Finally, the pencil was used, though very sparingly, for developing the textures in the dark foreground passages. The drawing was then ready for a spray of fixatif.

FIGURE 105 · THE FINGER, STUMP, AND KNEADED RUBBER COMBINED

Side-pencil Scumbling

An Expressive Technique

The reader has doubtless discovered before now that the terminology of the arist is far from uniform and precise. The term "to scumble," for instance, usually means "to smooch," "to stump," or "to rub," yet, as some artists employ it, "to scumble" means to draw in a more or less sketchy fashion with the pencil held on its side. So held, the strokes often merge or overlap in such a way that the resultant effect has what might be called a "run together" look.

Figure 106 indicates one of many possible results of this kind of side-pencil scumbling; such an effect, like that produced with a stump, might be called a scumble. Whatever it is called — and who really cares? — a drawing so created has a sort of haphazard character which can be very pleasing. Try the technique for yourself, perhaps holding your pencil as at 3, Figure 8, page 24. This is a useful technique, incidentally, for blending the hues of colored pencils; it is also timesaving when it comes to quick sketching.

Figure 106, done on kid-finished bristol, is less effective than some similar scumbles made on rough paper, window shade cloth, canvas, and other more unusual materials. So experiment with such surfaces; vary your pencils, too.

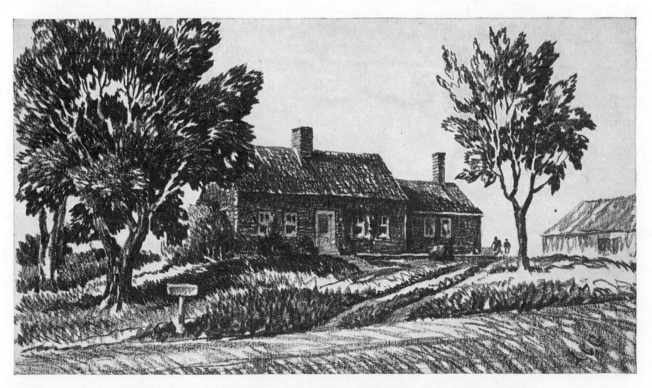

FIGURE 106 · THE PENCIL WAS HELD SIDEWAYS AND USED FREELY

45

Solvent-treated Pencil Work

Novel Results Are Obtainable

Perhaps we should again warn the young student not to allow unusual media or techniques to intrigue him too soon or too often; it would doubtless be advisable for him to keep away from them until he has mastered such orthodox materials and practices as have been presented in Part I. Even then, some of these Part II suggestions will prove to be more useful for getting him out of trouble when something occasionally goes wrong than for everyday application. The artist often turns, for example, to such smooching as was demonstrated in the first two sections of this chapter only because the technical quality of a drawing proves so disappointing that he picks up his stump as a last resort. So it is with such solvents as we shall deal with now, for seldom does an artist have them in mind at the time he starts a drawing. Only when he finds himself in trouble — his pencil strokes unpleasant, perhaps, or his values confusing — does he seek the aid of a liquid cure-all.

The type of solvent selected will depend largely on the medium to be dissolved. Is it graphite? Carbon? Wax? For most such things, the customary household spot removers — benzene, for instance, or carbon tetrachloride — will do very well. Occasionally, water alone is enough.

The application is simple: one merely brushes the liquid lightly here and there over the pencilled areas of a drawing, thus softening and distributing the particles in a somewhat wash-like manner. As a rule, the softer the grade of the graphite (or other medium), the darker will be the final effect. In the case of Figure 108, turpentine was slowly brushed over much of the completed pencil work with a watercolor brush. The tones deepened but slightly. In order to darken a few areas still more, the brush, wet with the turpentine, was rotated on a graphite-laden sandpaper pad, thus creating a sort of graphite paint which worked very well when applied to the paper.

Some such drawings call for fixatif; some do not. You should test each one.

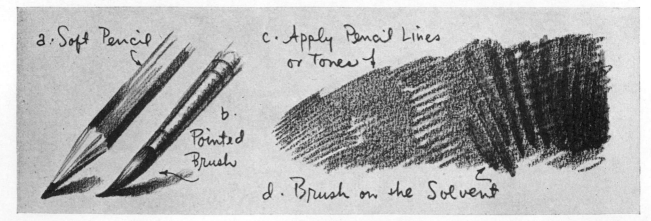

FIGURE 107 · SOFT LEADS DISSOLVE MORE READILY THAN HARD

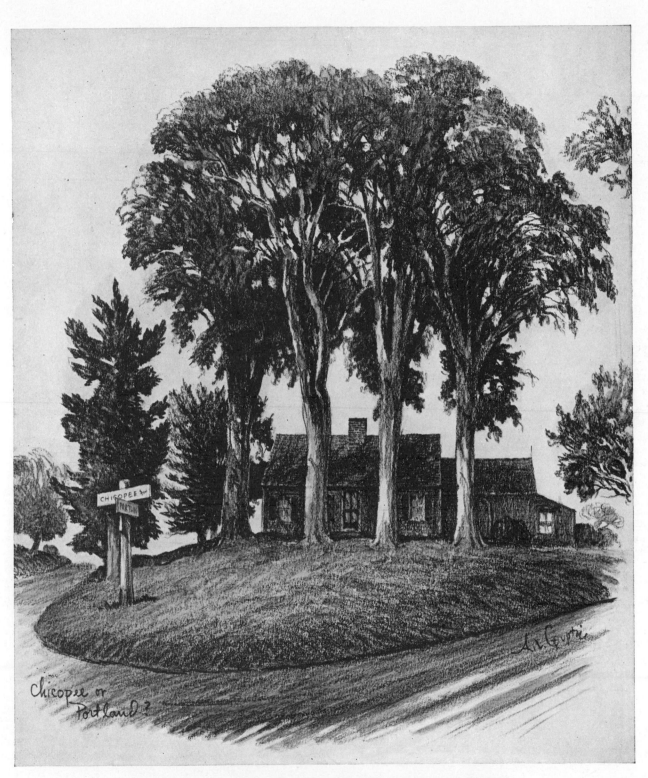

FIGURE 108 · A SOLVENT DISSOLVED THE GRAPHITE PARTICLES

Turpentine was brushed here and there over the previously applied
pencilling, greatly unifying the general effect.

46

Pencil, Wash, and Watercolor

A Natural Wedding of Media

While some of the techniques recently discussed are relatively unimportant, the serious student should not fail to investigate combinations of pencil with wash, and pencil with watercolor, as they can be extremely successful, each medium nicely supplementing the other.

If pencil, used by itself, has a conspicuous fault, it lies in its inability to cover large areas quickly. The brush, on the other hand, is ideal in this respect. It is quite natural, then, to do the line work of a drawing in pencil, then turning to the brush as a means of toning the larger areas with wash (sepia, lamp black, ivory black, black ink, etc.) or with watercolor. Also, drawings which on completion in pencil are disappointing can often be vastly improved through the discriminating addition of wash or watercolor.

If there is anything unpleasant about such combinations it is that pencilling, especially when of graphite, shines wherever untouched with water, while wash and watercolor dry flat, thus causing a lack of harmony between washed and unwashed areas. One good plan, therefore, is to reduce the pencil shine before applying any wash, merely by flowing or brushing water over the entire paper. (If such dampness buckles the paper noticeably, it may later be flattened by moistening it on the back and pressing it to dry between two drawing boards.)

In combining pencil and watercolor, transparent tints which permit the pencilling to show through plainly usually result in more pleasing effects than are achieved when translucent or opaque applications are used. In doing the tinting, a free, somewhat sketchy brush technique generally proves more successful than a precise handling.

Graphite is by no means the only pencil which combines well with wash and watercolor. Carbon pencil has its virtues, as do waxy points like the Koh-i-noor Negro.

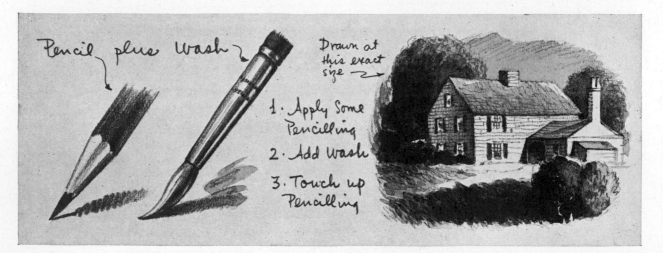

FIGURE 109 · PENCIL AND WASH POSSESS A NATURAL AFFINITY

FIGURE 110 · THE WASH WAS BRUSHED OVER THE PENCIL WORK

*The brush is faster than the pencil for covering large areas. It can
also "bring together" complex pencil lines and tones.*

47

Some Rough Papers

These Extend One's Technical Range

Pencil artists seem to fall into three classes: those with the attitude, "Any old paper will do," those who feel extremely handicapped if forced to work without their one or two favorite surfaces, and those who like a good assortment of papers at hand so as to be able to choose the appropriate one for every purpose.

In earlier chapters we have seen that paper is extremely important; that the surface on which one works can make a tremendous difference in the quality of his results. Our present aim is to develop this theme; in fact we shall devote this whole chapter to it in the hope that our readers, after a reasonable period of experimentation, will agree that the third type of artist just mentioned is the wisest man.

This doesn't mean that only drawing papers are satisfactory; beautiful drawings are being made every day on wallpaper, wrapping paper, printing paper — all kinds of paper. One should start early a collection of his own, and experiment freely; by this means alone can he gradually become a connoisseur. Before long he will be able to select, without conscious effort, the right paper — and the right pencil, of course — for any job, however demanding.

We can think of no better way in which to emphasize all of this than through reference to the little paper specimens shown in Figure 111, and to the drawings in Figure 112. Of the specimens, the two at the left are from an artists' materials dealer, the others from a paper house. All of these papers but the first were used in the drawings in Figure 112, as comparison will indicate. Our fourth drawing was done on white charcoal paper, a favorite surface for pencil work. Such rough papers permit one to create, with a minimum of effort, effects of atmospheric vibration or interpretations of rough textures; they are also interesting in their own right. In selecting papers, test them for erasing qualities, which differ greatly.

Though the papers here used were all white, colored papers are also effective.

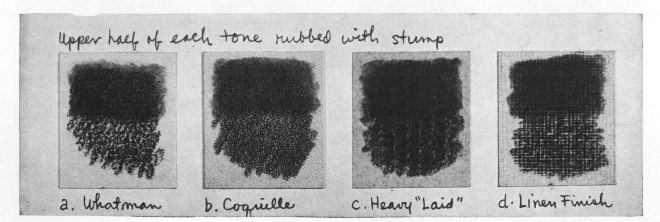

Upper half of each tone rubbed with stump

a. Whatman b. Coquille c. Heavy "Laid" d. Linen Finish

FIGURE 111 · DEFINITELY, "PAPER IS PART OF THE PICTURE"

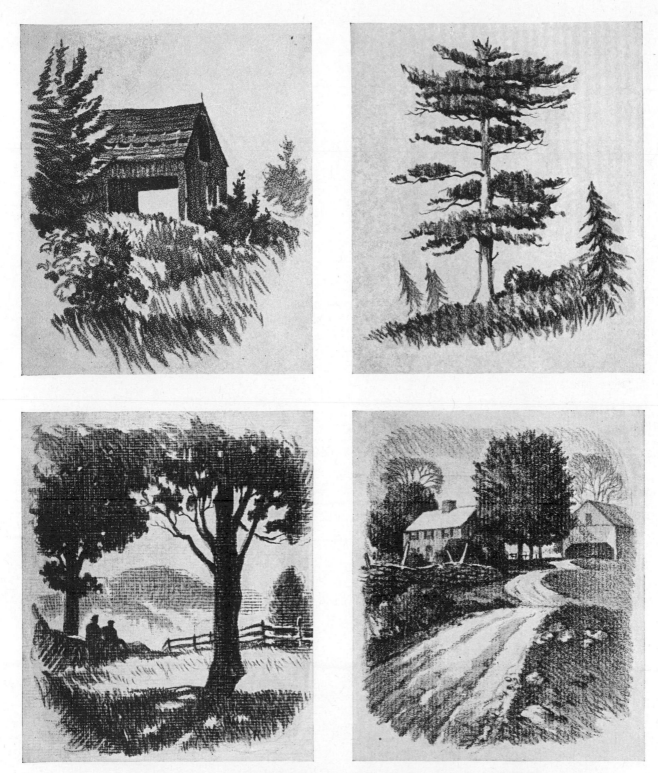

FIGURE 112 • A COMPARISON OF FOUR TYPICAL ROUGH SURFACES

*All of these were purposely drawn at very small size in order to permit
the paper surface to count to maximum advantage.*

48

Cameo Paper; Media Paper

One Is Scarce, the Other Rather New

Not so many years ago, one of the most popular papers among pencil artists was known as "Cameo." The hasty doodlings in Figure 113 give a hint of its virtues. So velvety and smooth it was — yet without gloss — that, with a single soft pencil, any line or tone could be made, ranging from a timid gray to intense black. Cameo would permit the finest of line work, and was ideal for crisp, staccato accents. True, it was so delicate that it was easily damaged, and it couldn't stand dampness. Though it objected to the eraser (which marred its surface), it would respond to the sensitive manipulation of the razor blade.

For some years, artists have sought in vain for a satisfactory substitute. Smooth bristol board, though quite different in character, has some of the virtues of Cameo, despite its shine. Another paper which has rapidly come into favor is Media. Though unlike Cameo, it has unique qualities for which it can be recommended. First of all, even with a hard pencil which will scarcely mark on most papers, one can draw a crisp black line on Media, due to its abrasive surface. Thus he can obtain practically any value with even the long-wearing hard points. The surface can be scratched and scraped with the razor, too, as attested by the two drawings, Figures 98 and 102. The colored pencil drawing on page 124 was also done on Media, which possesses the bite needed to catch and hold the color.

Figure 114 is rather photographic, the tones worked up with a medium grade carbon pencil.

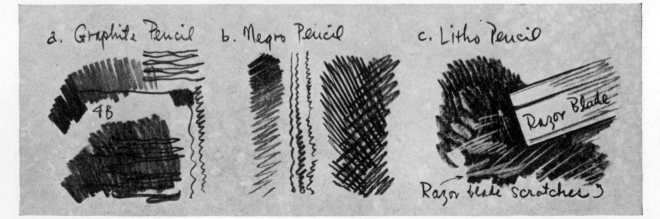

FIGURE 113 · TOO MUCH FIXATIF MOTTLED THIS BACKGROUND

FIGURE 114 · CARBON PENCIL ON MEDIA PAPER WAS USED HERE

49

Scratchboard; Ross Board

Unique Materials of Diversified Use

While on the subject of drawing surfaces, we should not neglect one type of board which, while by no means limited to pencil work, can nevertheless prove very valuable to pencil artists, and particularly to those who draw for reproduction. This is the unique product known as scratchboard.

Scratchboard is a cardboard which has been coated by the manufacturer with a hard, chalky surface which may be either smooth or rough. Though the smooth boards look much like any smooth drawing bristol, their coating — in fact, the coating of all scratchboards — is brittle and therefore easily cracked if abused. Our five specimens in Figure 115 are typical of the many rough surfaces available.

One draws on these boards with his pencil exactly as on any other surface, but if he wishes to create a white — a high light, perhaps — he can do so in an instant by scratching the surface with any suitable sharp instrument.

The commercial artist finds these boards valuable for another reason: Drawings made upon them, particularly if the contrasts are kept sharp — a wax or lithographic pencil is best for this — can be reproduced successfully by the relatively inexpensive line engraving process, whereas pencil work done on most other papers calls for the much more costly half-tone engraving. (One who draws for reproduction also uses ink on scratchboard — applied with either brush or pen — or he combines ink and pencil.)

Such of these boards as are made by Ross, along with certain imitations, are loosely known as Ross boards. Many artists think of the name Ross, however, in connection with boards — some smooth, some rough — printed with a wide variety of lines, dots, and patterns; the four in Figure 116 are typical. Scratching may be freely done on these, and ink can be employed. Reproduction may be by either line engraving or half-tone; ours was by the former process. These pattern boards have many uses. Fashion illustrators, for instance, sometimes select one design to represent a certain fabric, and a second design for another, etc., working them up as needed.

Our drawings 1, 2, and 3, Figure 116, were done in wax pencil; drawing 4 was in litho crayon.

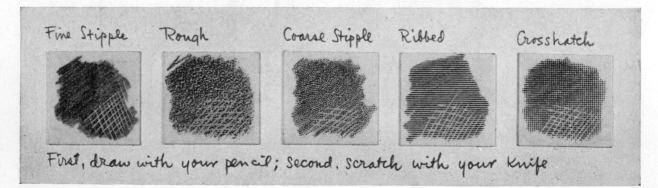

Fine Stipple Rough Coarse Stipple Ribbed Crosshatch

First, draw with your pencil; second, scratch with your knife

FIGURE 115 · SELECTED SPECIMENS OF WHITE ROSS BOARDS

FIGURE 116 · MANY ROSS BOARD PATTERNS OR "TINTS" MAY BE HAD

Reproduced by the inexpensive line engraving process.

50

Artificial Paper Surfaces

Rubbings and Burnishings

Architectural renderers, industrial designers, interior decorators, fashion artists, advertising artists, and commercial artists often need to represent convincingly a wide variety of materials: stone and brick, plastics and metals, numerous kinds of fabrics — an enormous number of things, some light, some dark; some soft, some hard; some smooth, some rough; and viewed under all sorts of conditions. Therefore, as repeatedly mentioned, such artists, when interpreting these diversified appearances, resort to every means at their command. Sometimes it's a matter of choosing the right pencil. Again, it's the handling that counts. Often, the choice of the proper paper plays a leading part in one's success. Usually, however, it is a combination of all of these which leads to a satisfactory result. Occasionally, a relatively little thing — some simple trick — can be utilized to great advantage.

One such trick, exemplified somewhat inadequately by the tracing paper demonstrations, Figure 117, (and previously on page 62), takes advantage of a stunt which most of us learned as youngsters — the making of a rubbing (usually by means of an ordinary pencil) of a coin or other low-relief or incised object. In the same manner, it is possible to produce rubbings of a wide variety of things.

Let us assume that you wish to represent, in a single drawing and perhaps rather hastily, a number of different textures. You choose a sheet of thin (or very sensitive) paper — tracing paper is good — and, having lightly outlined your subject matter upon it, you place the paper successively over a number of rough-textured surfaces — coarse paper, perhaps, or a book cover, or a sheet of oilcloth, canvas, window shade material, or sandpaper. Then, as you render each area, the surface beneath influences every line and tone. This is demonstrated in a simple way by the sketch of a book in Figure 117, in which the binding was rendered over two actual bookbinding fabrics. If full advantage is to be taken of this technical trick, the pencil should preferably be held flatwise, though there are exceptions to the rule. Experiment for yourself.

If you produce such rubbings with sufficient care, protecting your surface at all times from perspiration and other dampness, the mounting of your work will prove unnecessary; the tracing paper drawings opposite were not mounted for reproduction. Some artists, though, prefer to mount each job by first coating it on the back with diluted white paste, next smoothing it out carefully on a white mount to dry, weighted down to prevent buckling. It is something of a knack to keep out wrinkles and air pockets, so if you plan to do much mounting (or "floating," as the architects call it), have some expert — perhaps an architectural draftsman — give you a demonstration. It's not a method which can easily be described in a few paragraphs of print. For an important job, you can always turn to the professional architectural framer and mounter. When he is through, no one will ever be likely to detect that the job was on tracing paper. A poor job can be terrible, though.

Should you ever make a pencil drawing on sturdy rough drawing paper — Whatman, for instance — and wish to smooth the surface of some small area so as to be able to do delicate pencilling, you can probably burnish it smooth with a knife handle. Or, you can carefully scrape it smooth before the burnishing, using a razor blade or sandpaper.

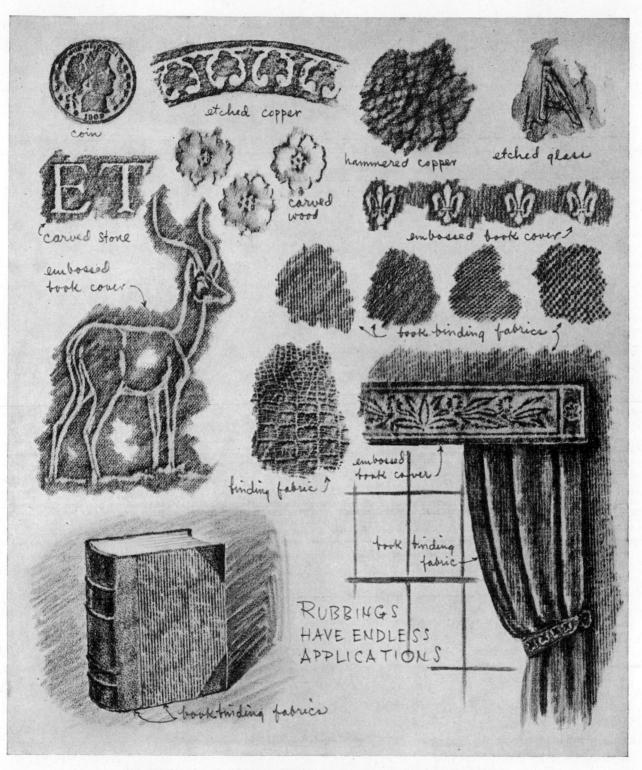

coin

etched copper

hammered copper

etched glass

carved wood

carved stone

embossed book cover

embossed book cover

book binding fabrics

binding fabric

embossed book cover

book binding fabric

book binding fabrics

RUBBINGS HAVE ENDLESS APPLICATIONS

FIGURE 117 · A SIMPLE TRICK OPENS UP MANY POSSIBILITIES

By this unique method the artist can produce, quickly and effectively, many textures in a single drawing.

51

Tinted Papers

Don't Overlook Their Possibilities

An entire book could easily be written on this subject, for its possibilities are practically limitless. In some instances, regular pencilling is used by itself upon a background of suitable tone; this may be either light or dark. In other cases, white (or creamy) lines or tones are added in white pencil, opaque ink, or opaque watercolor. Such a use of white is particularly effective when rendering strong sunlight, or such white subjects as buildings, sails, snow, sheep, swans, and gulls. Though this white may be applied boldly — white on black is especially striking — in some of the most pleasing examples the white is used more discriminatingly, reserved, perhaps, for small or pale touches.

For drawings of a somewhat photographic nature — those in Figure 119 might fall into this class — paper of a middle value is satisfactory, with the lights and darks modifying it as required. These somewhat static treatments are seldom as effective as those which give an impression of having been dashed off with freedom. Also, vignetted treatments seem to have a greater appeal, as a rule, than those occupying geometric picture areas as those in Figure 119.

One can tint his own paper, if he wishes, by running watercolor of the desired hue over it. If it buckles when dry, it can be pressed flat. Another possibility is to do a pencil drawing on tracing paper, afterwards mounting it on tinted board, the color of which will show through to modify the effect. Whites may be added if desired. For that matter, coloring can of course be done on any of the tinted papers, using colored pencils, watercolors, or both.

The demonstration in Figure 118, and the trees in Figure 119, were drawn on warm gray mat stock. The rose was pencilled on brown wrapping paper, and touched up with Chinese white. The house was on gray charcoal paper; it shows a type of distortion common to many photographs.

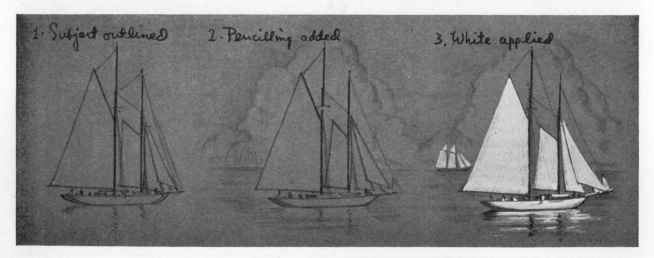

FIGURE 118 · BE SURE TO EXPLORE THE FIELD OF TINTED PAPERS

144

FIGURE 119 · SUCH PAPERS ARE FINE FOR PHOTOGRAPHIC EFFECTS

They serve equally well, also, for free, sketchy work.

145

52

More About Square Sticks

Side Strokes, Notching, et cetera

It is obviously impossible, in a single book of reasonable size, to deal fully with all of the media and methods available to the pencil artist. Before we close, however, we wish to add a word to what we have already said about one tool which is quite outstanding. We refer to the square (or rectangular) stick, whether made of graphite, carbon, lithographic crayon, etc.

While drawing is often done with the small end of this type of stick, which can be pointed to suit (a holder such as we picture keeps the fingers clean), we particularly call attention once more to the possibilities of the side (edge) stroke, as demonstrated in Figure 121. For amazingly effective results may be created with a minimum of effort, mainly by acquiring the knack of exerting pressure near one end of the crayon while using the sharp corner edge.

By notching one of these corner edges (or the end of the stick, for that matter) as shown in Figure 120, several parallel lines or bands of tone can be drawn as a single stroke. Conventionalized impressions of waves, ribbons, and the like can be dashed off in a jiffy. All of the stripes of a flag can be rendered effectively with but one movement of the hand or wrist!

Even in the more common kinds of pencil drawings, these same square sticks, un-notched, afford the means — when used on the side edge — of filling in large areas rapidly. For that matter, round crayons can be similarly employed. It takes practice to do side strokes well, though, and one's drawing surface must be absolutely flat.

If you have never explored this field, you have a pleasant surprise ahead.

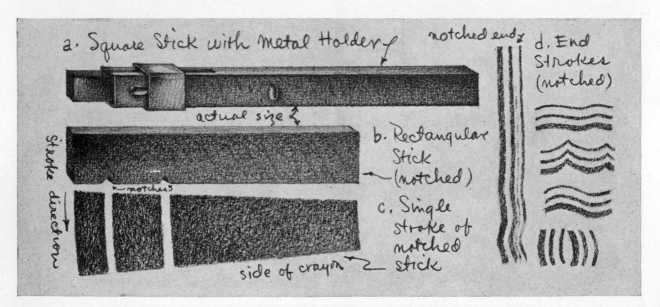

FIGURE 120 · SUCH STICKS ARE PERFECT FOR BROAD-STROKE WORK

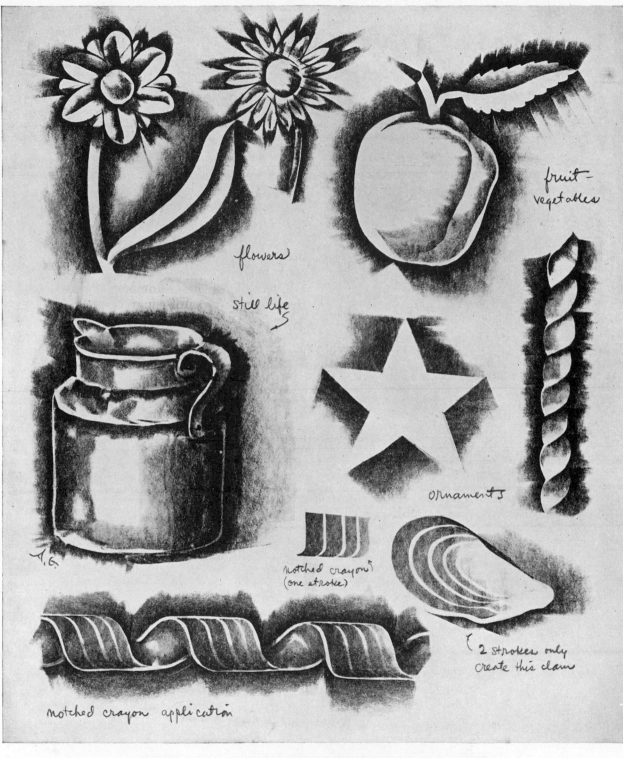

flowers

fruit-vegetables

still life

ornaments

notched crayon (one stroke)

2 strokes only create this clam

notched crayon application

FIGURE 121 · SQUARE STICKS WERE HERE HELD FLATWISE

Once the knack is acquired of holding the crayon stick correctly, it proves the perfect tool for certain types of drawing.